Murillo
& His
Drawings

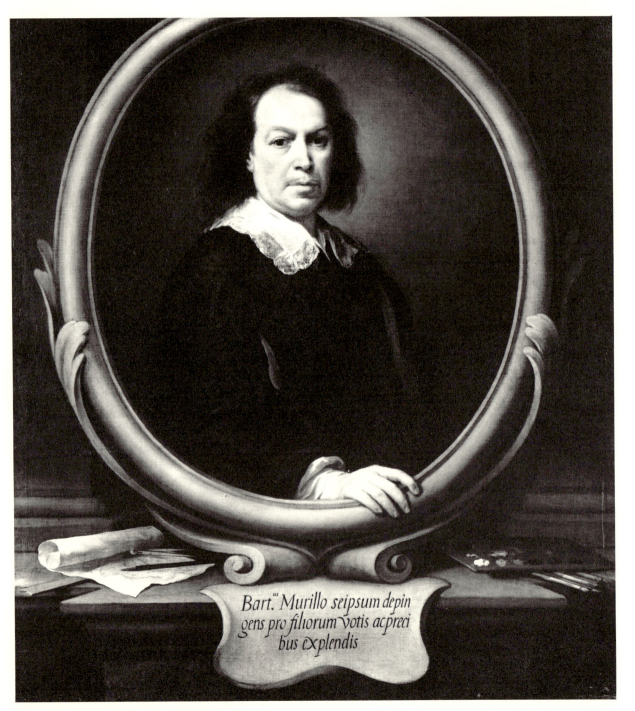

Bart.us Murillo seipsum depin
gens pro filiorum votis acpreci
bus explendis

Bartolomé Esteban Murillo
Self-Portrait.
London, National Gallery 6153.
Oil on canvas, 122 x 107 cm.

Murillo & His Drawings

JONATHAN BROWN

The Art Museum, Princeton University

Distributed by Princeton University Press

*Published in conjunction with an exhibition
of drawings by Murillo held at The Art Museum,
December 12, 1976-January 30, 1977. Drawings
with the following catalogue numbers are not in
the exhibition: 16, 18, 20, 24, 31, 33, 39, 43-49,
51, 53, 57, 59, 65, 72-74, 78, 80, 89, and 95.*

*Designed by James Wageman, Peterson Research Group
Type set by Peterson's Guides Incorporated
Printed by the Meriden Gravure Company*

*Library of Congress Catalogue Card Number 76-9395
ISBN 0-691-03916-X*

*Distributed by Princeton University Press,
Princeton, New Jersey 08540*

*This project is supported by a grant from the
National Endowment for the Arts in Washington, D.C.,
a Federal agency.*

To my mother and
the memory of my father

CONTENTS

DRAWINGS BY MURILLO

COMPARATIVE ILLUSTRATIONS

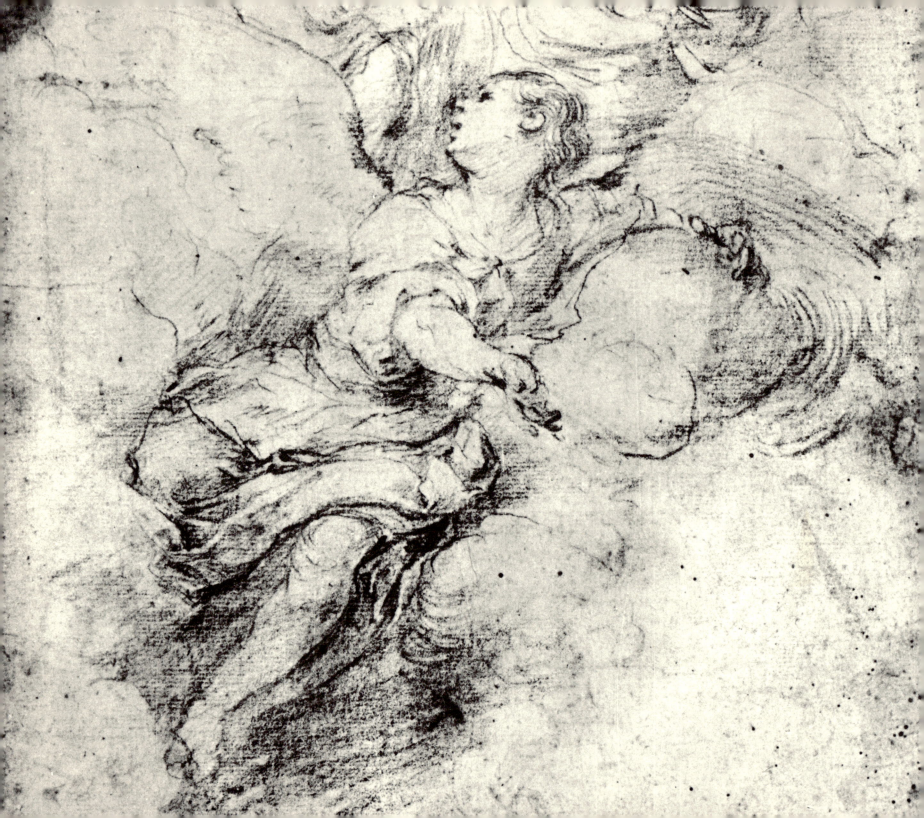

PREFACE

In 1973, I arranged an exhibition of the prints and drawings of Jusepe de Ribera that was held in The Art Museum of Princeton University. Among the several motives that inspired the exhibition was a desire to advance the monographic study of Spanish Baroque draftsmen. Up to that time, only the drawings of Alonso Cano had been studied as a group, but the results obtained in 1952 by Harold E. Wethey, the author of the study, were so important as to suggest how fruitful this line of approach could be. Of course, in the interim, other useful work in the study of Spanish Baroque drawings was carried on, principally by Diego Angulo Iñiguez and Alfonso E. Pérez Sánchez, although exclusively in an anthological format. But it became clear to me, as I surveyed the field, that the monographic study of drawings permitted, indeed invited, a more focused and revealing view of an artist-draftsman. Drawings are complex subjects of study, and simply to identify and classify them is demanding work, especially when, as is the case for Spanish Baroque drawings, very little reliable research has been done by earlier students. However, drawings are also passkeys to an artist's mind. By studying them in relation to each other, to the paintings of an artist, and to a variety of historical questions, drawings afford lucid insights into the process of visual thought and elaboration.

With this in mind, and encouraged by the generally favorable response to the Ribera exhibition, I decided to organize the material that I had been gathering for some time on another important Spanish draftsman. This exhibition and catalogue of the drawings of Bartolomé Esteban Murillo are the results. In general, the format is similar to the section on drawings in the Ribera catalogue. There is, however, one significant difference. In the earlier work, I included entries for only the drawings that were shown in the exhibition. This time I have catalogued all the drawings that I believe to have been done by Murillo, whether or not they will be seen in the show at Princeton. As it turns out, all but about two dozen of his accepted works are to be exhibited.* I hope that, in the long run, this small expansion of size will increase the utility of this book by allowing a complete exposition of the state of knowledge of Murillo's drawings up to December 1975, when I completed the manuscript. Needless to say, I am very grateful to Princeton University's Department of Art and Archaeology and Art Museum for their generosity in permitting the book to be done in this manner.

In undertaking this project, I have received valuable help from many people, whom I would like to thank here. First are my friends and former associates at Princeton University, who have kindly continued to treat me as one of the "Princeton family." The director of The Art Museum, Peter C. Bunnell, worked hard and effectively in coordinating the exhibition. Virginia Wageman, the Museum's editor, assumed responsibility for the production of this book and made many important suggestions regarding the organization and layout. Robert Lafond, the registrar, handled the complicated business of arranging loans from over twenty institutions and collectors, both in the United

*By my count, there are in existence ninety-five sheets by Murillo, with a total of one hundred drawings, including compositions on the verso. All but the following catalogue numbers are in the exhibition: 16, 18, 20, 24, 31, 33, 39, 43-49, 51, 53, 57, 59, 65, 72-74, 78, 80, 89, and 95.

States and Europe. Finally, I owe a great debt of thanks to my former colleagues in the Department of Art and Archaeology, who agreed to support the publication of the catalogue from the Departmental publication fund.

Many people assisted my research on Murillo's drawings and made the works in their care available for study and loan. I am particularly grateful to the museums and collectors who generously agreed to lend drawings to the exhibition. A number of individuals were especially helpful: Jacob Bean, Curator of Drawings, Metropolitan Museum of Art; John A. Gere, Keeper, Department of Prints and Drawings, British Museum; Fritz Koreny, Graphische Sammlung Albertina; Elena Paez, Curator of Drawings, Biblioteca Nacional; Maurice Serullaz, Conservateur en Chef du Cabinet des Dessins, Musée du Louvre; and Eckhard Schaar, Curator of Drawings, Hamburger Kunsthalle. On specific problems of research, I was ably assisted by Edward Sullivan, a student at the Institute of Fine Arts, New York University. I also profited from a seminar on Murillo that I offered at the Institute of Fine Arts in the spring of 1974. Two students in the seminar, Petra Barreras and Andrew Clark, discovered information that has been incorporated into the catalogue and is acknowledged in the text by the inclusion of their initials. José Francisco de la Peña did valuable work in the archives of Seville. Finally, I enjoyed the benefit of discussions and correspondence with two distinguished scholars of Spanish drawings, Enriqueta Harris Frankfort and Diego Angulo Iñiguez.

The preparation of the manuscript owes a great deal to Lynda Hunsucker, who typed it, and Judy Spear, who edited it with great skill and care.

This book was written in moments borrowed from a busy schedule of academic administration. I offer this observation not as an excuse for its shortcomings, but rather to direct gratitude to my associates in the administration of the Institute of Fine Arts. Without the dedicated help of Deborah Kneeland, Assistant Director for Administration, Linda Pleven, Administrative Assistant to the Director, and Frances Farrell, Administrative Assistant for Business Affairs, I would have been overwhelmed by my administrative responsibilities.

But my largest debt of gratitude is owed to my wife Sandra. Without being asked, she assumed more than a fair share of our mutual responsibilities and thus made it possible for me to find the time and tranquillity that are needed for scholarship.

Murillo
& His
Drawings

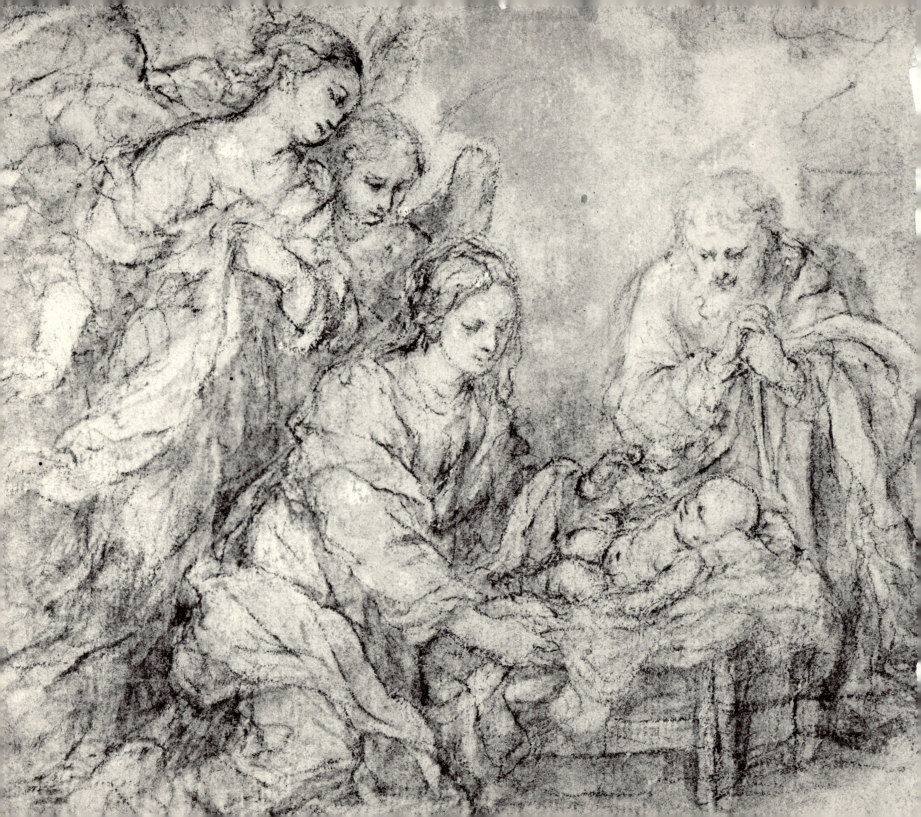

MURILLO AS A DRAFTSMAN

In recent times, the reputation of Bartolomé Esteban Murillo (1617-1682) has steadfastly resisted favorable reappraisal. Although art historians are scouring the past as never before in search of neglected or underrated painters, Murillo seems to be settled permanently in the limbo reserved for artists considered to have been overvalued by an earlier age. One measure of the indifference is the lack of research and writing on his life and work. The only comprehensive monograph is Charles B. Curtis's monumental work of 1883, still surprisingly useful in many respects, but unavoidably antiquated in others. Between 1883 and 1976, a space of ninety-three years, scarcely more than a handful of books and articles can be found that contribute significantly to the knowledge of this artist. Modern taste, of which art-historical writing is both a cause and a reflection, has been unreceptive to a painter formerly thought to be the equal of Titian and van Dyck.

The rise and fall of Murillo's reputation is a subject deserving of study in itself and one that is helpful to understand the special qualities of his art. In the broadest terms, Murillo's fame ascended steadily throughout the eighteenth and early nineteenth century, when it began to fade slowly. In the eighteenth century, his works were eagerly collected by French and English connoisseurs, who were setting the standards of taste. In 1779, the government of Spain, alarmed by the sale to foreigners of Murillo's paintings in Seville, issued a decree forbidding the export of all works by deceased painters.[1] Yet his paintings continued to trickle out of the country into the grasp of appreciative collectors. As his art became better known, Murillo's reputation soared to astounding heights.

The taste seems to have developed—and declined—faster in England than in France. Richard Cumberland, in his *Anecdotes of Eminent Painters in Spain*, published in 1782, referred to Murillo as "a painter better known in England than any of the Spanish school except Ribera." He esteemed Murillo's series of the Life of Jacob, then in the collection of the Marquis of Santiago, above "any [pictures] I have ever seen, one miracle alone excepted, the Venus of Titiano."[2] The comparison with Titian was destined to become commonplace. When Spanish paintings became widely available in the nineteenth century, the fashion became a craze. A symbolic peak was reached in 1852, when an *Inmaculada* taken by General Soult from the Hospital of los Venerables in Seville (Prado 2809) was sold in Paris at auction for a record price.

Thereafter, Murillo's fame began to decline. Admiration, though widespread, had never been universal and soon the detractors began to have their way. Their hero was Velázquez, who since the early nineteenth century had been paired with Murillo as one of the two greatest Spanish painters. As Velázquez rose in esteem, Murillo went down, as if on the heavier end of a seesaw. The reason behind the reevaluation of both artists was concisely and precociously stated in 1827 by the English painter David Wilkie. Writing to Thomas Lawrence from Madrid, he compared Murillo and Velázquez in these terms:

To our English tastes it is unnecessary to advocate the style of Velázquez. I know not if the remark be new, but we appear as if identified with him; and while I am in the two galleries of

1. The decree is quoted in Lipschutz 1972, pp. 266-67.

2. Cumberland 1782, vol. 2, pp. 101-2.

the Museum [the Prado], half-filled with his works, I can almost fancy myself among English pictures. Compared with Murillo, he has more intellect and expression, more to surprise and captivate the artist; still Murillo is a universal favorite, and perhaps suffers in the estimation of some only because all can admire him.[3]

Wilkie admittedly spoke as an artist in preferring Velázquez to Murillo, but his judgment was soon accepted by amateurs, who began to find Murillo as bland a painter as they found Velázquez a challenging one. By 1883, Charles B. Curtis felt himself obliged to offer apologies for Murillo in the preface to his book on the two artists. His words are still remarkably cogent and deserve extended quotation.

It is much the fashion nowadays with a certain class, to exalt Velázquez and decry Murillo. With such critics I have little sympathy. Each has merits; perhaps I ought to be frank enough to admit that each has his defects. Both were great, but in a diverse way. The difference between them is largely due to their temperaments and surroundings. Velázquez was worldly; Murillo, religious. Velázquez labored for artists and critics; Murillo for mankind. Velázquez painted kings, and knights, and dwarfs, things of earth; Murillo painted virgins, and saints, and angels, things of heaven. The one consorted with courtiers; the other with monks. . . .

Not only was there a contrast between the artists themselves, but there is a difference in those who observe and judge their works. Velázquez appeals to the critical and intellectual; Murillo to the sympathetic and spiritual.

One fires the brain; the other touches the heart. Each has his work and performs it with surpassing skill. There is room in the world for both.[4]

Curtis's keen perception of the audiences for Velázquez and Murillo is as telling as the description of their divergent qualities. But his equation of the two artists as different although equal masters of painting would not be widely accepted today. Murillo has come to be considered as a "sentimental" artist in an age that has lost the appetite for the frank expression of pious emotions. He also stands accused of provincialism, as epitomized in Arthur Symons's epigrammatic judgment rendered at the turn of the century: "Outside of Seville Murillo is an enigma." It is no wonder, then, that his paintings have not found many sympathetic students of late, nor, frankly, does the moment seem ripe for a change in taste.

The history of the appreciation of Murillo's drawings naturally follows the course set by the paintings. During the nineteenth century, his drawings were esteemed by collectors, especially in England. In the early 1800s, Frank Hall Standish, an English amateur, acquired in Seville twenty-two drawings attributed to Murillo, which he bequeathed to Louis Philippe in 1841 together with the rest of his collection of Spanish art.[5] Another important group was brought together by Alleyne Fitzherbert, Baron St. Helens, while he served as the British ambassador to Spain in the 1790s. In the sale of his collection, held at Christie's on May 26, 1840, over sixty drawings by Murillo, supposedly purchased by him from the library of the Seville Cathedral, were listed in the catalogue.[6]

3. Quoted by Bayne 1903, pp. 126-27.

4. Curtis 1883, pp. xxi-xxii.
5. See cat. 7.
6. See cat. 2 and Appendix 3.

The collection of Charles Morse, sold at Sotheby's on July 4, 1873, contained thirteen sheets given to Murillo, some of which, however, had come from the St. Helens sale. And a Mexican painter, José Atanasio Echevarría, amassed a total of twenty-eight drawings attributed to the artist, which are now in the Kunsthalle, Hamburg. Even after allowances have been made for misattributions and duplicate ownership, the quantity of drawings in these few collections surpasses the number known today.

The primary reason that so many of the drawings have disappeared is rooted in the pervasive indifference to Murillo's art just described. A second cause may be found in the scant attention paid until recently to Spanish drawings. And third is the lack of a reliable study of Murillo as a draftsman, which has encouraged the acceptance in his oeuvre of drawings by followers and maladroit imitators. Until the 1960s, there were hardly any studies of Murillo's drawings at all. In 1848, William Stirling-Maxwell compiled a list of twenty-nine drawings in the final volume of *Annals of the Artists of Spain*. All but seven had been in the Standish collection, and only two were illustrated. The most generous offering of illustrations appeared in volume 5 of Sánchez Cantón's *Dibujos españoles* (Madrid, 1930), which contained twelve drawings. Unfortunately, Sánchez Cantón's selection confused, rather than clarified, the image of Murillo as a draftsman, for only three of the twelve can now be taken as the work of Murillo. In the next thirty years, little progress was made in defining Murillo's style as a draftsman. Some drawings were reproduced in anthologies, but the same ones tended to appear again and again. Finally in 1960, the drawings found a serious student, Diego Angulo Iñiguez, who has also long been working on a catalogue of Murillo's paintings. In a number of articles published between 1960 and 1974, Angulo began to lay the groundwork for defining an oeuvre and its development. Angulo's researches have attacked the subject on two fronts—the identification of drawings and the problem of chronology—with notable results. What remains to be done in these areas is to introduce a further selection of drawings that will help to refine the definition and evolution of Murillo's style, and to consider additional evidence in order to build a chronological framework. It is also important to record the dimensions, techniques, and provenances as fully as possible.

But the fascination of Murillo's drawings is by no means exhausted when these two aspects have been explored. There remain to be investigated the matter of his stylistic sources and the question of how the drawings were used by Murillo in conjunction with his work in other media and formats. Finally, the vast area of the workshop and followers of this immensely influential artist needs study and clarification. Given the magnitude of these subjects, this catalogue will have, inevitably, a preliminary character. It is difficult to believe, for instance, that many more drawings will not come to light. Furthermore, a wider knowledge of Murillo's paintings will certainly invite a reconsideration of several questions. But the moment still seems opportune to make Murillo's drawings more widely known, if only to encourage the studies that will make the artist's work more accessible and better understood.

Definition and Development of Style

Murillo was a many-sided draftsman. He drew in several techniques, adapting his style to the capacities of the medium at hand. The diversity of style and purpose within the body of his drawings is fascinating but also confusing. Some of the drawings, notably the ones executed in pen and wash during the 1660s and early 1670s, are virtually monochromatic paintings. With their soft, rounded forms and subtle effects of light and atmosphere, they closely resemble his paintings of the period, and thus are readily recognizable. But when he drew in pen alone, Murillo employed a purely graphic style that is harder to identify, especially because his technique changed considerably during his life. Murillo was also an accomplished draftsman in chalk, using red and black chalk individually but frequently combining them. Some of his chalk drawings are highly finished, often to the point where they may be mistaken initially for copies of a much later date. Finally, there are a few drawings done almost entirely either in wash or gouache over chalk that are best compared to his paintings, although they are even more facile and unrestrained.

The chronology of the drawings is marked by a number of signposts in the form of dated or datable works. By coincidence, landmark drawings occur halfway through every decade of his life but the last, the 1670s. Furthermore, there are datable drawings done both very early and very late that enclose his career like a parenthesis. These works help us to reconstruct the evolution of his style with some degree of precision, though not of course to the point where a specific year can be assigned to each drawing. Moreover, they afford a behind-the-scenes view of Murillo's manners of thought and procedure that is illuminating and occasionally surprising.

Murillo's obvious talents as a "painterly painter" rested on the foundations of studious draftsmanship. The artist himself declared allegiance to drawing in the famous *Self-Portrait* in the National Gallery, London *(frontispiece)*. On the ledge beneath his image are two sets of artists' tools: to the right, the brushes and a palette of the painter, and, to the left, a set of draftsman's instruments with a partially rolled piece of paper alongside. To emphasize the fundamental importance of drawing, Murillo represented a life study in red chalk, of which the lower part, the legs of a man, can easily be seen. This type of drawing is now called an "academy," in recognition of the fact that the life study in chalk later came to be regarded as the indispensable foundation for the serious artist. By including the "academy" in his self-portrait, Murillo showed that he recognized the indivisibility of *disegno* and *colore* as the basis for artistic achievement, a fact that has been neglected in later evaluations of his work. By taking him at his "word," we are invited to consider his drawings as an integral part of his art and not simply as a separate pursuit.

The evolution of Murillo's drawing style broadly follows the course of his development as a painter. In the older literature, it was customary to divide Murillo's style into three parts: the *"estilo frío"* of the early years, the *"estilo cálido"* of the middle years, and the *"estilo vaporoso"* of the later years. This meteorological metaphor cannot be dismissed out of hand. It is simplistic and perhaps amusing; but it is not incorrect, only unrefined. Murillo began to emerge in Seville as an independent painter around 1640. During the next ten years, his art fundamentally followed the current of linear naturalism begun by Velázquez in the late 1610s and continued by Zurbarán and Cano in the two succeeding decades. Toward the middle of the 1650s, Murillo slowly began to develop a freer

technique of painting, a more varied palette, and a more active sense of composition. The sources of the transformation are not yet fully understood, but in a general way it can be said that Murillo drew upon sixteenth-century Venetian painting and the Baroque style of Flanders and central and northern Italy as he sought to find the formal means to convey the more emotional and involving art demanded by his clients. By the early 1660s, he had discovered a way to express sincere and exalted religious emotions through the use of warm, soft colors and attractive human types. By intensifying these elements of his style in later years, he became a great master of intimate religious painting.

The progression of Murillo's style runs true to a pattern of evolution often found in the great colorists. It is interesting here only because it also provides the framework of his development as a draftsman. To put it in the baldest terms, Murillo's evolution can be divided into three stages. The first spanned the decades of the 1640s and 1650s. Like the paintings of this period, the drawings have a vigorous, virile quality. The lines are heavily stressed and the contrasts between light and dark are strong. In the pen drawings, close hatching and cross-hatching are used to depict shadows. The second period began in the early 1660s and extended through the early 1670s. In this stage, the style of drawing became more open and free, running closely parallel to the paintings. The lines are curved and looping, forms are often left open, and washes are used to create effects of soft light and shadow. Finally, in the last decade of his life, Murillo's style erupted with a final burst of linear energy. The fast-moving pen created active surface patterns, scarcely stopping long enough to define a limb or facial expression. In the following pages, this rough sketch of his development will be elaborated in greater detail.

1645-1670

Pen-and-Wash Drawings, 1645-1660

The earliest drawings of Murillo are associated with his first major commission: a series of eleven pictures executed in 1645 and 1646 for the *claustro chico* of the monastery of San Francisco el Grande in Seville. Murillo's career as an independent painter had probably started about five years earlier. Hence, these drawings bring us within hailing distance of his beginnings as an artist. The first of two drawings associated with the *claustro chico* is a two-sided sheet in the Ecole des Beaux-Arts (cat. 1). On the recto is a preliminary drawing in pen with touches of red chalk for a painting of *Brother Juniper and the Beggar* (fig. 40). In many ways, the drawing is an epitome of Murillo's style as a pen draftsman, despite the morphological changes that continually occurred as he grew older. Drawing with a fine-tipped pen, Murillo used a combination of rhythmically arranged and straggly lines. The outlines are drawn with wiry, broken strokes, while the shadows are rendered by parallel lines, sometimes connected by a loop, sometimes freestanding. Deeper shadows, such as those on the upper right leg of the beggar and his right shoulder, show repeated reworking with heavier strokes. The ground shadows are represented by longer, sweeping strokes also arranged in a roughly parallel pattern. Two small but telling mannerisms of the early pen style are the spiky configuration of Brother Juniper's fingers and the single curved line on his right cheek that defines the bone structure of the face. The overall effect is strong: the vigorous, abrupt movements of the pen and the pronounced contrasts of light and dark impart a forceful, energetic character to the drawing.

The sketch in black chalk on the verso of the drawing is in another vein. As Diego Angulo first noted, the drapery study refers to a second painting for the *claustro chico*: *Saint Salvador of Horta and the Inquisitor of Aragon* (fig. 41). In contrast to the jumpy pen style, the chalk drawing is suave and finished. Light and shadow are gently modulated by the use of countless thin, faint parallel lines, which are sometimes blended into sfumato passages by rubbing. The difference between the pen and chalk techniques that emerges in this sheet, though striking, is commonly found in old-master draftsmanship and is therefore not noteworthy in itself. But for understanding Murillo's drawings, this chalk study is significant on two counts. First, it shows that Murillo was an accomplished chalk draftsman almost from the start. And second, it shows how carefully he conceived the compositions of his paintings. In the manner of a Renaissance draftsman, he first imagined a composition in its entirety and then proceeded to refine his ideas by separate analysis of the parts.

The second drawing for the *claustro chico* is also two-sided (cat. 2). On the recto is a preparatory study in pen and brown wash for a *Scene from the Life of Saint Francis Solano*, a painting that was completed but not incorporated into the ensemble (fig. 42). The composition is drawn over faint preliminary indications in black chalk, a practice that Murillo employed in the majority of his pen-and-wash sketches. Here, moreover, Murillo used wash for the shadows instead of parallel hatching, a wash that is uniform in value and without the subtle modulations of later years. Consequently, the contrasts between light and dark are striking, all the more so because the drawing is so well preserved.

On the reverse are two sketches in black chalk, one of which is so faint that it can hardly be seen.

The larger of the two is a sketchy depiction of Saint Francis Solano. Immediately to the left, Murillo returned to consider the composition of *Saint Salvador of Horta and the Inquisitor of Aragon*, this time showing the two central figures. The recurrence of the motif not only links the two sheets, but also shows how Murillo methodically planned his compositions. By a fortunate coincidence of survival, these two drawings preserve a revealing sample of the artist at work in the media he was to favor as a draftsman. They also provide a firm basis for understanding his subsequent development.

The next group of datable drawings forms a cluster around the years 1655 and 1656. At its center are three drawings for the imaginary portraits of *Saint Isidore* and *Saint Leander* that were given to the Cathedral of Seville in 1655 and almost certainly painted in that year, too (figs. 44 and 46). There are two studies for *Saint Isidore*, one in the Louvre, another in the British Museum. The Paris version (cat. 8) is fundamentally a pen drawing, with only small touches of wash in the background. It is a vigorous and energetic study that shows the vocabulary of the earliest sheets with relatively little change. The main difference lies in the intensification of hatching and cross-hatching. To the left of the saint, Murillo laid down a dense web of burin-like strokes to produce the effect of a dark shadow. Just above this area the lines break free of the restraining pattern, leaping upward in jagged trajectories. This combination of controlled and untrammeled lines repeats the graphology of the drawings done ten years earlier and indicates the continuity of the first period of Murillo's pen style.

The second drawing for *Saint Isidore* (cat. 12), done in pen and wash, shows a distinct change from earlier works. Initially, it is hard to accept a date contemporary with that of the Louvre sheet. In place of the emphatic, rough style of pen drawing is an open, flowing manner with no sharp angles or explosive lines. The initial design is suggested by faint chalk indications, some of which are picked up by thin, wavy lines done in pen and brown ink. Over this fragile structure Murillo laid down broad areas of transparent brown and gray wash. By varying the density of the wash, he achieved subtle and gentle modulations of light. This more painterly style of wash drawing contrasts with the technique used in *Scene from the Life of Saint Francis Solano*, where the tonal values are constant. The intermediate steps, however, can be seen in a drawing that helps to bridge the gap of ten years. This is a splendid *Adoration of the Magi* (cat. 7), a preliminary study for a painting of the early 1650s (fig. 43). Here the wash has acquired the same painterly quality that is seen in the British Museum *Saint Isidore*.

The study for the companion portrait of *Saint Leander* goes one step further in the liberation of the wash technique (cat. 13). Once again, the initial design has been sketched in black chalk. But pen and ink have been abandoned, with the result that the drawing has the appearance of a monochromatic painting. The two wash drawings for this commission of 1655 are forward-looking works and may even be taken as the first symptoms of a major stylistic change that is not evident in the paintings until a few years later.

A few more pen drawings can be grouped around the Louvre *Saint Isidore*. They include *Archangel Michael* (cat. 10), *Saint John the Baptist* (cat. 11), *Studies of Putti for the Virgin of the Immaculate Conception and of the Head of the Virgin Mary*

Weeping (cat. 15), and a *Young Saint John the Baptist with the Lamb* (cat. 9). All four drawings clearly exhibit Murillo's idiosyncratic pen style of the 1640s and 1650s and do not require lengthy analysis to make the point. They do, however, pose an insistent question: from what sources did Murillo acquire the rudiments of his distinctive pen style?

Sources of Murillo's Pen Style
The answer to the question of Murillo's sources is to be found within the walls of Seville, where a "communal" drawing style was developed in the seventeenth century. The ultimate sources of this pen style are not clear in the present state of knowledge. But by the first quarter of the century it was firmly established, as can be seen in the drawings of Francisco de Herrera the Elder (ca. 1590-1654). Herrera as a draftsman has never been comprehensively studied, but fortunately he signed and dated enough drawings to permit the identification of his style, especially in pen and ink.[7] Two drawings by Herrera from a series of Apostles, though dated in 1642, exemplify both his style and the *lingua franca* of the Sevillian draftsmen (figs. 1 and 2). Using a reed pen, Herrera modeled the figures with the tight hatching and cross-hatching that characterize his style. This assertive linear draftsmanship is the common denominator in artistic ateliers of Seville throughout the seventeenth century. It can be traced almost in genealogical fashion from 1600 to 1700.

Another early practitioner of the style appears to have been Juan del Castillo (1584-1640). Castillo was not a talented painter, judging from the handful of works that can be surely given to

Figure 1. Francisco de Herrera the Elder, Saint Thomas.
London, British Museum 1895-9-15-871.
Pen and brown ink, 297 x 185 mm.

Figure 2. Francisco de Herrera the Elder, Saint Bartholomew.
London, British Museum 1895-9-15-872.
Pen and brown ink, 304 x 180 mm.

7. For a sample of his drawing style, see Sánchez Cantón 1930, vol. 3, pls. 203-210. Plates 211 and 212 are not by Herrera.

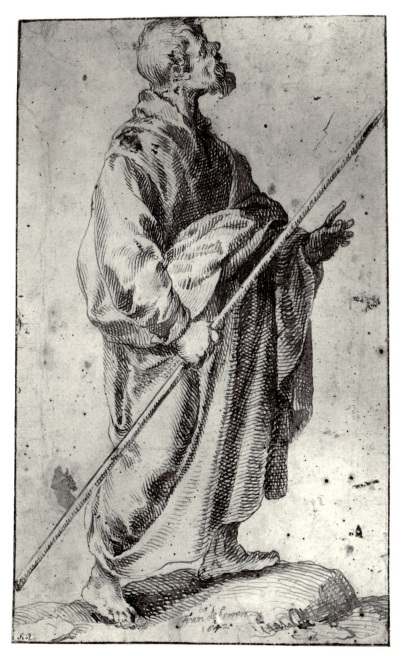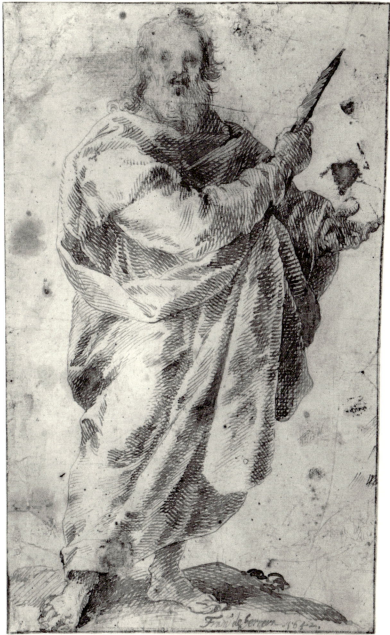

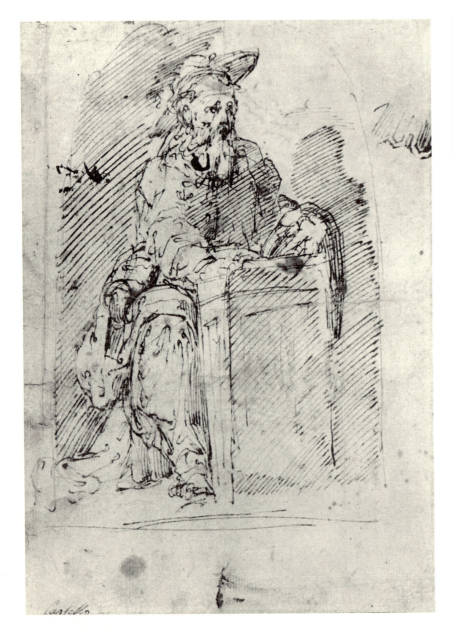

Figure 3. Attributed to Juan del Castillo,
Seated Male Figure.
Munich, collection of Family S.
Pen and brown ink, 209 x 148 mm.

Figure 4. Attributed to Juan del Castillo,
Standing Allegorical Figure.
Munich, collection of Family S.
Pen and brown ink, 216 x 147 mm.

him.[8] His paintings may best be called overbaked central Italian mannerism. They are composed of smooth, flat surfaces, sharp contours, and exaggerated but rigid poses; they are unified, if that is the word, by a pedestrian sensibility. Castillo's name figures in the history of Spanish baroque art primarily because of his connections with some of the major Andalusian painters. He was the uncle of Antonio del Castillo, a close friend of Alonso Cano, and supposedly the teacher of Murillo. The relationships with three of the most important draftsmen trained in Seville raise the question of Castillo's own accomplishments in this medium, and a troubling question it is. Few, if any, drawings have ever been attributed to him, rightly or wrongly. Hence, it is with all due caution that two sheets, both with sketches on the recto and verso, are here brought forward as having been done by Juan del Castillo.

The attributions are based initially on identical inscriptions of the name Castillo found on the recto of both examples (figs. 3 and 4).[9] Using what is called the "law of modest attributions" as a guide (the law states that early attributions to minor masters tend to be more accurate than early attributions to major masters), it becomes possible to see that the drawings conform to the canon of Sevillian draftsmanship. The direct, vigorous style and the bold use of parallel lines for shading agree with the Seville style and even predict its future use by Cano, Antonio del Castillo, and Murillo.

However, the drawings also have an archaic flavor; they lack the fluidity of line and the ease of movement found in later drawings. The awkwardness that infuses the drawings is reminiscent of Castillo's paintings. By gamely striving for "correctness," they make it impossible to achieve the subtle, apparently effortless harmony that is the very essence of *il buon disegno*.

As a hypothesis, the attribution of these drawings to Juan del Castillo makes sense.[10] They not only fit the measure of his style in paintings, but they also point to an important source for the drawings of Murillo, if he indeed studied with Castillo, as Palomino said. It would, however, be a mistake to limit the search for Murillo's origins as a draftsman to Castillo alone. The Seville style of drawing was a common style and was consequently practiced by many artists. Furthermore, the distance between these drawings attributed to Castillo and even the earliest sheets by Murillo is significant. To bridge it, we must look elsewhere.

The obvious place to start the search is among the drawings of Alonso Cano (1610-1667), a prolific and influential draftsman.[11] Unfortunately, very few sheets survive from Cano's years in Seville (1614-1638), making it difficult to speak precisely about his significance for the young Murillo. But every instinct as well as many of the later drawings suggest that he must have been a major force in the formation of Murillo's approach to drawing. For instance, there is his study of a *Seated Male Figure* (fig. 5). The lively, broken outlines and the rapid movement of the pen bring Murillo's earlier drawings immediately to mind. Similarly, the

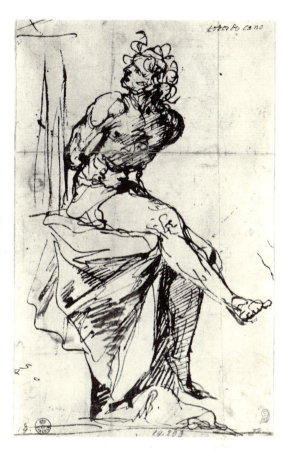

Figure 5. Alonso Cano,
Seated Male Figure.
Florence, Uffizi 10263.
Pen and brown ink, 219 x 137 mm.

8. For Castillo's life and art, the inadequate short account by Mayer (1911, pp. 127-31) must still suffice.

9. Fig. 3, verso: *Kneeling Male Nude* (possibly a study for the Good or Bad Thief), pen and brown ink, 209 x 148 mm. Fig. 4, verso: *Man on Crucifix*, pen and brown ink, 216 x 147 mm. Angulo and Pérez Sánchez (1975, nos. 110 and 112) attribute the drawings to G. B. Castello.

A third sheet by this hand is *Seated Male Nude Holding a Torch*, Hamburg, Kunsthalle 1958/90, as Pacheco; see Hamburg 1966, pl. 10.

10. It is possible that the drawings were by Castillo's brother Agustín (ca. 1565-1631), who was the father of Antonio, the well-known draftsman. However, almost nothing is known of Agustín's artistic work.

11. For Cano's drawings, see Wethey 1952.

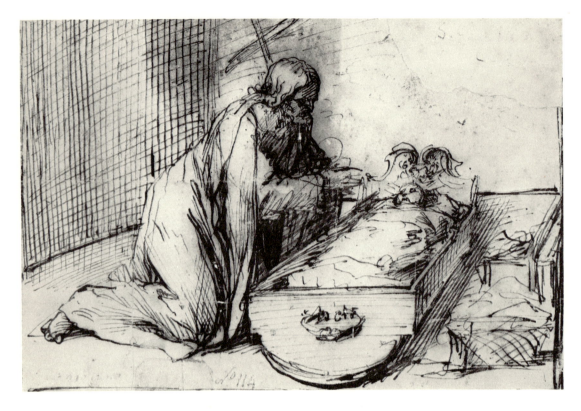

Figure 6. Alonso Cano,
Saint Joseph and the Christ Child in a Cradle.
Madrid, Museo del Prado F.A. 53.
Pen and brown ink, 120 x 175 mm.

imaginative *Saint Joseph and the Christ Child in a Cradle* (fig. 6) is Murillesque in subject and style. Cano left Seville in 1638, never to return. But that was time enough for Murillo, then twenty-one years old, to have learned Cano's lessons.

Murillo was by no means the only draftsman to absorb and perpetuate the Seville style of drawing. In his early drawings, Francisco de Herrera the Younger (1622-1685) shows the results of his father's training. A study sheet with a figure of Christ and heads (fig. 7) is fundamentally a livelier version of the elder Herrera's graphic pen style.[12] But the most prolific practitioner of the Seville manner was Antonio del Castillo (1616-1668), whose works in pen, historically speaking, are an amazingly vigorous and inventive variation of the Seville style.[13] His study of a *Kneeling Christ* (fig. 8), to pick an example almost at random, is done with characteristic heavy hatching and cross-hatching.

As these drawings show, and those of Murillo show as well, the Seville style was absorbed and interpreted by successive generations of artists. In the drawing academy founded in Seville in 1660, to be discussed later on, the style was institutionalized and thus kept alive until the end of the century.

12. For Herrera the Younger's drawings, see Brown 1974 ("Pen Drawings by Herrera the Younger"); and idem 1975 ("Drawings by Herrera the Younger and a Follower").
13. For Castillo's drawings, see Muller 1963.

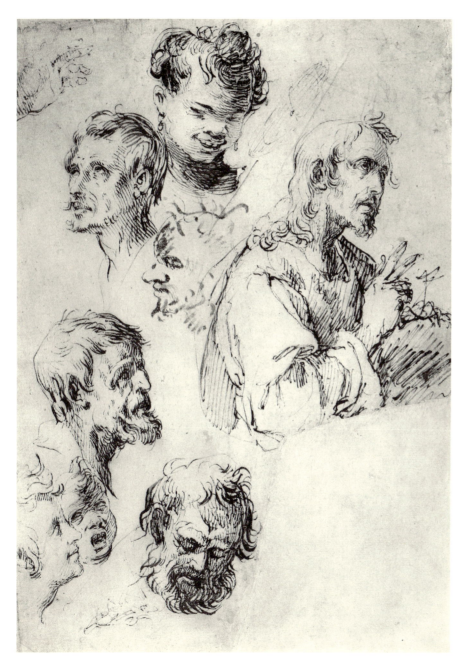

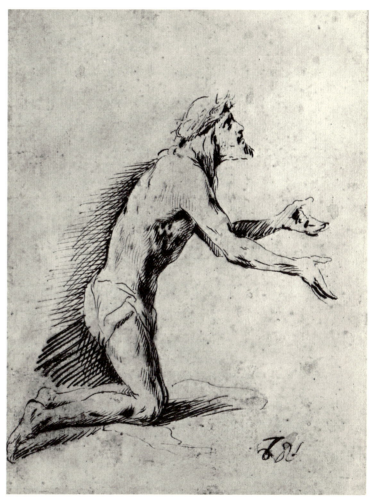

Figure 7. Francisco de Herrera the Younger,
Figure of Christ and Heads.
Hamburg, Kunsthalle 38512.
Pen and brown ink, 293 x 203 mm.

Figure 8. Antonio del Castillo,
Kneeling Christ.
London, art market.
Pen and brown ink, 190 x 147 mm.

Chalk Drawings, 1655-1670

The drawings in chalk by Murillo form a separate chapter in his career. Although their number is now not large, they played a significant part in Murillo's oeuvre, as he showed by including a red chalk drawing in his *Self-Portrait* (*frontispiece*). The best evidence of their existence is the collection made by Lord St. Helens, which contained almost forty sketches in black and red chalk, only a fraction of which can now be located. Where have they and others gone? Many of them probably still exist but are classified as later copies after Murillo's paintings. The reason for the misapprehension is twofold: some are closely related to known pictures, and almost all of them are so painstakingly finished that they suggest a copyist's, not a creator's, mentality. And yet the basis for the attributions is solid indeed.

As we have seen, Murillo's penchant for finished chalk drawings appeared at the threshold of his career as a draftsman, in the drapery study on the verso of *Brother Juniper and the Beggar* (cat. 1). There are very few chalk drawings that survive from the following decade. One of the exceptions, however, is important. A sheet (cat. 15) with a partial study for the putti in the *Virgin of the Immaculate Conception of Loja* (fig. 48) also has a head of the Virgin, with the drapery in black and the face in red chalk. The juxtaposition of the chalk drawing with an authentic pen sketch is obviously not conclusive proof of an attribution. But when taken with other points in its favor, a case can be made for accepting the authorship of Murillo. First of all is an apparent signature, reading *Murillo f.*, which is consistent with the color and texture of the black chalk drapery (see below for a discussion of Murillo's signature). Second is the relationship to a painting of the *Virgin Mary*

Weeping (fig. 49), for which the drawing is a preliminary study. And last is the existence of other red and black chalk drawings executed in the same style, which will be discussed shortly.

The case for this drawing needs to be made because the style and technique do not readily fit into existing notions of Murillo's oeuvre as a draftsman. The technique may seem too finicky, the facial expression too characterless and distinct from the type found in Murillo's paintings. But the evidence of this sheet invites us to expand our conception of his draftsmanship to include highly finished red and black chalk drawings, many of which can be related to paintings. Other drawings in this medium will, I believe, establish the authenticity of the entire group.

The majority of these drawings fall into the period between 1655 and 1668, although this concentration may represent an accident of survival and not the artist's determination to develop the medium. In any case, their stylistic cohesiveness and draftsmanship are impressive. The first drawing in the series is *Mystic Marriage of Saint Catherine* (cat. 14), which is precisely dated January 29, 1655, and is related to a painting (fig. 47).[14] The technique of the red chalk drawing is characteristic of this group. Firmly delineated forms have been modeled with soft, transparent shadows created by thin, closely spaced lines and smudging effects. Volume has been imparted to the drapery by small, dark areas that punctuate the hazy shadows. Murillo skillfully used the texture of the paper to produce halftones, especially in the flesh areas. The subtle but highly polished technique is masterful and reveals Murillo's endowments as a chalk draftsman.

14. It is not uncommon to find precisely dated drawings by Sevillian draftsmen. Pacheco and Herrera the Elder often inscribed the day, month, and year on their drawings.

In the following year, Murillo executed a study of *Angels* (cat. 17), a preparatory drawing for the monumental *Vision of Saint Anthony of Padua* (fig. 50), which was installed in the baptismal chapel of Seville Cathedral on November 21, 1656. As a partial study for a large painting, this black chalk drawing is rendered in a more summary manner than the *Mystic Marriage of Saint Catherine*, but there are still many common traits. Perhaps most striking is the treatment of the lower part of the angel's body, where the soft shadows around the leg contrast with deeper pockets of darkness in the drapery folds.

A third drawing in the group is a study of putti (cat. 22), which also bears an exact autograph date, October 17, 1660. This drawing, like the preceding one, appears to be a partial preparatory study for a painting (as yet unidentified). The precise delineation of forms, the soft, gently graded shadows, and the darker accents that impart a sense of relief to the shapes are all common and repeated elements of his chalk style.

The next datable chalk drawings appear after a gap of five years. They are three sheets that relate to the decoration of Santa María la Blanca, which was completed in 1665. The first (cat. 24) is a study for the central figure of *Virgin of the Immaculate Conception* (fig. 52), a painting that hung originally in the church. The other two (cat. 25 and cat. 26) are studies for paintings of *Young Saint John the Baptist with the Lamb* (fig. 53) and *Christ Child as the Good Shepherd* (fig. 54), which were installed in a temporary altar erected outside the church for the inaugural celebration. These drawings may well be controversial attributions because they appear initially to be copies. The close adherence to the paintings and, above all, the facial types and expressions invite this conclusion. Yet the technique and style are

unmistakably and closely related to other drawings. The *Young Saint John*, which is in better condition, displays the customary painstaking yet suave technique. Using red chalk for the flesh areas and black chalk for the rest, Murillo has blended the almost microscopic strokes into beautifully graded areas of shadow. Occasionally he has pressed down hard on the chalk, as at the right side of Saint John and under the neck of the lamb, to emphasize the borderline between two shaded forms. The result is comparable to the sfumato effects that are so well known from his paintings. In the *Good Shepherd*, now unfortunately marred by spots and stains, the same approach is used, though the background is described in less detail.

The last drawing in this manner to which a firm date can be assigned is a preparatory study (cat. 28) for the famous painting of *Saint Francis Rejecting the World and Embracing Christ* (fig. 55), executed for the Capuchinos of Seville in 1668 and 1669. Here again, the word "copy" comes to mind, but the handling of the drawing is simply too accomplished and refined to subtract it from Murillo's oeuvre. This red and black chalk drawing differs slightly from the others in the use of more pronounced hatching, visible in the beards of Christ and Saint Francis and in the drapery. But the technique of Christ's torso and legs displays Murillo's characteristic chalk style.

Another drawing for this composition (cat. 27) introduces a less usual manner of chalk drawing. This version of the scene in black chalk must have preceded the two-color drawing (cat. 28) because the artist was still experimenting with the composition, as explained in the catalogue. By using a softer grade of chalk, Murillo has exploited the potential of the medium for achieving effects of soft light and hazy atmosphere. Although a few typical mannerisms can be identified, such as the parallel strokes along Christ's torso and leg, the

result is notably different from the precise, meticulous drawings just discussed. The rarity of comparable drawings may be explained by the fact that Murillo usually employed this technique for the underdrawing of pen-and-ink sketches. In numerous pen drawings a faint and indistinct outline in black or red chalk was used to indicate the main elements of the composition. Perhaps this drawing, too, was meant to undergo further definition in ink. In any case, it is not quite unique because the verso contains an even looser black chalk *pensiero* for an *Adoration of the Shepherds* (fig. 56), also painted for the Capuchinos in 1668 and 1669.

Pen-and-Wash Drawings, 1660-1670
At the same time that Murillo was developing a tightly knit chalk style, his pen drawings were achieving unprecedented freedom. In the 1660s, Murillo cultivated a pictorial style in which washes play a predominant part. Indeed, the pure pen drawing becomes almost extinct during this period. In some drawings, line is used only to provide a summary annotation of forms that are realized with painterly applications of wash. Comparisons with his paintings now become not simply helpful but inevitable. Despite the concurrence of paintings and drawings, it is not easy to date the drawings of this period with precision, partly because the dates of the paintings themselves are often hard to determine. Two sheets can be dated by their relationship with documented paintings, but unfortunately the pictures, which were done for the Capuchinos of Seville, are close in date (1665-1668). Prudence dictates, therefore, that most of the drawings be dated only approximately. However, within the general species of pen-and-wash drawing, there seem to be two identifiable genres.

The first is represented by the beautiful *Christ in Gethsemane* (cat. 35). Comparison with a painting

is explicitly invited by the arched frame supplied by the artist himself. The excellent state of preservation permits an unusually clear view of the technique of this type of pen-and-wash drawing. First, Murillo outlined the principal figure in pen without any chalk underdrawing. Over these lines he applied wash in varying degrees of density to create an interplay of light and dark. Highlights are supplied by the untreated paper. A middle range is given by a transparent brown wash, while shadows are rendered by a dark, opaque brown wash. The brushwork is rapid, certain, and economical, and the result may justly be called brilliant. In a drawing of 1665-1666 (cat. 33), the study for *Saints Justa and Rufina* painted for the Capuchinos of Seville (fig. 59), both pen strokes and wash are applied with unprecedented freedom to produce a sketch of matchless spontaneity and confidence.

A second approach to pen-and-wash drawing in this period is found in a preliminary study (cat. 50) for *Vision of Saint Felix of Cantalice* (fig. 61) executed between 1668 and 1669 for the church of the Capuchinos. In this technique, more attention is paid to the linear structure. Initially, the composition was summarily sketched in chalk. Then some of the lines were reinforced with pen, and the passages of greatest interest, such as the saint's head, were further elaborated with tiny flicks of ink. Finally, a transparent wash was applied to model the figure. In some drawings, such as a well-known *Virgin of the Immaculate Conception* (cat. 54), the linear system is more extensive. Parallel lines and cross-hatching form the basis of this technique, which is a continuation of the pen style of the 1650s, though the lines tend to be shorter and less heavily stressed. The wash consequently becomes a secondary means of creating shadow, although its use adds brio and richness to the movement of light over the surfaces.

1670-1682

The last decade of Murillo's career as a draftsman is the most complex and the most prolific; over a third of the known drawings were done during this time. The 1670s are also in many ways the richest period. Not only are the technical horizons expanded by the introduction of new media, but the style itself assumes increased confidence and freedom. Even the apparent failure of Murillo's physical capacities at the very end could not curtail the immense energy of his draftsmanship. Regardless of medium, the late drawings evince a looseness and breadth that equals and at times surpasses the expressive style of his late paintings. The dating of these drawings must be approximate because only a single sheet can be tied to a datable painting or document.

Chalk-and-Wash Drawings

Right from the start of his career, Murillo had elaborated his drawings by sketching a preliminary idea in chalk, which was then clarified by the superimposition of pen and later the addition of wash. This technique was never abandoned, but in the 1670s he also began to experiment with transparent and opaque washes, sometimes over chalk, sometimes without any underdrawing at all. There are, to be sure, drawings in chalk alone. A beautiful *Christ on the Cross* (cat. 56), which is related to a *Crucifixion with the Virgin Mary and Saints John and Mary Magdalene* (fig. 63), is done in red and black chalk, but with a broader, less studied manner. *Saint Joseph and the Christ Child Walking* (cat. 58), also a study for a painting (fig. 64), is an even later chalk drawing in which a straggly line replaces the tight, dense linear constructions of

earlier periods. But there are, in addition, drawings in which wash is applied over an allusive design in chalk. The tender and moving *Virgin and Saint Joseph with Two Angels Adoring the Christ Child* (cat. 61) is a magnificent example of this technique. Silken lines drawn in red chalk are used to delineate the forms. Over these lines a brown wash is freely applied to create the shadows. An opaque white wash, now oxidized, provides the highlights on the figures and some of the ground shadows. The *Vision of Saint Anthony of Padua* (cat. 62), a study for a painting (fig. 65), is executed in a similar way, though pen and ink are used sparingly to strengthen a line here and there.

The culmination of the wash drawings is found in two closely related studies of *Saint Joseph and the Christ Child Walking*. In one of them (cat. 64), the black and white washes follow a black chalk outline. But in the other (cat. 65), the chalk is omitted, making it virtually a small watercolor drawing. Murillo seldom created these nonlinear, entirely painterly sketches. A less ambitious but equally interesting drawing is done in an unusual green wash, the only pure wash drawing that is now known (cat. 63). These sheets add an important dimension to his oeuvre and also help to reveal the freedom of expression that he sought in his later years.

Pen-and-Wash Drawings

The late pen-and-wash drawings develop logically from the works in this medium of the previous decade. The looseness and movement predicted in *Saints Justa and Rufina* of 1668 (cat. 33) are fulfilled in the 1670s. These drawings have a uniform technique: the initial design is freely rendered in black chalk; then, some of the chalk lines are reinforced with pen and ink. Many of the chalk lines, however, remain visible and contribute to the atmosphere and movement of the compositions.

Last, wash is laid down in thin, broken patches that animate the surfaces.

The group of late pen-and-wash drawings may be organized around a few sheets, three of which can be related to paintings by or after the master. The first is *Saint Thomas of Villanueva Receiving the News of His Impending Death* (cat. 69), a study for one of the pictures commissioned by the monastery of San Agustín (fig. 67). Over short, cramped pen lines Murillo has laid down an even, transparent veil of brown wash, pierced in places by highlights of untreated paper. The charming *Boy with Dog* (cat. 72) is a genre scene of a type made famous in Murillo's paintings but otherwise unknown in the drawings. Here the casual subject matter seems to have inspired the use of a marvelously insouciant technique based on scrawling pen lines. Two more drawings, *Dream of Joseph* (cat. 71) and *Caritas Romana* (cat. 70), both related to paintings, equally exemplify the late style of Murillo.

Pen Drawings

In the last decade of his life, Murillo returned to the energetic and purely linear style of his youth. The dozen known drawings in pen and ink supply a surprisingly frenetic conclusion to his work as a draftsman. The late pen drawings are generally done with a wide-tipped pen that hurries back and forth across the figures with a driving rhythm, blurring details and allowing only essential forms to emerge. The movement becomes progressively faster and faster until at the end the forms are almost lost in a welter of lines. The increasing abstraction of the style makes it possible to arrange the drawings in a relative chronological order.

The earlier drawings are exemplified by the magnificent study (cat. 79) for *"Santiago" Madonna and Child* (fig. 69). Although Murillo has added wash to the drawing, the graphic style is characteristic of the period. Basically, two linear movements are employed: a short, "crumpled" line, most visible on the Virgin's right arm and shoulder, and looped, parallel lines that are used for shading. Most of the other drawings in this group were done without wash, and in them the roiling linear movement is irresistible. The *Young Virgin of the Immaculate Conception* (cat. 84) and *Saints Felix of Cantalice, John the Baptist, Justa, and Rufina* (cat. 77) are drawn with great breadth and freedom. The putti in the former drawing are barely distinguishable among the tangle of pulsating lines.

A distinctly later phase begins to be visible in a drawing like *Christ Child as the Good Shepherd, Standing* (cat. 88), in which the forms appear almost to erode as the line becomes increasingly summary and ragged-looking. More and more, the descriptive details are suppressed; the background, for example, is suggested by only a few twisted lines. The process of disintegration is still at work in a *Virgin of the Immaculate Conception* (cat. 92), and even more advanced in an *Annunciation* (cat. 93). The style of these drawings has loosened to an extraordinary degree; the forms are implied, not really delineated. The putti above the main figure are virtually linear abstractions with only the faintest clues to suggest their identity.

Beyond this point, there is only a single work. The last known drawing by Murillo (cat. 94) may be one of the latest drawings he did. This is a study for the large altarpiece of the church of Santa Catalina in Cádiz (fig. 71). Here we may detect signs of failing physical powers. The forms have an unmistakable trembling quality, almost as

if the artist were no longer entirely able to control the movements of his hand. But despite the frailty, or perhaps because of it, this is a grand drawing. The contest between the failing physical strength and a still-robust artistic imagination is won by the artist's will to succeed in producing a major commission against odds. The lines, though wan and spent, clearly establish the composition. The forms, though vague and ravaged, finally take shape from the weakened hand.

The Role of Drawing in Murillo's Art

Nearly half the known drawings by Murillo can be related to his paintings. This simple statistic confirms the impression gained from a preliminary survey of the drawings: that they played an important part in the creative process that generated his finished works in oil. This use of the drawing is, of course, entirely commonplace and unexceptional. But it might be said that Murillo does not give the impression of being an artist who required a great deal of preliminary work before setting brush to canvas. Many subjects appear in his art again and again, and the very facility with which he painted suggests a well of invention that could be drawn upon with ease. However, his drawings tell the story of a thoughtful, methodical artist whose virtuosity came as the result of method as well as manual dexterity. The preliminary drawings also help us to appreciate the impressive variety he brought to the limited number of themes he was asked to paint.

It is difficult to generalize about Murillo's preparatory process, first, because the total number of his drawings is small and, second, because it does not appear to have followed an inflexible procedure. There are, for instance, studies in pen and ink, or pen and ink with wash, that reveal the artist's first thoughts for a composition. The drawing of *Brother Juniper and the Beggar* (cat. 1) is such a work. Here Murillo concentrated on the figure group and established the poses that appear, with variations, in the painting (fig. 40). Judging from this example alone, it would appear that the significant differences between drawing and painting were resolved as the artist worked on the canvas. But the elaboration of another painting in this series indicates that the details of a composition were given further thought. A hasty sketch in black chalk on the verso of the drawing of a *Scene from the Life of Saint Francis Solano* (cat. 2) shows the composition of *Saint Salvador of Horta and the Inquisitor of Aragon* taking shape. A second stage is visible on the verso of the *Brother Juniper* drawing itself, where a drapery study in black chalk spells out the details of the Inquisitor's costume. Similarly, the pose of Saint Francis Solano is studied by itself in black chalk on the reverse of the complete compositional study for the painting. These early studies show that Murillo's conceptualization of a theme could proceed in distinct stages and in distinct media. The point is confirmed in later drawings, such as the study of *Angels* (cat. 17) for the monumental *Vision of Saint Anthony of Padua* (fig. 50), and *Saint Francis Rejecting the World and Embracing Christ* (cat. 28), which carefully establishes the central figure group for the painting (fig. 55) after the design had been fixed by a rougher sketch of the whole composition (cat. 27).

But even this consecutive elaboration did not end the preparatory process. There are some indications that a final synthetic step occurred before the painting was begun. This step was a small-scale oil sketch. Murillo's oil sketches are the least-known part of his work and consequently are

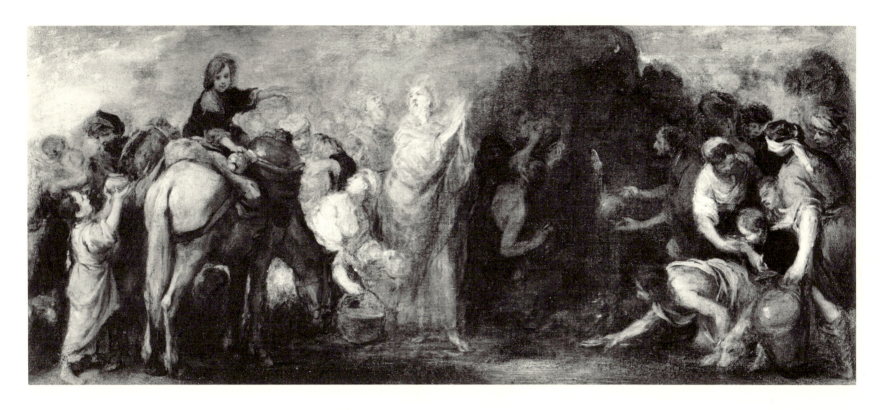

Figure 9. Murillo,
Moses and the Miracle of the Waters.
England, private collection.
Oil on canvas, 32.9 x 74.6 cm.

usually considered to be copies by other artists.[15] The case for their authenticity is not easy to make precisely because they closely resemble the paintings for which they were intended as preliminary studies.

The ignorance of this part of Murillo's oeuvre is relatively recent. A few oil sketches are mentioned in the inventories of both Murillo and his son Gaspar, taken after their deaths in 1682 and 1709, respectively.[16] During the eighteenth and nine-

teenth centuries, the sketches were recognized and collected, and abundant references to them can be found in sale and exhibition catalogues. In 1883, Curtis mentioned about seventy sketches that he had either seen or read about, some of which can be traced from earlier times to today. A useful example is the sketch of *Moses and the Miracle of the Waters*, which is related to one of eight paintings executed in the late 1660s for the church of the Hermandad de la Caridad in Seville. A study of this subject, mentioned in Murillo's inventory, may be identifiable with an oil sketch now in an English private collection (fig. 9; see Appendix 2, no. 1). In 1850, the work was in the collection of the Earl of Normanton and was exhibited at the

15. For a preliminary checklist of Murillo's oil sketches, see Appendix 2.

16. Murillo's inventory was published with annotations by Angulo (1966); his son's inventory, by Montoto (1945).

British Institution. Thirty-three years later, Curtis listed it as number 15 in his catalogue. One of the last references was made in 1907 by A. F. Calvert, who rightly called it "a very spirited sketch by Murillo for this picture of Moses striking the Rock . . . in the Hospital de la Caridad, Seville." The attribution of this splendid work is not difficult to accept. It has the verve and spontaneity of an original and a masterwork, and the small size and lack of finish help to indicate the purpose. There are also minor variations between sketch and finished picture that indicate how Murillo kept making adjustments on the composition right up to the final moment. Finally, there is evidence that sketches existed for at least four of the remaining seven pictures in this commission, or five of eight in all. Although no drawings have been related to the Caridad paintings, it may be assumed from other examples that they preceded the sketches.

The entire preparatory process can be demonstrated in the development of Murillo's last picture, the monumental *Mystic Marriage of Saint Catherine* (fig. 71). The first stage was the drawing already discussed (cat. 94), in which Murillo laid out the main lines of the composition. After further thought, and perhaps detailed studies that no longer survive, he made an oil sketch that considerably clarifies the drawing (fig. 10; see Appendix 2, no. 33). In the painting, which was partly executed by assistants, the sketch was closely followed, the only differences being the position of the arms of the angel at the far left and an adjustment in the scale of figures to architecture.

A second example may be seen in the development of the painting of *Saints Justa and Rufina* (fig. 59). A preparatory drawing in pen and ink with wash established the basic composition (cat.

33). In the succeeding oil sketch (fig. 11; see Appendix 2, no. 19), Murillo changed the poses by substituting the tower of the Giralda for the earthenware jars held by the saints in the first version. The picture follows the sketch, except for the addition of more jars in the lower right corner and the delineation of the landscape background.

A final illustration of the process can be mentioned, even at the risk of belaboring the point, only to show that the use of the oil sketch, if not invariable, was not uncommon either. One of Murillo's most unusual paintings was a *Caritas Romana* that was destroyed by fire in 1845, but whose appearance is preserved in an engraving of 1809.[17] Enriqueta Harris identified a preparatory drawing (cat. 70), which differs from the painting in the relation of the two figures. The drawing, as Harris showed, follows a composition of Rubens that was engraved by Panneels and van Caukerken. The painting, while it still conforms to Rubens's prototype, is different in one respect: the woman holds her clothing instead of her breast with her right hand. The change is already apparent, however, in the oil sketch (fig. 12; see Appendix 2, no. 17), where the stocks for the man's feet have also been added.

The oil sketch, then, had a part to play in Murillo's creative process. By identifying the genre and its purpose, we are better able to understand Murillo as an artist and, of course, to restore the ignored and misattributed sketches to his oeuvre. The sketches are important because they bridge the gap between preparatory drawings and finished paintings, thus situating the drawings on the frontier of artistic creation. They also indicate an unsuspected concern with settling the details of a composition before committing it to final form.

17. The engraving by Tomás López Enguídanos is reproduced in Harris 1964, pl. 42c.

Opposite:

Left: *Figure 10. Murillo,
Mystic Marriage of Saint Catherine.
Collection unknown.
Oil on canvas, 73.3 x 53.3 cm.*

Top right: *Figure 11. Murillo,
Saints Justa and Rufina.
Tokyo, National Museum of Western Art P-376.
Oil on canvas, 34 x 24 cm.*

Bottom right: *Figure 12. Murillo,
Caritas Romana.
Scarsdale, N.Y., collection of
J. O'Connor Lynch.
Oil on canvas, 31.1 x 40.6 cm.*

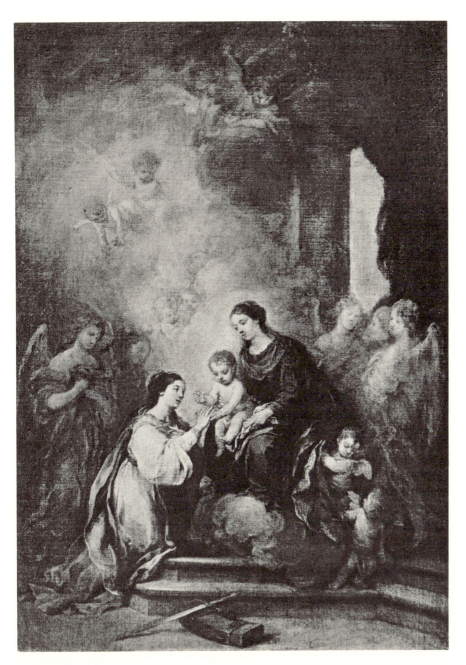

Murillo's virtuosity as a painter was hard-won, effortless though it may appear. Although he always sought to improve on details of his compositions, he may never have put brush to canvas without a complete idea of what the final result would look like.

This conception of Murillo's working procedure is important to the consideration of a special class of drawing: the finished red and black chalk study. In some cases, the drawings correspond almost entirely to a part or all of a painting, a fact that raises the question of whether they were done before or after the paintings. In his discussion of the Hamburg *Mystic Marriage of Saint Catherine* (cat. 14), Mayer advanced the idea that it may have belonged to a *liber veritatis*. Although there is no other indication that Murillo made records of his paintings, the evidence for this drawing as an autograph copy is strong. First of all is the presence of an exact date, written in the lower margin. Then there is the fact that the composition stops well short of the lower edge of the paper, an unusual occurrence that can be explained by the fact that the drawing ends amost exactly where the painting ends. Finally, the technique is extraordinarily finished, perhaps in imitation of the blended surface of the painting.

But this drawing is almost unique. Other chalk drawings of this type usually are focused only on a central part of the composition, a practice that follows Murillo's step-by-step procedure for preliminary designs. For example, the drawing of *Saint Francis of Paula* (cat. 30), a study for a painting (fig. 57), concentrates on the main actor and omits the crowd of putti in the sky. The group of figures in the background is done as a free sketch and thus conforms more closely to the notion of preparatory work. Two drawings in the same vein are the companion studies of *Young Saint John the Baptist with the Lamb* (cat. 25) and *Christ Child as the Good Shepherd* (cat. 26). Here the relationship between drawings and paintings (figs. 53 and 54) is very close because the composition calls for only a single figure. Nevertheless, Murillo has not attempted to define the landscape settings, reserving their elaboration and the consequent adjustment of scale for the oil sketches. Luckily, the oil sketch for *Christ Child as the Good Shepherd* survives (fig. 13; see Appendix 2, no. 6) to illustrate the final stage of preparation. When he worked on the picture, Murillo also modified the exaggerated facial expression.

After allowance has been made for drawings done for paintings that have been lost, the number of preparatory drawings in his oeuvre indicates that Murillo was more a functional than a recreational draftsman. For him, the drawing was as much a means to an end as an end in itself. This observation, coupled with the fact that Murillo often made more than one preliminary study for a painting, has important implications for understanding his art. Viewed without prejudice, Murillo's paintings are outstanding for their clarity and directness of expression (and, of course, for their predominantly religious character). His compositions are seldom complicated or crowded. Instead, he concentrated on a few figures and on revealing their emotions. The reason for this highly distilled art is explained by the spiritual aim of his works. In keeping with the development of religious art in the later seventeenth century, Murillo sought to minimize the distance between the mortal and the divine. His method of accomplishing the unification was to depict the divinities as human beings of exceptional physical attractiveness and spiritual warmth. In later years, these handsome, benevolent gods were placed in indeterminate settings of soft clouds and hazy light. The

Figure 13. Murillo,
Christ Child as the Good Shepherd.
London, Dulwich College Picture Gallery 272.
Oil on canvas, 44.5 x 31.5 cm.

effect of benign divinities in agreeable surroundings is inviting and intimate. Murillo's universe is uncomplicated by drama, heroics, pain, or suffering. The result is an art of deliberate superficiality. The emotions and effects have been simplified and presented without ambiguity so that they may be instantly perceived and understood. It would be pointless to plead for acceptance of this accomplishment in the forum of contemporary taste because it is so clearly at odds with our criteria for artistic greatness. But the accomplishment can be appreciated for what it was and for what was required to achieve it. At this point, the drawings become an important element for grasping the essentials of Murillo's art.

Throughout his artistic career, Murillo rationally explored ways to heighten the emotional impact of his art. This is the principal reason that he drew. Even when he was composing a scene with but one figure, he made repeated experiments with pose, setting, and expression. Furthermore, he constantly sought variety in his paintings. Long after the twentieth Virgin of the Immaculate Conception had been painted, he continued to invent new groupings and configurations of putti and new poses of the Virgin. By resisting set formulas, he posed a formidable challenge to his creative powers. Drawing was the means by which this challenge was met and it is to the drawings that we must look to understand the process by which he refined the special character of his art. This deliberate and thoughtful process explains why Murillo is not an ordinary devotional artist, whose limited talent ultimately leads to hollow religiosity. Right to the end of his life, he kept refreshing his inspiration with the aid of a careful preparatory process, the knowledge of which makes it possible to penetrate beneath the pleasing and artful surfaces of his canvases.

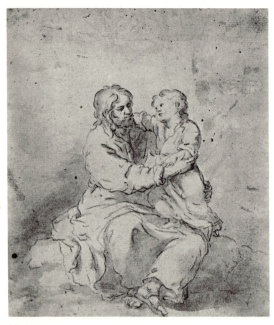

14

Copies, Imitations, Fakes, and Works by Followers

Around the small core of authentic drawings there spreads a vast number of spurious attributions, which is explainable by three factors: the lack of a critical study of Murillo's drawings, the popularity of his style among successive generations of Sevillian artists, and the demand for his works by eighteenth- and nineteenth-century collectors. These factors have made it possible for imitations, both well and ill intentioned, to invade Murillo's oeuvre. The number of wrongly attributed drawings is as legion as the hands that made them. At this point of study, it would be folly even to attempt to gather a corpus of all the drawings now and once attributed to Murillo, let alone to sort

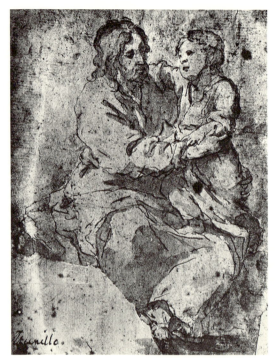

15

them out. For the present, it will have to suffice merely to establish general categories into which the drawings seem to fall.

First would be the copies, of which there are two types: copies of drawings and copies of paintings. Murillo's drawings became available, in one way or another, to lesser talents who used them as a means to absorb the master's style and improve their own skills as draftsmen. From this practice stem numerous sheets that faithfully copy known drawings by the master. The quality may vary from drawing to drawing, but it is never very great. To take an example that illustrates the range and degree of quality in the copies, there are two sheets after Murillo's *Saint Joseph and the Christ Child Seated* (cat. 36). Copy number one (fig. 14)

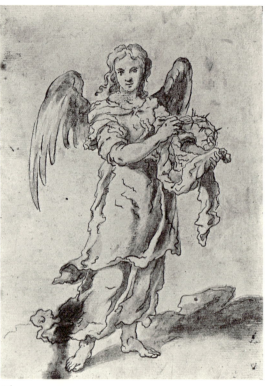

16

Figure 14. After Murillo,
Saint Joseph and the Christ Child.
Hamburg, Kunsthalle 38578.
Pen and brown ink with brown wash over black chalk, 229 x 199 mm.

Figure 15. After Murillo,
Saint Joseph and the Christ Child.
Collection unknown, formerly Gijón, Instituto Jovellanos.
Pen and brown ink with brown wash, 180 x 140 mm.

Figure 16. After Murillo,
Angel with Crown of Thorns.
Hamburg, Kunsthalle 38631. Pen and rose ink with rose-gray wash, 195 x 136 mm.

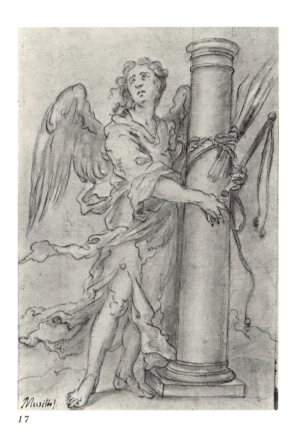

17

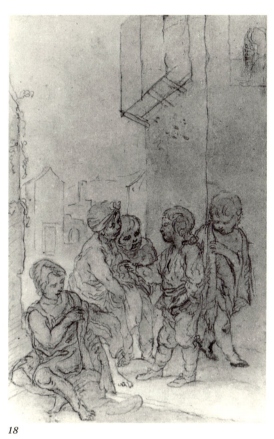

18

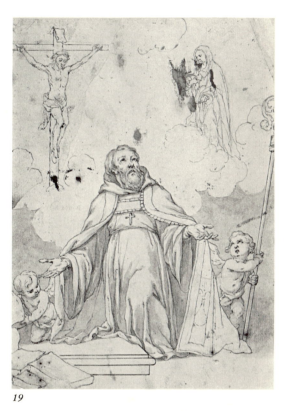

19

is clearly weak and bland; copy number two (fig. 15), if somewhat better, is still well distant from an authentic work. Copies were made by a single artist of some of the Angels with Instruments of the Passion (cat. 40-cat. 49), which further demonstrate a copyist's procedures and limitations in reproducing an original. In *Angel with Crown of Thorns* (fig. 16), jittery, often meaningless lines are used to imitate the splendid dynamism of the original (cat. 49), whereas *Angel with Column and Scourge* (fig. 17) comes much closer to duplicating Murillo's technique (cat. 41).

The copies after paintings are more deceptive because they may be mistaken for preparatory drawings if the style as well as the composition has been derived from Murillo. Once the painting that served as the model has been recognized, however, it becomes easy to detect the copy. *Young Saint Thomas of Villanueva Giving Away His Clothes* (fig. 18) is a weak and loosely drawn copy of a painting in Cincinnati. A copy of the Prado's *Saint Augustine's Vision of the Virgin and the Crucified Christ* (fig. 19), though somewhat stronger, is still far from being an original.

Figure 17. After Murillo, Angel with Column and Scourge. *London, private collection. Pen and brown ink with brown wash over red and black chalk, 195 x 135 mm.*

Figure 18. After Murillo, Young Saint Thomas of Villanueva Giving Away His Clothes. *Frankfurt, Staedelisches Kunstinstitut 13655. Pen and brown ink with brown wash over black chalk, 215 x 143 mm.*

Figure 19. After Murillo, Saint Augustine's Vision of the Virgin and the Crucified Christ. *Hamburg, Kunsthalle 38598. Pen and brown ink with brown and gray wash, 224 x 160 mm.*

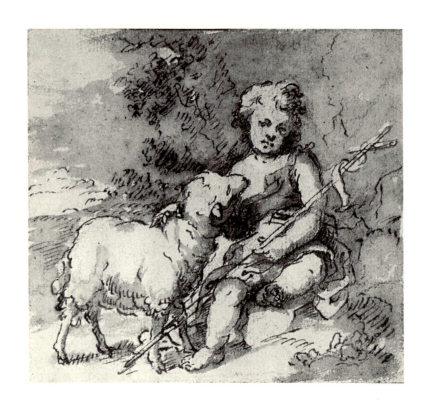

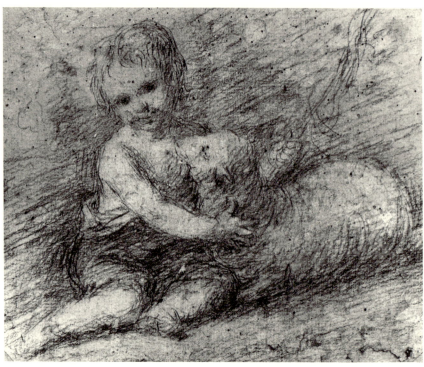

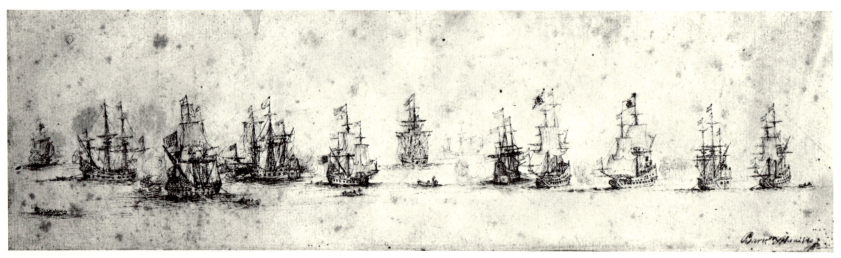

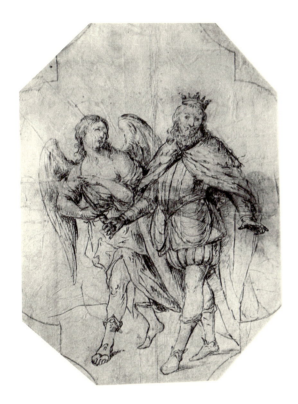

Figure 22. Imitator of Murillo,
Saint Ferdinand and an Angel.
Collection unknown. Pen and brown ink.

More deceptive still are the imitations, which can be defined as drawings that employ elements of Murillo's style to produce his characteristic themes, though without exactly copying a known original. This category can be illustrated by two drawings of *Young Saint John the Baptist with the Lamb*. The two sheets (figs. 20 and 21) are obviously dissimilar, but both clearly attempt to mimic Murillo's style and types. Another drawing, which represents *Saint Ferdinand and an Angel* (fig. 22), is the work of a capable follower, who has grasped the rudiments of Murillo's pen technique but employs it in far too studied a manner.

A third category can only be called fakes. This comprises drawings that have no apparent link to Murillo except a false signature. A classic example of the type is *Naval Battle between Dutch and Spanish Fleets* (fig. 23), a drawing that was in the collections of Ceán Bermúdez and Lefort. Except for the presence of Murillo's name, written by another hand, the drawing would probably be classified as Dutch, not as Spanish. Drawings of this sort are literally too many to count.

The fourth and last category poses the greatest problems because it consists of Murillo's followers, artists who followed the master's style without becoming submerged in it and who achieved standing and recognition as capable painters in their own right. The distinction of their work from Murillo and from each other is the most difficult task for connoisseurs of later seventeenth-century painting in Seville.[18] Although their names are known, their paintings are largely unrecognized, as are their drawings. An occasional name can be associated with an occasional drawing. Clearly, this is not the moment to solve these problems, which

Opposite:

Top left: *Figure 20. Imitator of Murillo,*
Young Saint John the Baptist with the Lamb.
London, private collection. Pen and brown ink with brown wash, 115 x 127 mm.

Top right: *Figure 21. Imitator of Murillo,*
Young Saint John the Baptist with the Lamb.
*Madrid, Museo del Prado F.A. 87.
Black chalk, 179 x 209 mm.*

Bottom: *Figure 23. Anonymous Dutch artist,*
Naval Battle between Dutch and Spanish Fleets.
*London, private collection.
Pen and brown ink, 122 x 422 mm.*

18. The study of Murillo's assistants and followers is still in a primitive state. The best introduction to the artists is Angulo 1975.

must await the time when careful monographic studies of these artists have been made. In their absence, we can only advance provisional attributions, more in the spirit of identifying the problems than in solving them.

Pedro Nuñez de Villavicencio (1640-1700), a close friend of Murillo and an executor of his will, is known primarily for an interesting signed genre painting in the Prado, to which a drawing (fig. 24) is related. In a more Murillesque vein is a sheet with *Saints Sebastian and Roch* (fig. 25), which has been given traditionally to Villavicencio and may be attributed to him on a tentative basis.

A close contemporary of Villavicencio is Matías Arteaga y Alfaro (d. 1704), who belonged to the Seville drawing academy, soon to be discussed, of which Murillo was the first co-president. Arteaga was both a painter and an engraver. Angulo has attributed a few drawings to him, to which two more sheets can be added. One is *Portrait of a Dominican* (fig. 26), which is inscribed with his name by the same hand that is found on an architectural study in the Metropolitan Museum of Art (64.182.4). Its style is close to the *Marriage of the Virgin* in Hamburg (38574), given to Arteaga by Angulo. Still another work in this style is a *Portrait of an Ecclesiastic*, also in Hamburg (fig. 27).

The succeeding generation of followers, who lived on into the middle of the eighteenth century, includes Alonso Miguel de Tobar (1678-1758), a facile copyist of Murillo. A drawing of *Young Saint John the Baptist* (fig. 28) has traditionally been given to him, though without specific reasons. Related to it is a sheet showing the *Infant Christ in Glory* (fig. 29). Though they obviously follow Murillo's style, these two drawings are difficult to attribute with certainty.

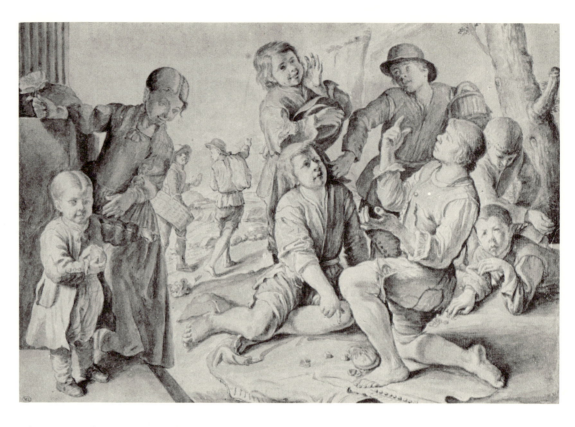

Figure 24. Pedro Nuñez de Villavicencio, Genre Scene.
Paris, Musée du Louvre 18492.
Pen and brown ink with gray wash, 227 x 331 mm.

Opposite:

Left: *Figure 25. Pedro Nuñez de Villavicencio,* Saints Sebastian and Roch.
Hamburg, Kunsthalle 38637.
Pen and brown ink with brown wash, 292 x 207 mm.

Top center: *Figure 26. Matías Arteaga y Alfaro,* Portrait of a Dominican.
Pittsburgh, Pa., private collection.
Pen and brown ink with brown wash.

Top right: *Figure 27. Matías Arteaga y Alfaro,* Portrait of an Ecclesiastic.
Hamburg, Kunsthalle 38608. Pen and brown ink with brown wash, 200 x 142 mm.

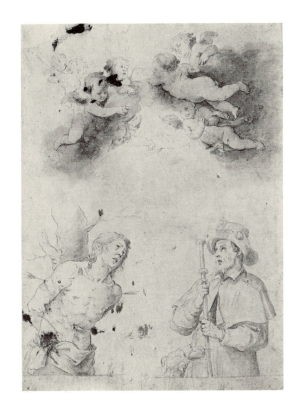

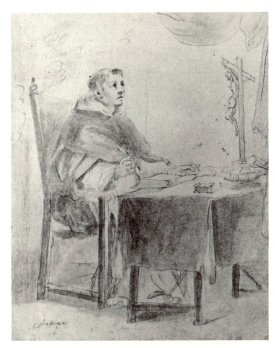

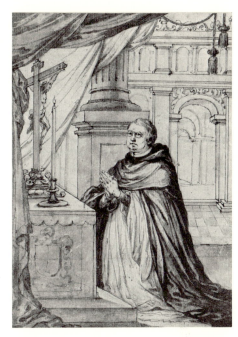

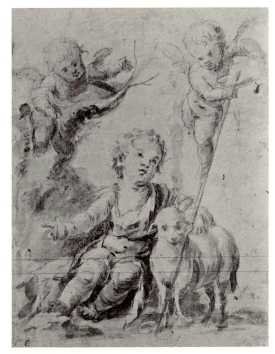

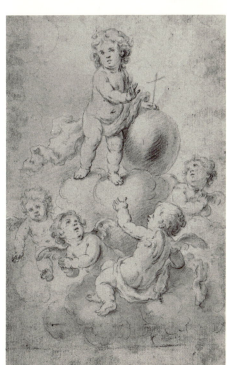

Bottom center: *Figure 28. Attributed to*
Alonso Miguel de Tobar,
Young Saint John the Baptist.
Hamburg, Kunsthalle 38611.
Black chalk with brown wash, 240 x 185 mm.

Bottom right: *Figure 29. Attributed to*
Alonso Miguel de Tobar,
Infant Christ in Glory.
Hamburg, Kunsthalle 38589.
Pen and brown ink with brown wash over red
and black chalk, 192 x 123 mm.

The Drawing Academy of 1660

The diffusion of Murillo's style thus proceeded in ways known from the examples of other influential draftsmen. Some of his imitators learned their craft while working as assistants in the master's studio, while others must have copied drawings that had passed into wider circulation. In addition to these routes of transmission, there was another and noteworthy means of communication—a drawing academy founded in Seville in 1660 under the leadership of Murillo and Francisco de Herrera the Younger. Drawing academies must have existed elsewhere in Spain during the seventeenth century, but so far only the records of the Seville academy have come to light.[19] Thus, it is important not only because of Murillo's involvement, but also because it gives us a glimpse of how the art of drawing was taught in seventeenth-century Spain.

On January 11, 1660, a group of prominent Sevillian painters signed a constitution that created the first drawing academy in Seville. The bylaws that they agreed to uphold and the minutes of subsequent meetings permit us to reconstruct its goals and practices in some detail.[20] The first by-law established nightly meetings to be held in the Casa de la Lonja, the mercantile exchange, for purposes of the *"excercicio del dibujo,"* in accordance with an informal practice that had been in effect since January 1. There were to be two co-presidents, who would act as chief critics and instructors. They performed this function on alternate weeks and served as "judges in the questions and doubts that may arise about the precepts and practice of our art." Finally, they were empowered to promote students to the rank of academician when their work had achieved the requisite degree of competence. The main administrative duty consisted in fining violators of the academy's code of behavior. As its first two presidents, the painters selected Bartolomé Murillo and Francisco de Herrera the Younger, a choice that accurately reflected their preeminent positions in Seville's artistic community. Other offices created by the constitution were two consuls, who were essentially administrative assistants or vice-presidents (Sebastián de Llanos y Valdés and Pedro Onorio de Palencia); a sergeant-at-arms (Cornelius Schut II); a secretary (Ignacio de Iriarte); and a treasurer (Juan de Valdés Leal).

The regulations for the conduct of the academy do not reveal much of its main purpose, but rather are concerned with rules of order. One regulation stated that, upon entering the academy precincts, every member had to say these words: "Praised be the Holy Sacrament and the Immaculate Conception of Our Lady." Once inside, all conversation irrelevant to drawing was forbidden and violators were subject to fines according to the severity of the offense. If the disturbance continued even after the president had twice rung a warning bell, the guilty parties were to suffer an additional penalty. Another rule prohibited swearing or uttering oaths, both of which were punishable by a fine. With an amusing touch of practicality, a cash box was provided, where violators would deposit their fines. Finally, financial support for the academy's program was arranged through a plan whereby each academician paid a fee of six *reales* a month

19. Around 1606, Vincencio Carducho and other Madrid painters attempted to form an academy, apparently without success. See Volk 1973 for the interesting documentation.

20. The constitution and minutes are preserved in the Real Academia de Bellas Artes de Santa Isabel de Hungría, Seville. They were discovered and partially published by Ceán Bermúdez (1806, pp. 137-65). A more complete transcription was made by Gestoso y Pérez (1916, pp. 66-76). The last two years of the history are reconstructed by Banda y Vargas (1961).

to cover the anticipated expenditures for oil, coal, and a model. All others who wished to use the academy's facilities on an occasional basis were charged a fee of sixteen *maravedis* per session.

A document of February 30, 1660, describes the plans for remodeling the academy's section of the Lonja, which was done simply by constructing partition walls. Each academician was asked to contribute bricks or mortar for the building. Murillo, whose name heads the list, offered two hundred bricks, while Herrera the Younger, who may have been the victim of a scribe's error, brought only four. Juan de Valdés Leal contributed a bag of lime for the mortar. Clearly, the artists were hopeful that their academy would become a fixture in Seville's artistic life. Their hopes were disappointed, however, for the academy endured only until 1674, when persistent financial problems finally forced it to close. Murillo was president for one year, until 1661, when Sebastián de Llanos y Valdés was elected to a two-year term. The other president, Herrera the Younger, left soon after the academy's foundation to pursue a career at the court. His name is missing from the list of participants in the meeting of November 1 and does not appear again. Valdés Leal became the third president in 1663, when he was elected to a four-year term. But he served for only three years, resigning in 1666 for unknown reasons. From that point forward, the academy's registers are filled mainly with names of secondary artists.

The impetus for the foundation of the academy cannot be identified in the documents, but it would be logical to suppose that the two co-presidents played an important part. Murillo, as we have seen, was a dedicated draftsman. Herrera the Younger was the son of an influential draftsman and had, moreover, apparently spent time in Italy.

His Italian experience, if it did indeed occur, might have been responsible for the superficial resemblance of the Seville academy to the Accademia di San Luca in Rome. First, the administrative structures of the two academies were alike in some respects.[21] The *presidente* of Seville corresponded to the Roman *principe*; both had lieutenant officers called counsels (*consigliero* and *consul*) whose positions were administrative, as well as a secretary and treasurer (although the last two would be found in almost any organization). Second, there was a moderate religious influence in both. The Roman academy's revised constitution of 1627 bound itself to follow all the reforms and dogma promulgated by the Council of Trent, while the Spaniards had to utter the praise of the Holy Sacrament and the Immaculate Conception before entering their meetings. Each academy had punitive measures for members who disrupted meetings or broke the rules. Federico Zuccaro, the Accademia's first *principe*, wrote an article into the constitution calling for the expulsion of any troublemaker from a session in progress. Furthermore, the penalty for taking the name of the Lord in vain was permanent dismissal. In the constitutional revision of 1621, however, the punishments were modified to a twenty-five-*scudi* fine, which is paralleled by the Sevillian practice of monetary penalties.

On balance, however, the structural similarities between the two academies are outweighed by the differences of substance. A comparison of their educational aims and programs shows this very clearly. From its beginning, a major concern of the

21. For the Accademia di San Luca, see Missirini 1823; and Pevsner 1940, pp. 55-66. Zuccaro's program is analyzed by Mahon 1947, pp. 153-91.

Accademia di San Luca was the education of young artists. To this end, regularly scheduled classes were held under the tutelage of twelve specially appointed academicians, each of whom instructed for a month. In addition to life drawing, casts of antique sculpture and the works of major artists of the past were analyzed in an effort to extract the enduring principles of great art. During Zuccaro's tenure, a certain amount of time was allotted to art theory, although it never became as important as he would have liked. In contrast, the educational program in Seville was always vague and, after Murillo and Herrera resigned their joint presidency in 1661, was directed by a single person. The foundation document does not insist on education as one of its principal goals and mentions it only when defining the role of the president, who was to "assist and award the title of academician to those who have completed the course and who are found capable." What the course might have been was never specified, which leads us to assume that regular attendance coupled with steady improvement fulfilled the requirements. This aimless, pragmatic approach to artistic education is strikingly different from the thoughtful program of the Accademia di San Luca and shows that Seville had borrowed only the organizational procedures from the Accademia. For its educational program it turned to another Italian artistic tradition, the life-drawing academies that became popular in the seventeenth century.

Like its Italian forerunners, the major activity of the Seville academy was life drawing, as indicated by the fact that most expenditures were made to hire models. The acceptance of casual sketchers who could, for the payment of a set fee, attend the sessions underlines this aspect of the academy's character. A normal sketching meeting of

the academy lasted about two hours in the evening and consisted of drawing a nude male figure as he held varying poses. A clearer idea of the procedure is gained from the record of payment made to a model called Pedro, who posed for the eight nights from February 16 to February 23 of an unspecified year, probably between 1660 and 1663, because the payment was made by Juan de Valdés Leal, the treasurer during those years. The note goes on to say that the model alternated four basic poses during the first few days, and then switched to a different pose, which he maintained for three more sessions. Another record of payment to a model designated as *"Juan de nación francés"* furnishes the additional information that the modeling fee for the nightly sessions was two *reales*, payable in monthly installments.

Thus the Seville academy was fundamentally a life-drawing academy whose members were aspiring or practicing painters who wished to improve their skills through the time-honored medium of life drawing. The restriction of its activities to drawing was probably deliberate in order to avoid conflict with the traditional master-apprentice method of artistic instruction or with the complicated guild rules that governed the practice of painting.

The reconstruction of the academy's precedents and procedures needs to be supplemented by the answer to one more question: what manner of drawing did the professors teach to the students? Perhaps the answer may be found in a large group of drawings that, until recently, was bound together in an album. Before the album was dismantled, it consisted of approximately 315 sheets.[22] The drawings are by no means homogeneous in style, date, and level of competence.

But the majority, about eighty percent, share certain characteristics. First is the medium, which is predominantly pen and brown ink or pen and brown ink with brown wash. Second is the technique, which is based on vigorous hatching and cross-hatching. Last is the frequent appearance of what might be called exercise drawings, either copies after master drawings and paintings or life studies. All of these qualities would fit the hypothesis that the album is partially a collection of drawings from an academy.

There are further indications to suggest that this academy was identical to the Seville drawing academy. For instance, one of the drawings is an *Infant Christ and Saint John* signed by Cornelius Schut, the first sergeant-at-arms of the academy. In addition, several drawings are copies after works by artists who lived at one time in Seville, including Murillo, Cano, Valdés Leal, and Antonio del Castillo. Finally, certain typically Sevillian subjects frequently appear, such as the Virgin of the Immaculate Conception and the Young Saint John the Baptist with the Lamb.

The student drawings are naturally maladroit, but some of them need to be discussed to illustrate the methods and techniques of instruction. The album contains about a dozen drawings of the Virgin of the Immaculate Conception. The subject was, of course, popular in Seville in the second half of the seventeenth century, especially in the work of Murillo. Two drawings (figs. 30 and 31) show that both the technique and the theme derive from Sevillian tastes. The basic technique followed by the student draftsman involves strong hatching and cross-hatching in pen and brown ink. Both the medium and the way it is handled correspond to the manner of drawing employed by artists in Seville throughout the seventeenth

Figure 30. Anonymous student of the Seville drawing academy, Virgin of the Immaculate Conception. *Hanover, N.H., Dartmouth College Museum, gift of William B. Jaffé. Pen and brown ink.*

Figure 31. Anonymous student of the Seville drawing academy, Virgin of the Immaculate Conception. *Hanover, N.H., Dartmouth College Museum, gift of William B. Jaffé. Pen and brown ink.*

22. The so-called Jaffé album is briefly described by Brown (1973).

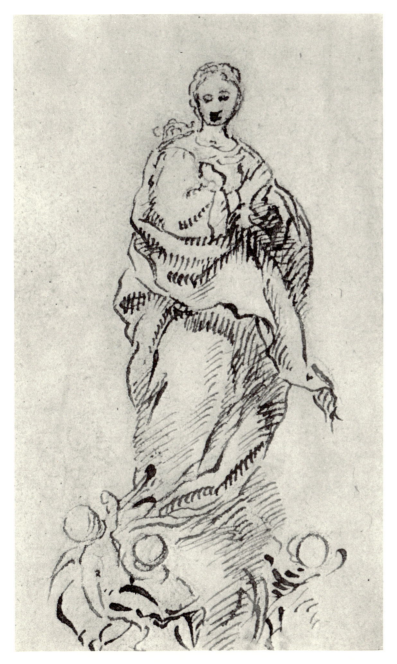 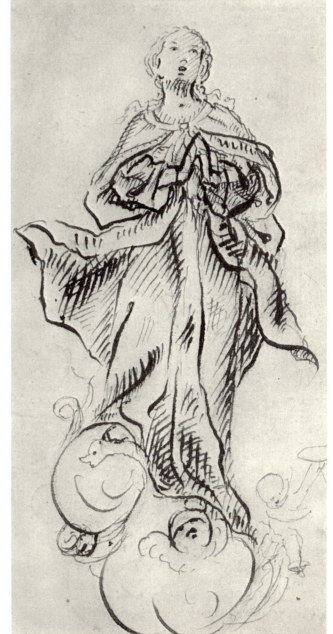

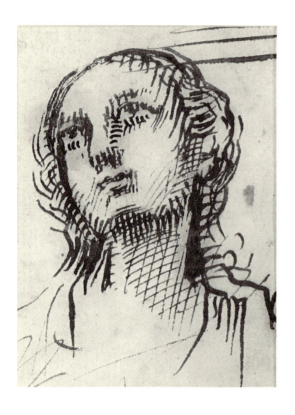

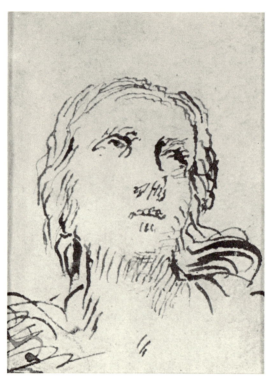

century, as discussed above. A further indication of the academic origin of the album is found in two detailed studies of the Virgin's head that are derived from the theme of the *Inmaculada* (figs. 32 and 33). The practice of dividing a motif into its component parts is also a typical instructional device. Neither of these unpromising draftsmen is able to produce inspiring results, but the very lack of skill lays bare the method and style they are being taught.

It would be wearying to study further examples of the student work contained in the album. These few drawings are typical enough to make an important point: that the academy of 1660 intended to perpetuate a singular manner of pen drawing. This approach to the medium seems to have been established by the early seventeenth century and to have remained remarkably resistant to fundamental change right to the end of the 1600s. The elements of the manner are few and uncomplicated; indeed, a more straightforward graphic technique is hard to imagine. It is this style that imparts the characteristic virile and energetic quality to Sevillian drawings.

The academy of 1660 thus institutionalized and regularized a common language of drawing. It also gave Murillo, as the leading draftsman of his day, the opportunity to influence the generation of artists who lived to the end of the century. The combination of the academy and other means of diffusion made Murillo's drawing style virtually irresistible in Seville.

The academy also reminds us how many important draftsmen worked in the tradition of the Seville pen style. The two Herreras, Cano, Antonio del Castillo, and Valdés Leal, as well as Murillo, were not surpassed in the quality and quantity of their work by artists working in other parts of Spain. In a historical sense, Murillo holds a central place among his fellow draftsmen, for he was mainly responsible for sustaining the style that he had inherited, through both the example of his teaching and his own splendid creations as a draftsman.

Signatures and Inscriptions

Almost two thirds of the known drawings by Murillo have some form of his name or initials written on them. A majority of the inscriptions fall into two groups, one with seventeen sheets in the same handwriting, the second with about a dozen sheets in another hand. Can either of these scripts be taken as an authentic signature?

The more distinctive handwriting occurs in the larger group of drawings, on sheets from every period of the artist's career (fig. 34). [23] In all but two instances, the form *Bartolome Murillo*, followed by the abbreviation $fa^t.$, is used. (In the two exceptions, the abbreviation is omitted.) The inscription is always placed in the center of the lower margin of the paper and is always written in ink. The handwriting is cursive and is characterized by several idiosyncrasies. The capital letter *B* is made with a downward right-to-left stroke, terminating in a flourished serif. Then a single double-looped line, bulging at the bottom, completes the letter. It is not joined to the succeeding letter. The capital *M* invariably has a pronounced flourished serif at the top. Another characteristic letter is *l*, which is slanted to the right and made with flourished serifs at the top and bottom. It, too, is not joined to the preceding or succeeding letters.

This distinctive handwriting has been found so far only on drawings that can surely be attributed to Murillo. Hence the initial supposition is that it was written by the artist himself. [24] However, comparison with Murillo's authentic signatures on documents leaves no doubt that his name as it

Figure 34a. Detail of inscription, cat. 11 (verso).

Figure 34b. Detail of inscription, cat. 91.

23. The complete list of drawings with this handwriting is as follows: cat. 9-cat. 11, cat. 34, cat. 50, cat. 60, cat. 63, cat. 69-cat. 71, cat. 84, cat. 87, cat. 88, cat. 90, cat. 92, cat. 93, and cat. 95.
24. Angulo (1961, pp. 15-16) accepts the inscriptions as signatures.

Figure 35. Autograph letter of Murillo, June 14, 1665.

appears on these drawings was written by another hand. A letter requesting admission to the Hermandad de la Caridad, received with approval by the governing board on June 14, 1665, is entirely in Murillo's hand (fig. 35).[25] Although the formal purpose of the document would have led the artist to write somewhat more carefully and elaborately than usual, it still provides a useful point of comparison because of the length. The capital *B* is made with a single stroke and begins with a florid, curving stroke that is present in other signatures as well (fig. 36; dated June 23, 1678). It slants strongly to the right. The capital *M*, as it appears in the body of the letter as well as in the signature, is marked by the nearly equal length of all the lines and the narrow angle formed in the middle of the letter. The *r* is cramped and looks like an *x*. Finally, the double *ll* of the last name is made with a single connected stroke that joins the last letter. From these observations, it is clear that the inscription on the seventeen drawings was not written by Murillo.

The author of this inscription is a matter for speculation. Two possibilities suggest themselves at once. First, the name could have been written on the drawings found in Murillo's atelier after his death, either by an executor of the will or an estate evaluator. Second, it could have been written by a contemporary collector who acquired the drawings from Murillo or his estate. The latter hypothesis may be closer to the truth, because of the apparently perfect accuracy of the writer, who put the artist's name only on authentic drawings. Also, the use of the artist's full name with the abbreviation fa^t. would be more appropriate to a collector than to an evaluator who, if he followed

25. The document is preserved in the Archivo Municipal, Seville, among the papers of the Conde del Aguila.

Figure 36. Autograph signature of Murillo, June 23, 1678.

the normal pattern, would have used only the artist's last name and then given his estimate of the drawing's value in *reales* (i.e., 20rs, 30rs, etc.).

It would be interesting to be able to identify this collector, if such the writer was, but only the most circumstantial evidence exists for this purpose. Given the lack of any firm basis for proposing a name, it may seem unwarranted to bring forward a candidate. But on the grounds that the argument will contain some useful information about early collectors of Murillo's drawings, I will advance the name of Nicholas Omazur as the author of the inscriptions.

Omazur was a Flemish silk merchant born in Antwerp in either 1603 or 1609.[26] At a date yet to be determined, but probably after 1663, he moved to Seville, where he befriended Murillo. Their association is confirmed by works of art, one a portrait of Omazur painted by Murillo in 1672, now in the Prado. Then, published in Antwerp in 1682 was a portrait engraving of Murillo by Richard Collin, commissioned by Omazur, according to the inscription, as a "token of friendship."

Evidence of friendship is not, of course, proof that Omazur collected Murillo's drawings. But it can be shown that the Flemish merchant was a collector of drawings and that his collection included works by Murillo. In 1809, the famous collection of art and books owned by the Conde del Aguila, and his personal papers, were dispersed following his death in the preceding year (for the Conde del Aguila, see cat. 7). Most of his books and manuscripts were acquired by the chapter of the Seville Cathedral for the Biblioteca Colombina and many of his personal papers ultimately came to the Archivo Municipal in Seville. Among his papers is a group that was donated to the archive

by a certain Antonio Fernando García. This bound volume contains the Conde's notes on artists and monuments of Seville, including the drafts of his correspondence with Antonio Ponz, who relied heavily on Aguila when compiling the section on Seville for his *Viaje de Espana*.[27] Folio twenty-nine is the transcription of a title page from an album of drawings that reads as follows:

Título del libro de dibujos originales que fué de los Laurenni, y oy tiene D. Francisco de Bruna.

De tres ingenios mui ilustres en el arte de la pintura. Varias ideas y dibujos divididos en tres partes siendo la primera a la mano y invencion de Cornelio Schut, natural de Amberes, qe murió en Seva. año 1684. Y la segunda parte de Juan de Valdés de dha Ciudad de Sevilla que murió año 1681. La tercera parte del insigne dn. Bartme Morillo, que murió en Agto año 1682. Recopilado por N. Omazur, Antuerpeinse. A° MDCLXXXI.[28]

In other words, an album with drawings by Cornelius Schut II, Juan de Valdés Leal, and Murillo was made by Nicholas Omazur, and subsequently owned by persons called Laurenni. During the Conde del Aguila's lifetime it was owned by a friend, Francisco de Bruna, a government official and an amateur scholar of art history. The later history of the album is unknown and there is no solid reason to connect the drawings bearing the inscription *Bartolome Murillo fa*t. with this collection.[29] But the hypothesis would account for the reliability of the attributions and the uniformity of the hand. For the moment, it is safer to

26. For Omazur and his relationship with Murillo, see Angulo 1964, pp. 269-78.

27. The correspondence between Ponz and the Conde del Aguila is published and discussed by Carriazo (1929).

28. Archivo Municipal, Seville, papers of the Conde del Aguila.

29. Given the Conde del Aguila's reputation as a collector, there is the possibility that he himself came to own the album. According to Richard Ford (see cat. 56), his collection of drawings was acquired after his death by Julian B. Williams, British vice-consul in Seville. Williams was both a collector and a dealer and apparently sold some, if not all, of the Aguila drawings to Frank Hall Standish (see cat. 7). The Standish collection, ultimately bequeathed to King Louis Philippe in 1841 and sold by him at auction in 1852, contained over twenty drawings attributed to Murillo, fifteen to Valdés Leal, and none to Schut. However, most of the Murillo drawings are now known and do not have the characteristic inscription on them. If Standish did not acquire the album, then perhaps

Figure 37a. Detail of signature, cat. 15.

Figure 37b. Detail of signature, cat. 54.

Figure 37c. Detail of signature, cat. 12.

Figure 37d. Detail of signature, cat. 52.

designate this characteristic hand as the "inscription of the Contemporary Collector." And until a sheet that is not by Murillo is found with this handwriting, it may be taken as an initial indication of authenticity.

There remains the second group of drawings to be discussed. As a group, it is considerably less consistent than the first one because Murillo's name appears in several forms—full name, last name only, first initial of last name, first and last name abbreviated—and in both cursive and printed script, although the latter predominates.[30] In

many cases, the abbreviation *f*ᵉ. is appended. A key signature is found on the *Studies of Putti* (see fig. 37a). Several points argue in favor of its authenticity. First, the ink is the same as that used in the drawing. Second, the thickness of the script is the same as the lines of the sketch. Finally, the letter *M* is close to the shape found in the autograph letter, except that the first stroke is detached from the letter. The single initial is followed by *f*ᵉ, the *f* written without the upper loop.

Williams never owned it and therefore neither did the Conde del Aguila. Williams, however, might have sold the album separately and perhaps it still exists somewhere intact. Alternatively, it could have been broken up by a person unknown and sold as individual sheets. This would account for the distribution of the inscribed sheets in several collections and for the fact that none remains in Spain.

30. The first name is almost always spelled as "Bartolome." However, in one apparently authentic signature (cat. 58), it is written as "Bartholome."

Figure 37e. Detail of signature, cat. 29.

Figure 38a. Detail of signature, cat. 51.

Figure 38b. Detail of signature, cat. 56.

Figure 38c. Detail of signature, cat. 84.

In later drawings, the abbreviation evolves into a curious form: the *e* is written without a loop, making it appear as an *i*. A period to indicate the abbreviation is placed immediately below it. The signature always appears in brown ink at the lower left side of the sheet and most often in the extreme left corner.

Four of the drawings are signed with the last name only, followed by the distinctive abbreviation of *fecit* (fig. 37b-e). One drawing has the full name with the abbreviation after it (fig. 38a), while a second abbreviates both names, followed again by the *f^e*. (fig. 38b). Another drawing contains only the last name and the abbreviation, written entirely in minuscule script (fig. 38c). Finally, there are two more drawings that seem to be inscribed in Murillo's hand. The first has only the last name without the abbreviated form of *fecit* (fig. 38d), and the second has a shortened form of both the first and last names (fig. 38e).

Figure 38d. Detail of signature, cat. 30.

Figure 38e. Detail of signature, cat. 25.

Figure 39a. Detail of signature, cat. 1.

Figure 39b. Detail of signature, cat. 2.

There is one more variation of the signature to be discussed. It is found on two of the earliest known drawings (fig. 39a-b) and consists of the complete name, followed by *f*, all in printed minuscule. Here again, the color and consistency of the ink, and also the width of the stroke, are entirely uniform with the lines of the composition. No majuscules are used, but the form and space of the letters are still close to the later style of handwriting. The most telling point of comparison is the formation of the letters *llo,* which are joined by a single stroke, beginning with a tick serif on the initial *l.* The configuration of *tolo* of *Bartolome* is also very close to the shape of the letters in the 1665 document. It should also be remembered that these drawings were probably made to show to the patron, thus supplying a logical reason for the artist to have written his name on them.

Taken as a group, the signatures appear to be considerably more heterogeneous than the signature of the so-called Contemporary Collector. It might be argued, however, that the difference in consistency is simply a symptom of the different mentalities of a collector and an artist. Handwriting, in any case, is a notoriously inconsistent thing, being subject to the ebb and flow of events and emotions. Age and the state of mind and body are only the most obvious factors that influence it. This being so, I have refrained from basing arguments of the authenticity of drawings on the presence of what I believe to be signatures. Until more information on the subject comes to light, the signature of the artist can be used only as secondary evidence for attribution.

Catalogue Raisonné of Drawings by Murillo

The catalogue of drawings is arranged in the groups established in the introductory section of this volume. The support is white or off-white paper, unless otherwise noted. Measurements, taken along the left and bottom margins, are given in millimeters, height preceding width. Inscriptions and signatures are discussed in detail on pages 49-54.

The following drawings in the catalogue are not included in the Princeton exhibition: 16, 18, 20, 24, 31, 33, 39, 43-49, 51, 53, 57, 59, 65, 72-74, 78, 80, 89, and 95.

1 *Brother Juniper and the Beggar* (recto) and *Saint Salvador of Horta and the Inquisitor of Aragon* (verso)

Paris, Ecole Nationale Supérieure des Beaux-Arts 1679.

213 x 228 mm. Recto: pen and brown ink with some red chalk and illegible traces of black chalk in left margin; signed in brown ink at upper left: *bartolome murillo f*; small number three (written as iii) in upper right corner. Verso: black chalk.

Provenance: J. Boilly (Paris, March 19-20, 1869, lot 60) to A. Valton (donor to Museum, 1908).

References: Delacre and Lavallée 1927, p. 24, no. 12, pl. 12; Angulo 1961, pp. 3-4, pl. 3, fig. 4; Baticle 1964, fig. 2; Angulo 1970, pl. 1; Brown 1973, p. 30, fig. 3; Angulo 1974, pp. 97-98.

The attribution of this drawing and its relationship to a painting now in the Louvre (fig. 40) are first mentioned in the Boilly sale catalogue. In 1970, Angulo published the verso and noted the connection to the figure of the Inquisitor in a painting now in a private collection, Paris (fig. 41).

Both of these paintings, which illustrate episodes in the lives of Franciscan friars, were part of the series executed in 1645 and 1646 for the *claustro chico* of San Francisco el Grande in Seville (see Angulo 1961, pp. 1-6, for the reconstruction of this important work; and Kubler 1970, pp. 11-31, for its iconography). Hence the drawings are securely dated to the early period of Murillo's career and serve as focal points for defining his style in pen and chalk at that moment (see introductory section, pp. 21-22, for a description of the stylistic traits of this period).

The recto is a typical preliminary sketch. The artist has concentrated on the figure group and made only summary indications of the background. Before he executed the painting, Murillo

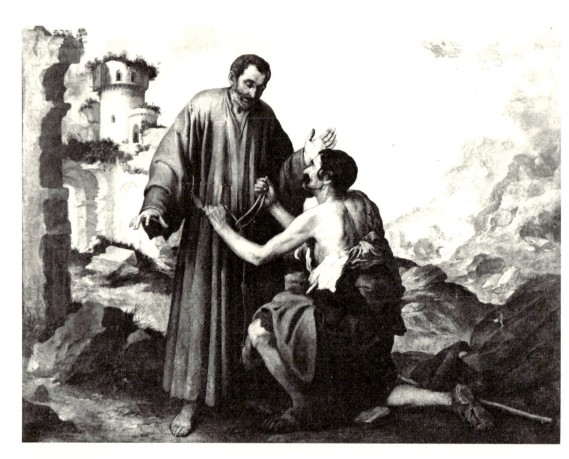

Figure 40. Murillo,
Brother Juniper and the Beggar.
Paris, Musée du Louvre 1964.1.
Oil on canvas, 176 x 221.5 cm.

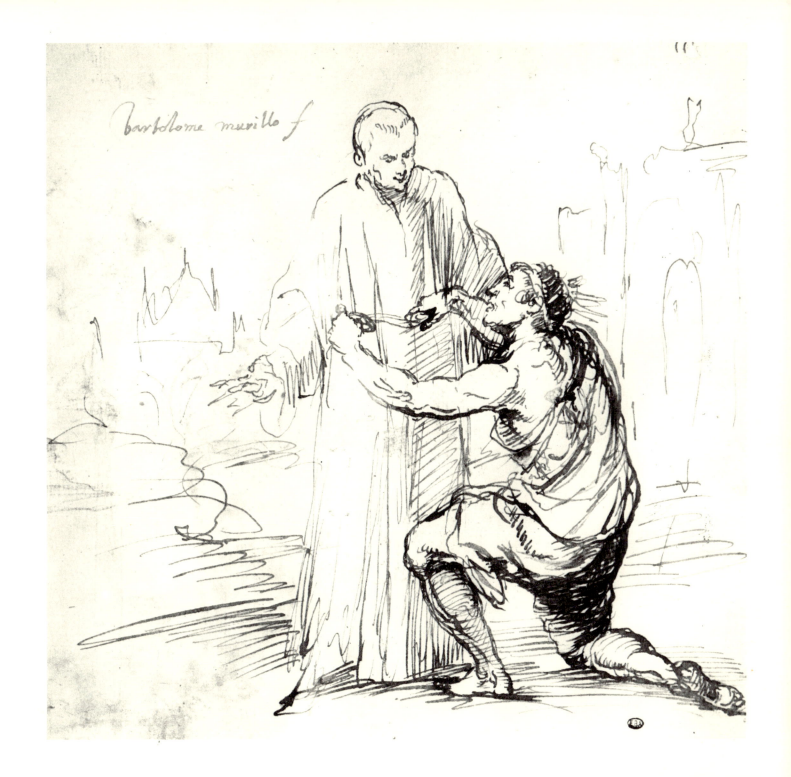

bartolome murillo f

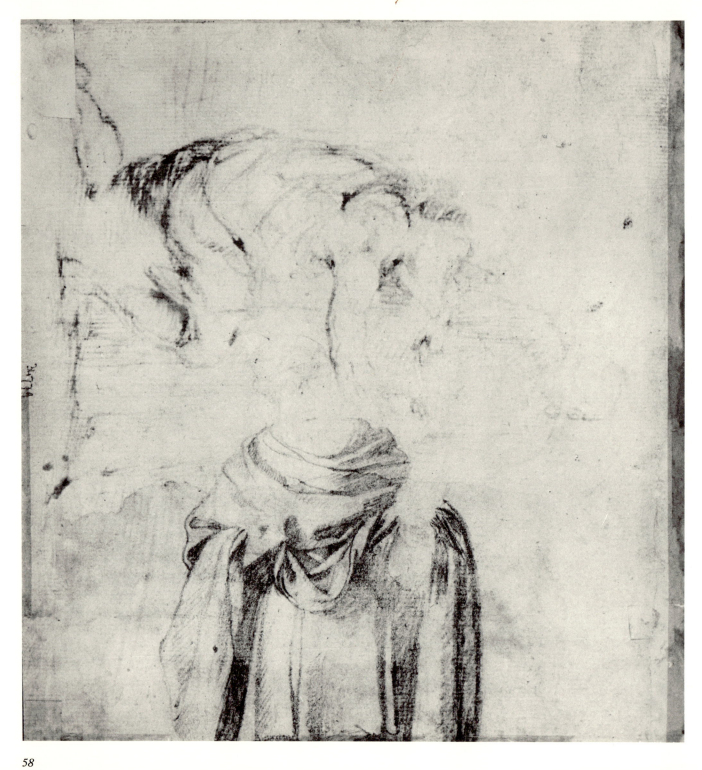

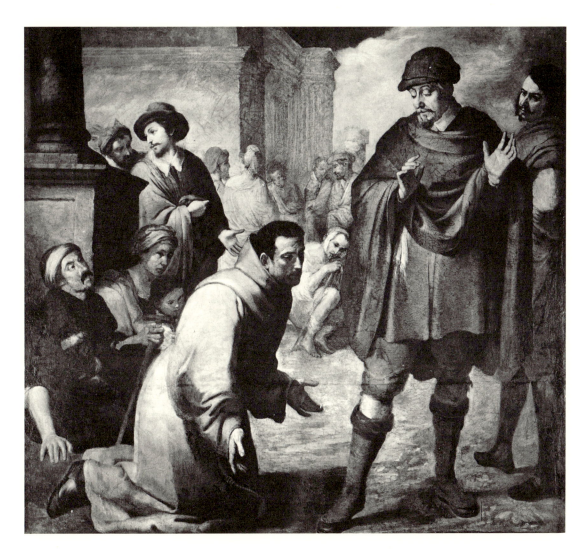

Figure 41. Murillo,
Saint Salvador of Horta and the Inquisitor of Aragon.
Paris, private collection.
Oil on canvas, 178 x 190 cm.

made several important compositional changes. First, he stabilized the figure group by inclining the saint's head to the right and placing the beggar's head in an upright position. He also made both figures appear as older men. Finally, he placed a mountainous landscape at the right, forming a contrast to the architecture at the left.

As Angulo (1970) pointed out, the sketch on the verso has been partly trimmed below, indicating that it was drawn before the recto, which is whole. Hence, it may be supposed that the conception of *Saint Salvador of Horta* preceded *Brother Juniper*.

In addition to the signature, the recto also bears the small number three (written as iii) in the upper right corner. The presence of the designation for four (written as iiii) in the same place on another sheet related to the series (cat. 2) suggests that Murillo executed a complete set of preparatory drawings that were ordered in a certain sequence, probably for the client's approval.

The subject on the recto was identified by Angulo (1961) with the following passage from the *Little Flowers of Saint Francis.*

Juniper [an early Franciscan friar] so often gave his tunic away that he was commanded to do so no more. Soon he encountered a poor man asking alms. "Naught have I save my tunic to give thee, and this my superior hath laid on me, by obedience, to give to no one. . . . But if thou wilt take it off my back, I will not gainsay thee." He spake not to deaf ears, for straightaway this poor man stripped him of his tunic and went his way with it (Everyman's Library, New York, 1910, p. 140).

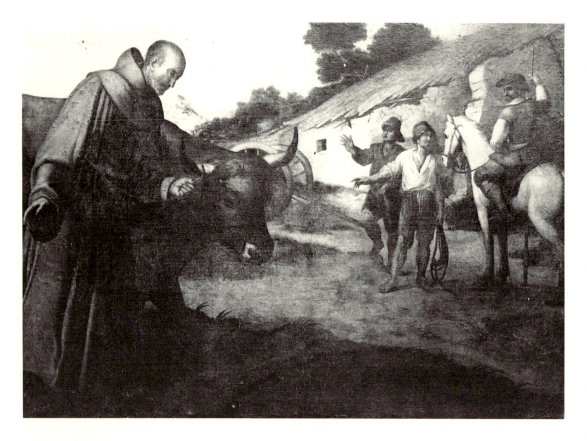

Figure 42. Murillo,
Scene from the Life of Saint Francis Solano.
Seville, Alcázar.
Oil on canvas, 157 x 225 cm.

2 *Scene from the Life of*
Saint Francis Solano (recto) and
Saint Francis Solano and Saint Salvador of
Horta and the Inquisitor of Aragon (verso)

Boston, Museum of Fine Arts 20.811 (Frances
Draper Colburn Fund, 1920).

222 x 335 mm. Recto: pen and brown ink with
brown wash over black chalk; signed in brown
ink at lower right: *bartolome murillo f*; small number
four (written as iiii) in corner. Verso: black
chalk.

Provenance: Library, Seville Cathedral; A.
Fitzherbert, Baron St. Helens (Lugt 2970 in lower
right corner; Christie, May 26, 1840, lot 102) to
W. Buchanan; C. Morse (Sotheby, June 4, 1873,
lot 154) to Gaskell; H. Adams; Mrs. H.D. Quincy
(vendor to Museum, 1920).

References: Brown 1973, p. 30, fig. 5; Angulo
1973, pp. 435-36, fig. 1; U. of Kansas 1974, p. 49;
Angulo 1974, p. 97.

The recto was published simultaneously by Angulo
and myself in 1973, and associated with a painting
(fig. 42) discovered by Angulo. Angulo did not
initially accept the painting as an authentic work
by Murillo, and attributed it to a follower or assistant.
But later in the same year, he reversed his
opinion and rightly gave it to the artist.

The subject seems to be a conflation of two episodes
from the life of Saint Francis Solano, a
Spanish Franciscan missionary in Peru, as told by
his biographer, Diego de Córdoba (*Vida, virtudes*
y milagros del nuevoapostol del Peru, el Venerable
P.F. Francisco Solano, Lima, 1630, p. 195). In
one story, a wild bull that had escaped from a bullfight
was subdued by Saint Francis, who held the
cord of his habit in front of the creature. The

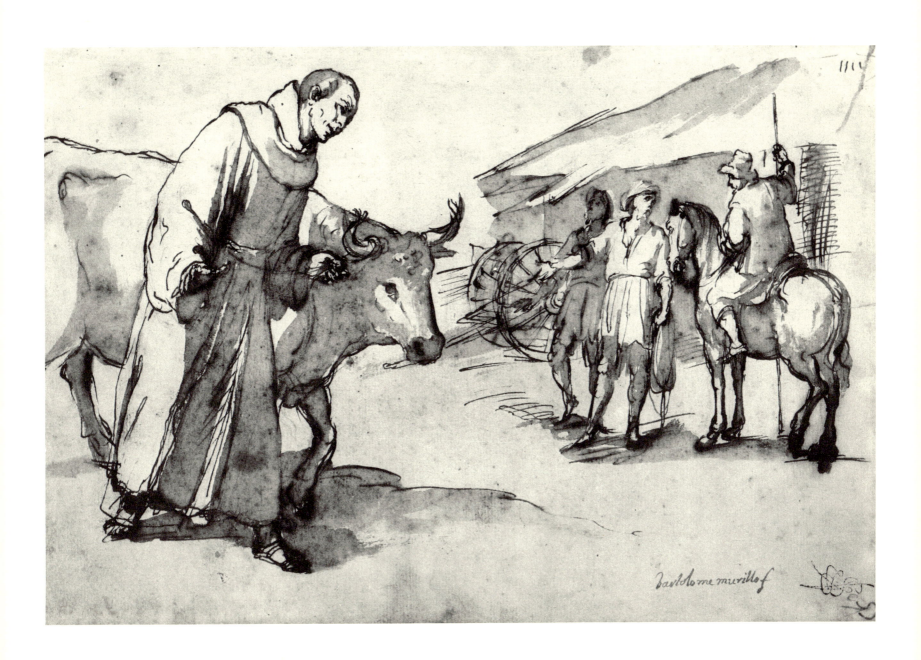

Bartolome murillo f

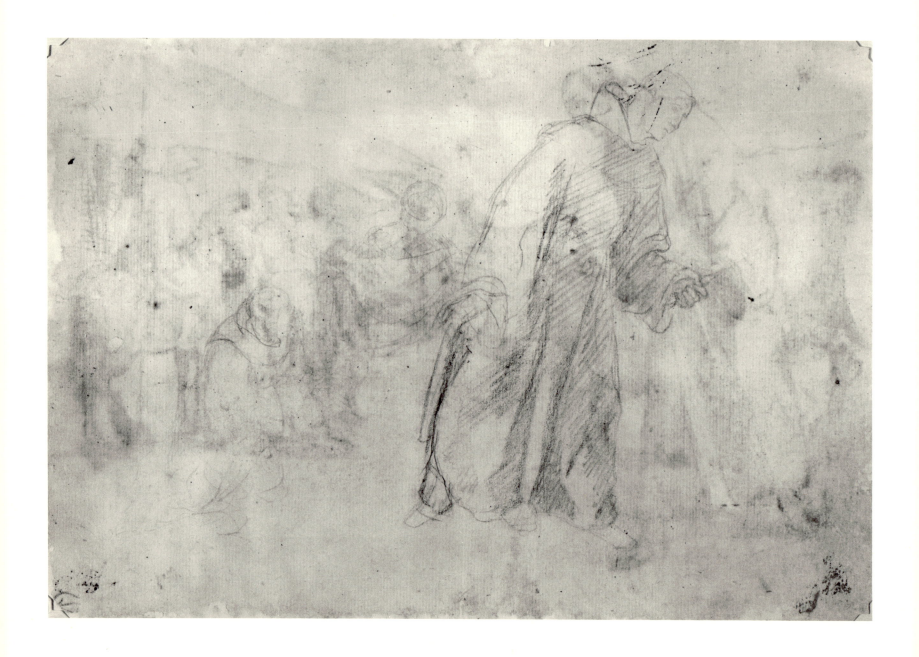

second account tells how Saint Francis tamed a wild bull that had threatened to attack him and a companion on horseback as they traveled on the road.

The Franciscan subject and the early date raise the question of whether this composition was connected with the *claustro chico* commission. The answer seems to be yes, at least in principle. On the verso is a partial study for the painting of *Saint Salvador of Horta and the Inquisitor of Aragon*, which was one of the paintings in the series. This seems to provide a link for the *Saint Francis Solano* to the *claustro chico* decoration. Furthermore, the recto has a small number four (written as iiii) in the upper right corner, exactly where the number three is written on cat. 1, which implies that the preparatory drawings for the series were all numbered in this way. Finally, the *claustro chico* paintings drew heavily on the lives of Spanish Franciscans for their subjects. Saint Francis Solano was himself a Spaniard, who had died as recently as 1610 (he was not canonized until 1726). This evidence indicates that at one time the painting was to be incorporated in the cloister.

Nevertheless, for some reason it was not used. None of the earliest descriptions records its presence. In addition, the painting lacks the painted inscription in verse found at the bottom of all the other works in the cloister. (I am not convinced that the *Two Friars* in Ottawa, the only painting without an inscription, was part of the cycle. Its size and format do not agree with any of the other pictures.) It seems probable that, for some reason, the *Saint Francis Solano* did not find favor with the patron and thus was excluded at the last moment.

The drawing comes from the most important collection of Murillo's drawings made in the nineteenth century, the one belonging to Alleyne Fitzherbert, Baron St. Helens (1753-1839). St. Helens served as British Ambassador Extraordinary to Spain from 1790 to 1794. During this time, he acquired a sizable collection of drawings attributed to Murillo, which had been in the library of the Seville Cathedral. At least this is the provenance given in the catalogue of the sale of his collection by his heir and nephew, Sir Henry Fitzherbert, which was held at Christie and Manson on May 26, 1840. The sale catalogue lists forty-eight lots with over sixty drawings, of which barely twenty percent are known today. The attributions of the known drawings are generally correct, but not infallible. (The two drawings in lot 96, now in the Public Library, Museum and Art Gallery in Folkestone, are copies of cat. 42 and cat. 48). But some of Murillo's most important drawings were in this collection (e.g., cat. 25, cat. 26, cat. 31, and cat. 70). Given its importance and potential value in identifying drawings by Murillo, the relevant part of the 1840 sale catalogue is reprinted in Appendix 3. St. Helens's calligraphic collector's mark is found on some but not all of the drawings formerly in his possession.

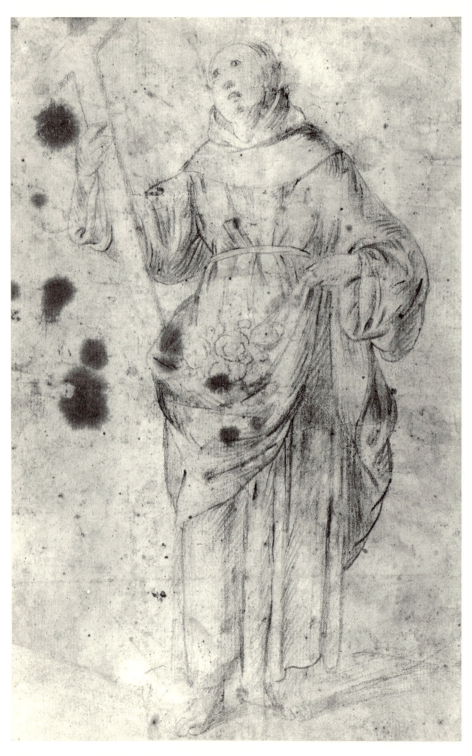

3 Saint Diego of Alcalá Holding a Cross

Hamburg, Kunsthalle 38593.

256 x 131 mm.; black chalk. Laid down; stained; repaired loss in lower left corner.

Provenance: J. A. Echevarría; B. Quaritch (vendor to Museum, 1891).

Exhibition: Hamburg 1966, no. 163.

The long-standing attribution of this drawing to the school of Murillo was changed in 1966, when it was reattributed to Domingo Martínez. Martínez (d. 1750) was a mediocre imitator of Murillo who was active in Seville in the first half of the eighteenth century. On the evidence of a few signed drawings in pen and ink, he does not appear to have been capable of making a drawing of this quality.

An attribution to Murillo himself is suggested by comparison with cat. 1, verso, and cat. 2, verso, both done in black chalk around 1645 or 1646. As discussed in the introductory section, Murillo made finished chalk drawings from the beginning of his career. This sheet shows many of the mannerisms of this chalk style, which also appear in the study for *Saint Salvador of Horta and the Inquisitor of Aragon* (cat. 1). The contrast between shadows, made with tightly spaced parallel lines, and highlights, formed by patches of blank paper, is found in both drawings. Also comparable are certain drapery folds formed by a series of short parallel lines placed at an angle to a highlight.

In size and subject, this drawing is close to cat. 6, although here Saint Diego appears to contemplate the cross rather than simply to hold it.

4 Infant Saint John the Baptist Embracing a Lamb

Hamburg, Kunsthalle 38585.

143 x 201 mm.; red and black chalk. Laid down; stained; small repaired tear in lower margin.

Provenance: J. A. Echevarría; B. Quaritch (vendor to Museum, 1891).

Like most of Murillo's finished red and black chalk drawings, this one has been catalogued as a school piece. However, it is a characteristic, though early, example of his work in this medium. (The arguments for accepting this class of drawing are advanced in the introductory section, pp. 21-22.) It is closely related to cat. 3 in form and execution. In these two sheets, Murillo appears to have used fairly soft chalks that produced thicker lines, and thus a warmer and broader effect than is found in the chalk drawings of the later 1650s and 1660s. Accents are provided by groups of short parallel lines, as on Saint John's loincloth and the sleeves of Saint Diego's habit in cat. 3. The summary execution of the right foot of each figure is also remarkably close.

The theme of Saint John with the Lamb appears in nine of Murillo's known drawings, but in no case is a composition repeated, even with variations.

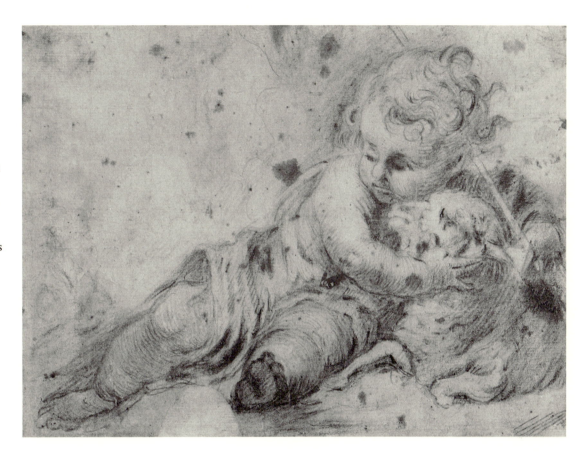

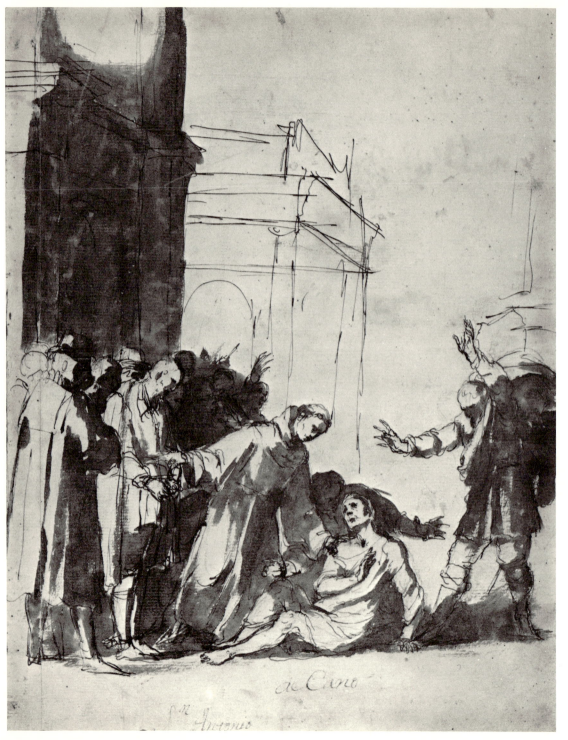

5 Saint Anthony of Padua and the Miracle of the Irascible Son

London, British Museum 1920-11-16-20.

346 x 265 mm.; pen and brown ink with brown wash. Inscribed in brown ink in lower center: S^n *Antonio* and *de Cano*.

Provenance: J. Rushout, 2nd Earl of Northwick; G. Rushout, 3rd Earl of Northwick; Lady E.A. Rushout; E.G. Spencer-Churchill (Sotheby, November 1-4, 1920, lot 308, as Cano) to Museum.

References: Wethey 1952, p. 233; Brown 1973, p. 30, fig. 4.

Until 1973, the drawing was given to Alonso Cano on the basis of the inscription, although Wethey had rejected the attribution in 1952. It is, however, an early work by Murillo and is closely related to the two pen drawings for the *claustro chico* of 1645 and 1646 (cat. 1 and cat. 2). In all three drawings the same figure type is used, a similarity that is heightened by the presence of Franciscan friars. More specifically, the British Museum sheet shares several idiosyncrasies with cat. 1, notably the spiky fingers, the unusual jagged lines in the architecture, and the small S-shaped lines for the cheekbones. The strong contrast between light and shadow achieved by the wash, though somewhat muted by fading, is close to the effects found in cat. 2. Both of these drawings incorporate the strong tenebrism of Murillo's early painting style.

The presence of Saint Anthony of Padua raises the question of whether this composition was ever a candidate for inclusion in the *claustro chico* series. Saint Anthony was to become a favorite saint of Seville, judging from the numerous representations of him made by Murillo in his later career. Given his fame and importance, Saint

Anthony's absence from the 1645-1646 series is conspicuous. Furthermore, he was not only a famous Franciscan but also was of Iberian origin, having been born in Lisbon, a circumstance that should have strengthened the case for his inclusion in a commission that had a strong chauvinistic bias. (Over half of the scenes depict incidents in the lives of Spanish Franciscans.) Finally, there is evidence (see cat. 2) that the monks may have changed their minds about the contents of the cycle as the commission evolved, and substituted some scenes for others. Despite these circumstances, however, there is, in the end, no unequivocal proof that this drawing was a preparatory study for a *claustro chico* painting that was excluded from the final selection.

6 *Saint Diego of Alcalá Holding a Cross*

Hamburg, Kunsthalle 38591.

257 x 137 mm.; pen and brown ink with brown wash over black chalk on brown paper. Laid down; somewhat faded. Fragmentary inscriptions and arithmetic calculations in brown ink.

Provenance: J. A. Echevarría; B. Quaritch (vendor to Museum, 1891).

This small sheet is related in style and subject matter to cat. 1, cat. 2, and cat. 3, and it forms part of what may be called the "Franciscan Group" of drawings, datable roughly to the period between 1645 and 1650. If the line in this drawing is slightly looser than in the others, there are still numerous points in common to indicate the homogeneity of these drawings.

Saint Diego was the most beloved of the Spanish Franciscans and was frequently represented in Spanish Baroque painting and sculpture. He is the hero of the *claustro chico* series, appearing as the

protagonist in two paintings, whereas the other figures appear but once. Given the special emphasis on his life, it is curious that his most famous miracle—the transformation of bread into roses—was omitted from the cycle. Against the orders of his superior, Saint Diego distributed the bread of the monastery to the needy. One day, as he was carrying loaves to the poor in the folds of his habit, he encountered the prior, who ordered him to reveal his burden. When he opened the habit, it was discovered that the bread had been miraculously transformed into roses.

This is the incident that Murillo adapted for representation in this drawing. However, the miraculous roses have been combined with another attribute, a cross, to form an unusual image of the saint. It is impossible to know whether this hybrid subject was invented by Franciscan friars for a specific purpose or whether Murillo conceived it himself. However, once again the coincidence of a Franciscan subject done in the 1640s with the knowledge of a specific Franciscan commission from the same period is suggestive of a common patron for cat. 1-cat. 3, cat. 5, and cat. 6. For another version of this subject, see cat. 3.

It is possible that Murillo did a painting based on this composition. A picture by a follower of Murillo's early style somewhat resembles the drawing (H. Soehner, "Greco in Spanien," *Münchner Jahrbuch der Bildenden Kunst* 7 [1957]:190, fig. 64, as a copy after El Greco).

This drawing was part of a collection of Spanish drawings, including twenty-eight sheets attributed to Murillo, that was made in the late nineteenth century by a Mexican painter named José Atanasio Echevarría. The collection was acquired by the London dealer B. Quaritch, who sold it to the Kunsthalle in 1891. For the history of the acquisition, see Hamburg 1966, pp. 3-4.

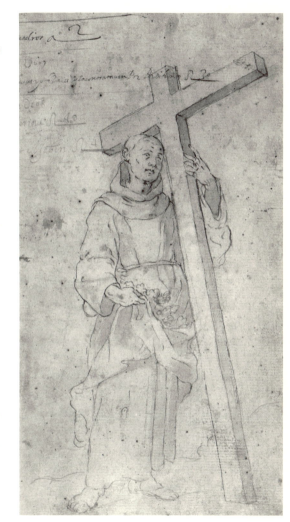

7 Adoration of the Magi

Paris, private collection.

273 x 226 mm.; pen and brown ink with brown wash over red and black chalk. Laid down; a recent cleaning has left the washes somewhat faded.

Provenance: J.I. de Espinosa y Tello de Guzmán, 3rd Conde del Aguila; J. Williams; F.H. Standish; Louis Philippe (Paris, December 6, 1852, lot 593); J.P. Chapelle (Versailles, March 1, 1970, lot 132).

References: *Catalogue . . . de la Collection Standish* 1842, p. 78, no. 426; Stirling-Maxwell 1848, vol. 3, p. 1446.

This drawing was correctly given to Murillo in the 1842 catalogue of the Frank Hall Standish collection (see below) and is a preparatory study for a painting formerly in the Contini-Bonacossi collection (fig. 43). It is noticeably freer in execution than the pen-and-wash drawings of the 1640s and begins to approximate Murillo's mature style. The angularity of the earlier drawings has been softened and the wash is used in a more painterly manner, as, for instance, in the Virgin's robe. A date in the range of 1650 to 1656 is also corroborated by the style of the painting.

This sheet was one of twenty-two drawings attributed to Murillo in the Frank Hall Standish collection. Standish (1799-1840) was an English Hispanophile who lived much of his mature life in Seville, where he acquired a major collection of Spanish paintings and drawings. The collection was bequeathed to Louis Philippe in 1841 and exhibited at the Louvre as part of the Galerie Espagnole until 1848. The drawings were sold in the sale of the king's library in 1852, twelve of them ultimately being acquired by the Louvre.

The catalogue of the sale lists the drawings without dimensions, but the measurements are given in the 1842 catalogue of the Standish bequest.

According to Curtis (1883, p. 5), Standish's collection of Spanish drawings formerly belonged to Juan Ignacio de Espinosa y Tello de Guzmán, third Conde del Aguila (ca. 1760-1808). The Conde del Aguila was a Sevillian nobleman whose activities as a collector and student of Spanish art deserve study. He owned a large collection of paintings, sculpture, prints, drawings, and archaeological objects that was dispersed after his tragic death during the Peninsular War at the hands of a mob that wrongly suspected him of being a French sympathizer (see Velázquez y Sánchez 1872, pp. 63-67, for a detailed account of his persecution and death). Some of the Conde's collection had been inherited from his father, Miguel de Espinosa y Maldonado, including 484 drawings. They are summarily described in a document of January 10, 1785, relating to the settlement of the second Conde's estate (see Gestoso y Pérez 1916, p. 218). No drawings by Murillo are mentioned in this list. After the third Conde's death, the drawings were acquired by Julian Williams, the British vice-consul in Seville (see the inscription by his friend Richard Ford on cat. 56). He, in turn, seems to have sold at least part of the collection to Standish.

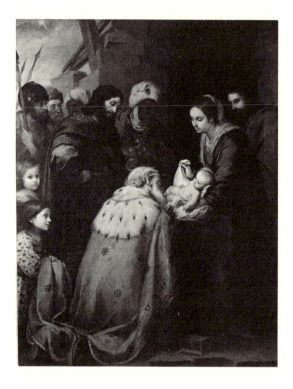

Figure 43. Murillo,
Adoration of the Magi.
*Collection unknown, formerly Florence,
Contini-Bonacossi collection.
Oil on canvas, 187 x 146 cm.*

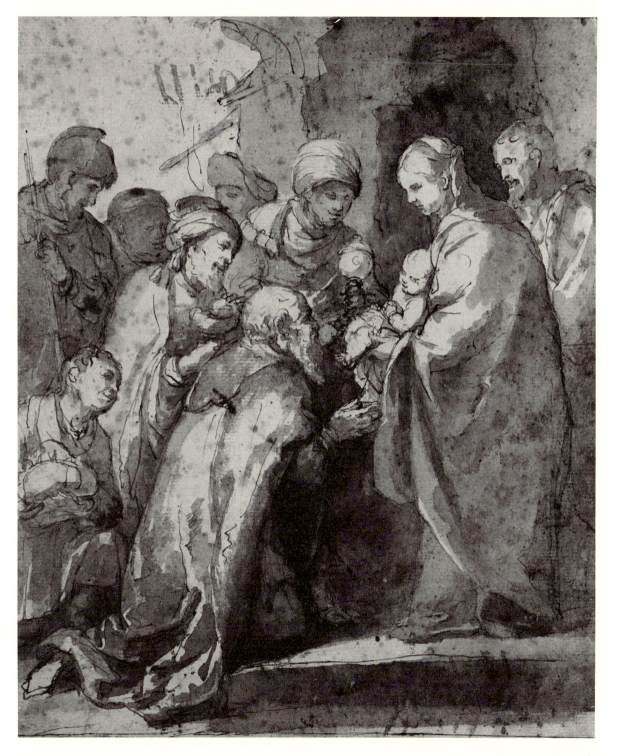

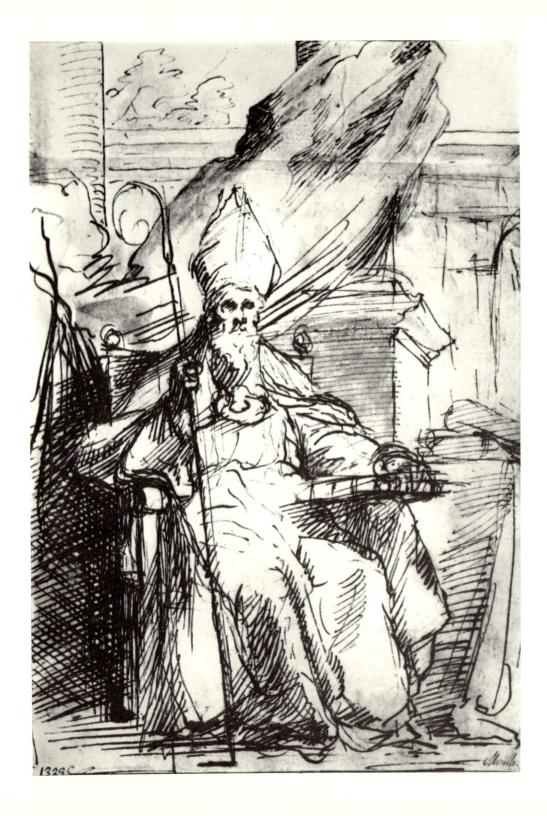

8 Saint Isidore

Paris, Cabinet des Dessins, Musée du Louvre 18.445.

238 x 167 mm.; pen and brown ink with brown wash. Laid down; sheet is heightened at top by addition of strip 4 cm. wide. Inscribed in brown ink at lower right corner: *Morillo*.

Provenance: P. Crozat (Lugt 2951).

References: Baticle 1961, p. 82, repr. p. 50; Angulo 1974, p. 101, fig. 15.

Baticle first published this drawing and related it to a painting in the sacristy of the Seville Cathedral (fig. 44). This picture and its companion, *Saint Leander* (fig. 46), were donated to the Cathedral in 1655 by Juan de Federigui, Archdeacon of Carmona. There is no reason to doubt that they were painted at this time, rather than at some prior date. Recently, Angulo has questioned whether this drawing was intended for the painting in the sacristy. He notes the psychological differences between the saint as represented in the drawing and painting, characterizing the one as *"polémico y batallador,"* the other as *"estudioso."* Then he points out the differences in pose, setting, and scale. Finally, he draws attention to the minutes of a meeting of the Cathedral chapter, held on December 4, 1656, at which the construction of a chapel in honor of this saint was discussed. The chapel was to have an altarpiece with yet another painting of Saint Isidore above it, presumably commissioned from Murillo.

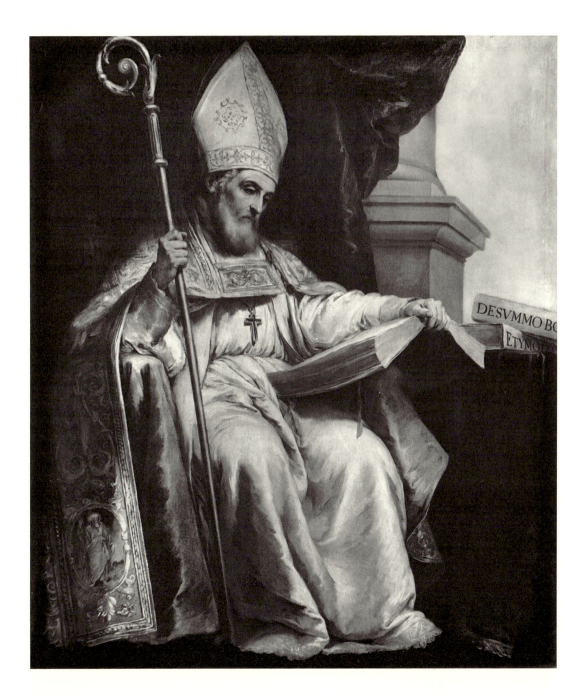

Figure 44. Murillo,
Saint Isidore.
Seville, Cathedral.
Oil on canvas, 188 x 160 cm.

DESVMMO B

ETYMO

The hypothesis, though intriguing, is not plausible for several reasons. First, the chapel of Saint Isidore never had a recorded portrait of the saint painted by Murillo or anyone else (no artist's name is recorded in the minutes). Second, substantial differences between Murillo's preliminary drawings and the final composition are occasionally found. Sometimes they were the result of an evolution of the artist's thought. But it is equally likely that they were caused by the wishes of a patron, as possibly happened here. Saint Isidore was renowned for his scholarship. Murillo's first idea, as expressed in this drawing, perhaps did not convey this fact with sufficient clarity to Archdeacon Federigui, who, with reason, asked for adjustments to be made. The changes were incorporated in a second drawing (cat. 12), which closely approximates the final pose of the figure. Hence, it seems reasonable to suppose that cat. 8 is related to the painting and was done around 1655.

As such, it is a valuable landmark in Murillo's career as a draftsman and can serve as the nucleus for a group of drawings executed in this vigorous, linear style (see cat. 9-cat. 11). Parallel hatching is used in these drawings for interior modeling of the figures, with dense cross-hatching to depict shadows.

Bartolome Murillo f.a.

9 Young Saint John the Baptist with the Lamb (recto) and A History Scene (verso; not illustrated)

Munich, collection of Family S.

268 x 189 mm. Recto: pen and reddish brown ink over black chalk; inscribed by the Contemporary Collector in brown ink at lower center margin: *Bartolome Murillo fa^t*. Verso: pen and brown ink.

Provenance: J. A. Ceán Bermúdez; Beurnonville (1875); A. van Beckerath; Kaiser Friedrich Museum (1902-1945; Lugt 1612 on verso); Bode Museum (from which obtained by exchange by present owner).

Reference: Lefort 1875, p. 261, repr. p. 259.

The recto was published in 1875 as by Murillo. The verso, a weak drawing by another hand, might represent Dido and Aeneas.

The drawing is closely related to cat. 8, although it does not have shading in brown wash. The forceful calligraphic style, with parallel hatching for interior modeling and cross-hatching for shadows, is typical of a small group of drawings that was done in the mid-1650s. This manner is a development of a technique, visible in Murillo's first-known drawings, that served as a basis for the pen style throughout his career.

10 Archangel Michael

London, British Museum 1873-6-14-216.

267 x 189 mm.; pen and brown ink over black chalk. Laid down; repaired losses near right leg, bottom of cross, helmet, and left side of torso. Inscribed by the Contemporary Collector in brown ink at lower center margin: *Bartolome Murillo fat*.

Provenance: J.H. Anderdon (donor to Museum, 1873).

Reference: Angulo 1974, p. 102, fig. 7.

Although more free in technique than other members of the Louvre *Saint Isidore* group, this work is related to those drawings. The date implied by Angulo in his discussion of the sheet, about 1655, is plausible, although certain passages, such as the angel's right side, which is loosely defined, suggest a slightly later moment in Murillo's career.

Murillo did a now-lost painting of this subject for the high altar of the Capuchinos, Seville (1665-1666), but it is otherwise unknown in his oeuvre.

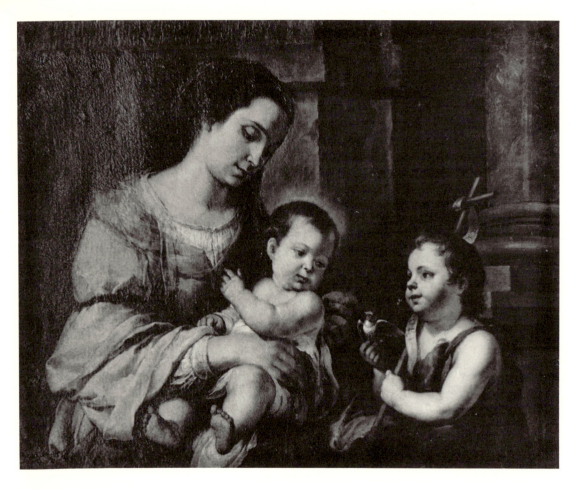

Figure 45. Murillo,
Virgin and Child with Saint John.
Mallorca, March collection.

11 *Saint John the Baptist* (recto) and *Putti Holding a Crown and Palm Branch and a Seated Figure* (verso)

London, British Museum 1873-6-14-212.

221 x 339 mm. Recto: pen and brown ink; inscribed by the Contemporary Collector in brown ink at lower center margin: *Bartolome Murillo*; inscribed at lower right corner: *15* (inverted); inscribed at lower left corner: *Lord St. Helens' Collection 26 May 1840*; cross in black chalk at upper right corner. Verso: pen and brown ink with brown wash over faint indications in red chalk; seated figure in black chalk; inscribed by the Contemporary Collector in brown ink: *Bartolome Murillo. fat.*; inscribed at upper left corner: *16*; cross in black chalk at upper left corner.

Provenance: Library, Seville Cathedral; A. Fitzherbert, Baron St. Helens (Lugt 2970; Christie, May 26, 1840, lot 93) to J. H. Anderdon (donor to Museum, 1873).

Reference: Angulo 1974, pp. 101-2, fig. 17.

Angulo recently published the recto of this sheet and related the kneeling figure at the right to the painting of the *Virgin and Child with Saint John* in Pollok House, Glasgow. He also noted that this little Saint John is even closer to one in another version of the theme (fig. 45). Angulo considered the latter painting to be a studio replica, but its quality seems sufficient to include it as an authentic work of about 1650 to 1655. If this is so, then the figure on the British Museum sheet is a preparatory sketch for the picture. A date in the mid-1650s is also indicated by the stylistic relationship to cat. 8, which has the same technique of parallel and cross-hatching.

The older Saint John with a lamb at the left is based on a print by Guido Reni (Bartsch 3), which

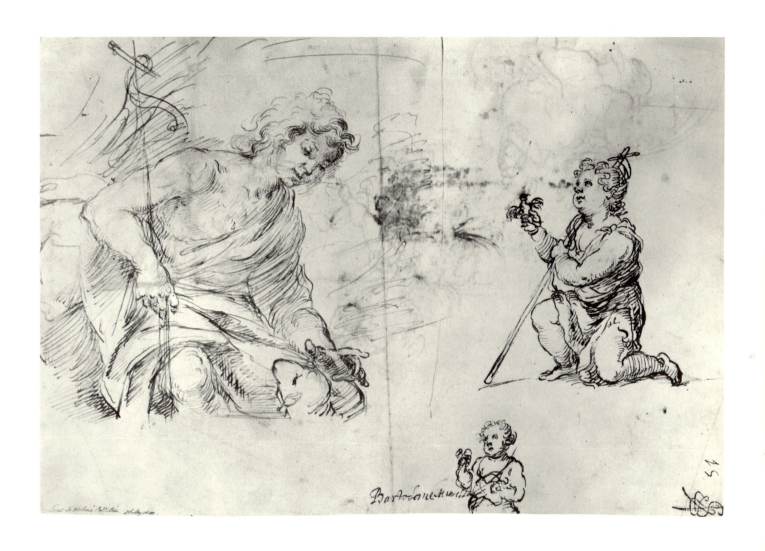

Bartolomeomilla

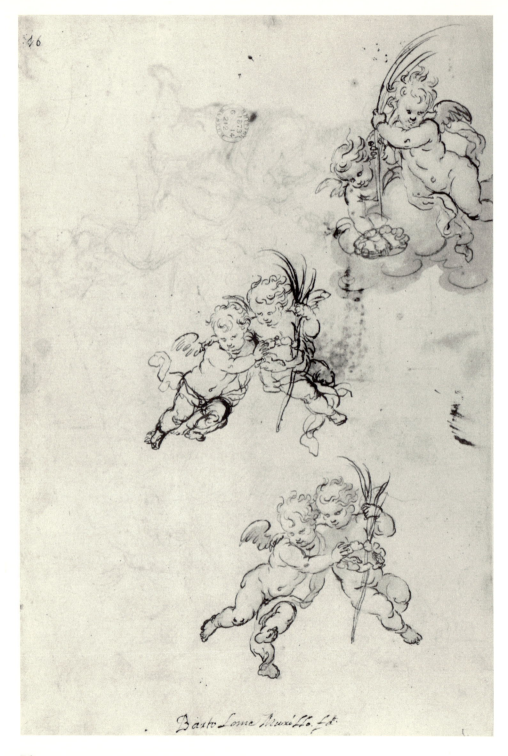

explains why the composition stops short even though there is ample space to continue (*A.C.*).

On the verso, which was not discussed by Angulo, there are studies for three pairs of putti that were probably intended for a scene of martyrdom, now unidentifiable. Yet another figure is present—a seated man faintly sketched in black chalk, visible just below the kneeling figure showing through from the recto. The loose chalk style was commonly used by Murillo for underdrawing.

The sheet is numbered in the corner on both the recto [*15*] and verso [*16*], suggesting that it was once bound in a volume of sketches. The peculiar calligraphy of these numbers, always in an upper corner, is found on six other authentic drawings by Murillo: *Saint Francis of Paula* (cat. 30), which has the number *29* or *49*; *Christ on the Cross* (cat. 55), which has the number *14*; a study of putti for a Virgin Immaculate (cat. 76), which has numbers *10* and *11*; and three versions of the *Virgin of the Immaculate Conception* (cat. 24, cat. 51, and cat. 54), which have numbers *18*, *46*, and *116*, respectively. Another curious detail that is shared by three of the seven sheets is a cross in black chalk at the upper left corner. The meaning of the cross is an enigma. But with regard to the numbers, it is tempting to speculate that there once existed a bound volume of Murillo drawings with no fewer than 116 compositions, including rectos and versos.

12 Saint Isidore

London, British Museum 1873-6-14-214.

262 x 209 mm.; pen and brown ink with brown and gray wash over black chalk. Laid down. Signed in brown ink at lower left corner: *Murillo f*e.

Provenance: J.H. Anderdon (donor to Museum, 1873).

Reference: Trapier 1941, p. 36, fig. 26.

This drawing is a further development of the composition begun in cat. 8 for the painting in the sacristy of the Seville Cathedral (1655; see fig. 44). In striving to depict Saint Isidore as a scholar, Murillo altered the pose so that the saint studies an open book on his lap, whereas earlier he looked outward and held a book on the arms of the chair. Furthermore, the artist suppressed the architectural background and enlarged the swath of drapery to provide an enclosed, roomlike setting. The solution used in the painting borrows from both drawings: the architectural element is partly reinstated, as is the table with two books resting on its top.

The marked difference between the two preliminary drawings is the result of two distinct techniques. Cat. 12 is fundamentally a wash drawing in which the pen is used only to shape outlines and to indicate the placement of shadows. The composition was rendered initially in black chalk, following a procedure often favored by Murillo. The same technique can be seen in a drawing for the companion piece, *Saint Leander* (cat. 13), which, however, does not include pen and ink; only wash over black chalk is used. In both drawings, washes are applied with subtle and telling differences in tone.

Saints Leander (d. 601) and Isidore (d. 636) were brothers and successive archbishops of Seville. They were regarded as two of the city's patron saints.

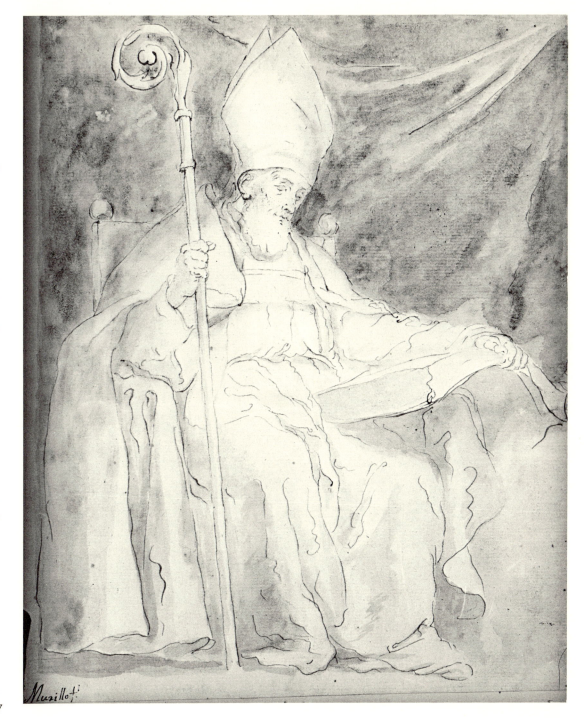

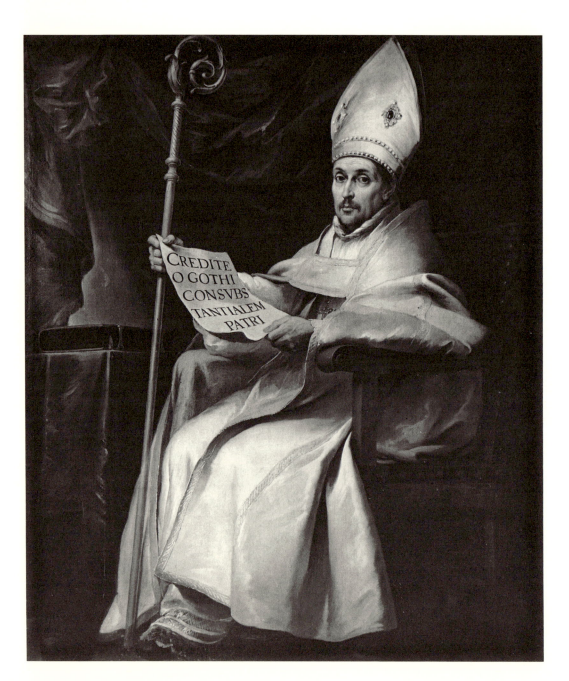

13 *Saint Leander*

London, British Museum 1873-6-14-215.

211 x 180 mm.; brush and brown wash over black chalk. Laid down.

Provenance: J. H. Anderdon (donor to Museum, 1873).

References: Trapier 1941, p. 36; Brown 1973, p. 30, fig. 6.

A companion piece to cat. 12, the *Saint Leander* is a splendid example of Murillo's style as a draftsman with brush and wash. The underdrawing is done entirely in black chalk, without additional indications in pen and ink, over which brown wash has been painted with considerable freedom. In the backdrop, Murillo rendered the shadows by unblended brushstrokes that both achieve an effect of contrast and impart the impression of spontaneous execution.

The preparatory wash drawings for the two portraits are interesting to compare with their respective paintings (figs. 44 and 46) because they represent approximately the same stage of progress (for a discussion of *Saint Isidore*, see cat. 8 and cat. 12). When he painted the picture of *Saint Leander* (fig. 46), Murillo made two significant changes in the pose. First he shifted the crozier from the left to the right hand, then he placed the paper in both hands, rather than in one. These changes may have been motivated by the desire to vary the rigid symmetry found in the paired wash drawings.

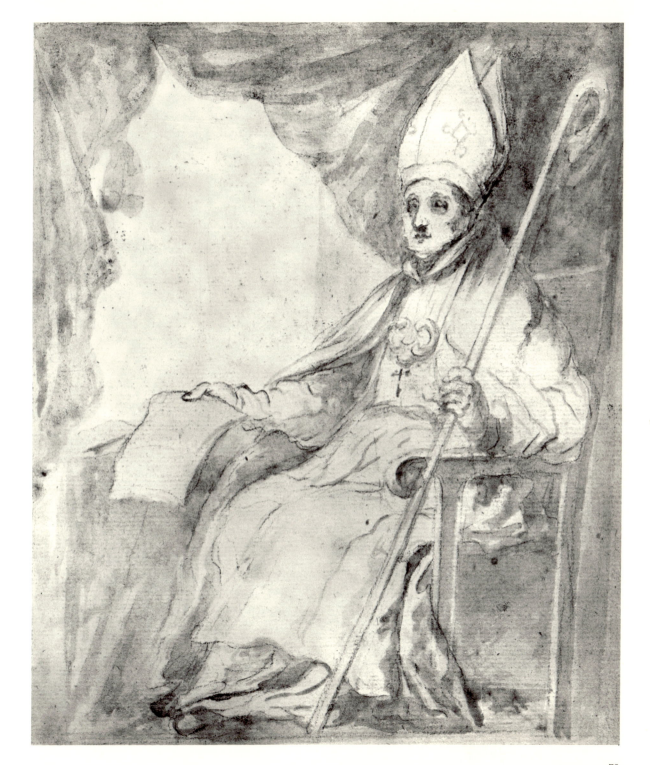

14 *Mystic Marriage of Saint Catherine*

Hamburg, Kunsthalle 38592.

182 x 206 mm.; red chalk with traces of black chalk. Laid down. Dated in red chalk at bottom margin; *En°. 29 de 1655.*

Provenance: J. A. Echevarría; B. Quaritch (vendor to Museum, 1891).

References: Mayer 1918, p. 113, fig. 4; Mayer 1920, repr. p. 131; Gradmann [1939], p. xv, no. 17, pl. 17; Gómez Sicre 1949, pl. 69.

This often-published drawing is a key piece in the definition of Murillo's work in chalk. As Mayer pointed out in 1918, it is related to a painting in the Vatican, which he thought to be a copy, as indeed it is. The original is in the Museu Nacional de Arte Antiga in Lisbon (fig. 47). Mayer hypothesized that the drawing was part of a *liber veritatis*, an idea that may be partly correct, insofar as the drawing appears to have been done after the painting. The distinction between an autograph copy and a preliminary study in the chalk medium is not easily made because Murillo's chalk drawings were often highly finished and sometimes closely approximated the paintings. Moreover, as a general rule, he used detailed chalk drawings to study the central groups of his compositions. But there are two points that indicate that the drawing was done after, not before, the painting, even though the drawing duplicates the composition. First is the fact that the composition stops short of the bottom of the page, at a point that corresponds closely to the lower edge of the painting. All other chalk drawings cover the entire surface of the sheet, which suggests that this drawing stopped here for external reasons. Second, the shading is carried out almost entirely with the side of the chalk and with blended strokes, while in other chalk studies, thin parallel lines are extensively employed. The smoother finish that results can be interpreted as an effort to emulate the surface of an oil painting.

We may then suppose that this drawing is an autograph copy. The presence of a specific date on the drawing, January 29, 1655, lends additional weight to Mayer's *liber veritatis* hypothesis. But here the evidence ends. Only one other dated chalk drawing is known (cat. 22), but it is a partial study, not a complete composition. Unless several more drawings in this vein appear, the *Mystic Marriage of Saint Catherine* must be considered as a rare, if not unique, self-copy. Nevertheless, the drawing is important for establishing the highest limit of finish for Murillo's works in chalk. By comparison with it, most of the other drawings in this medium can eventually be seen as less studied than they first appear.

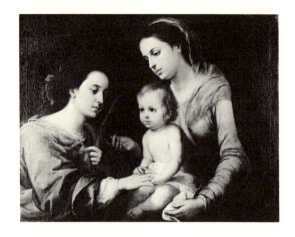

Figure 47. Murillo,
Mystic Marriage of Saint Catherine.
Lisbon, Museu Nacional de Arte Antiga 1608.
Oil on canvas, 76.5 x 94.5 cm.

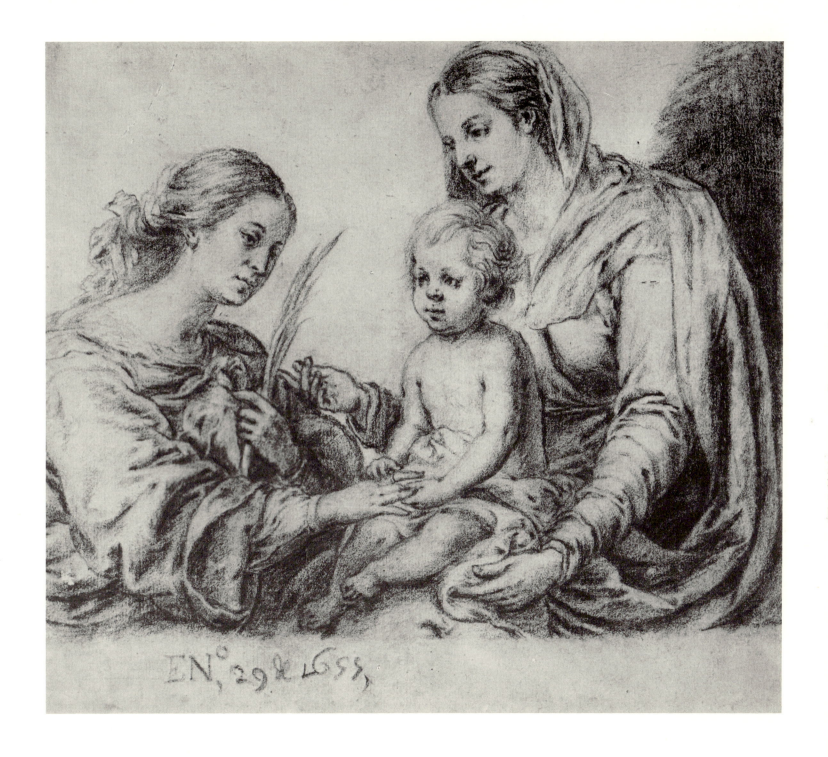

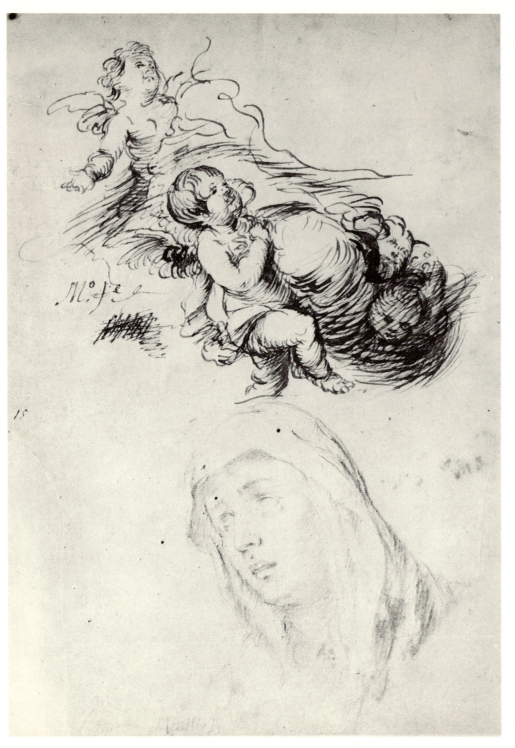

15 Studies of Putti for the Virgin of the Immaculate Conception and of the Head of the Virgin Mary Weeping

London, British Museum 1873-6-14-213.

284 x 198 mm.; putti in pen and brown ink; head of Virgin in black and red chalk. Laid down; large repaired losses in lower left and right corners. Signed in black chalk at lower center: *Murillo f.*; signed in brown ink at left of putti: *M°. fe* and *15*.

Provenance: J.H. Anderdon (donor to Museum, 1873).

Reference: Angulo 1974, pp. 103-4, fig. 6.

This study sheet is one of the most interesting and informative drawings by Murillo because it contains preparatory sketches in his favored media. As Angulo recognized, the putti are studies for the *Virgin of the Immaculate Conception of Loja* (fig. 48). He also tentatively associated the head of the Virgin on the lower half with one of two paintings of *Virgin Mary Weeping*—the half-length version in the Prado (fig. 49) or the full-length version in the Museo de Bellas Artes in Seville. Of the two, the Prado painting seems closer to the drawing.

The appearance of a red and black chalk drawing on the same sheet as a surely identifiable preparatory sketch helps to confirm the attribution of finished works in two colors of chalk by Murillo. The additional evidence provided by the fact that the chalk drawing is related to a painting is also important. If the head of the Virgin Mary is still somewhat looser in treatment than other chalk studies, the use of red chalk for flesh tones and black chalk for drapery is a constant device.

The pen sketch is important in its own right because it shows how Murillo studied a small passage of a picture in isolation from the total composition. Angulo has noted how the drawing also

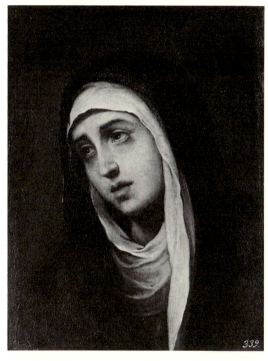

establishes the pattern of light and shadow that ultimately appears in the painting, with the seraphim in shadow and the lefthand putti in bright light.

Angulo dates the drawing on the basis of the style of the *Virgin of the Immaculate Conception of Loja* (fig. 48), which he plausibly places around 1655 to 1660.

Murillo's last name is written twice on the drawing, once in monogram form in brown ink, the second time in black chalk beneath the Virgin's head. Both of these signatures seem to be of a piece with the respective drawings and may be considered as autographs.

Figure 50. Murillo,
Vision of Saint Anthony of Padua.
Seville, Cathedral.
Oil on canvas, 550 x 330 cm.

16 Vision of Saint Anthony of Padua

Collection unknown.

212 x 196 mm.; black chalk. Inscribed in ink at lower left: *Murillo*.

Provenance: Marqués de Argelita; F. Boix; R. Chaveau Vasconcel.

References: Sánchez Cantón 1930, vol. 5, pl. 413; Lafuente Ferrari and Friedländer 1935, p. 130, pl. 58; Trapier 1941, p. 35.

As Sánchez Cantón noted, this drawing is a study of the central figure in the monumental *Vision of Saint Anthony of Padua*, painted for the baptismal chapel of Seville Cathedral in 1656 (fig. 50). The pose was transferred to the canvas almost without alteration.

For another preparatory sketch for this work, see cat. 17.

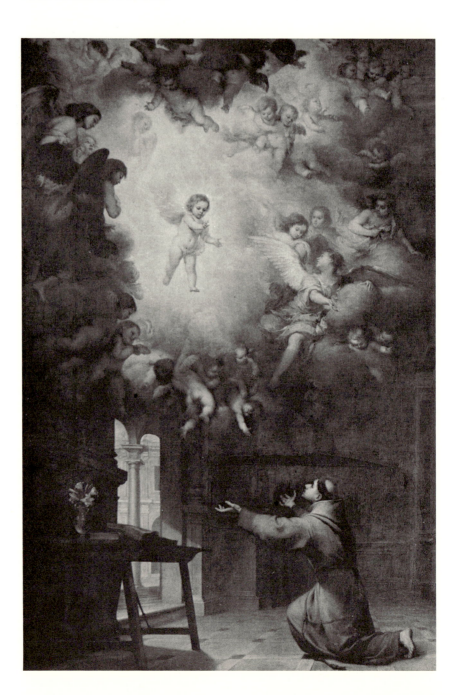

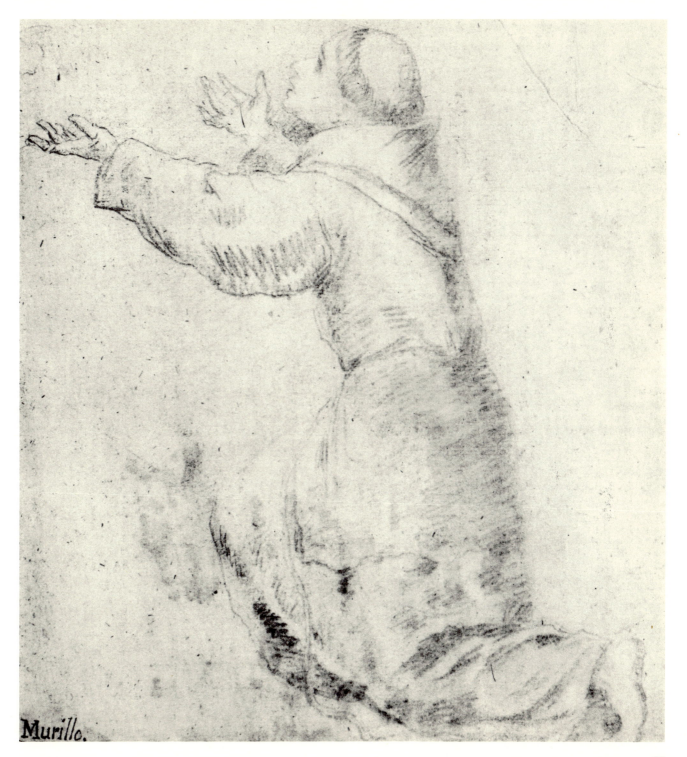

Murillo.

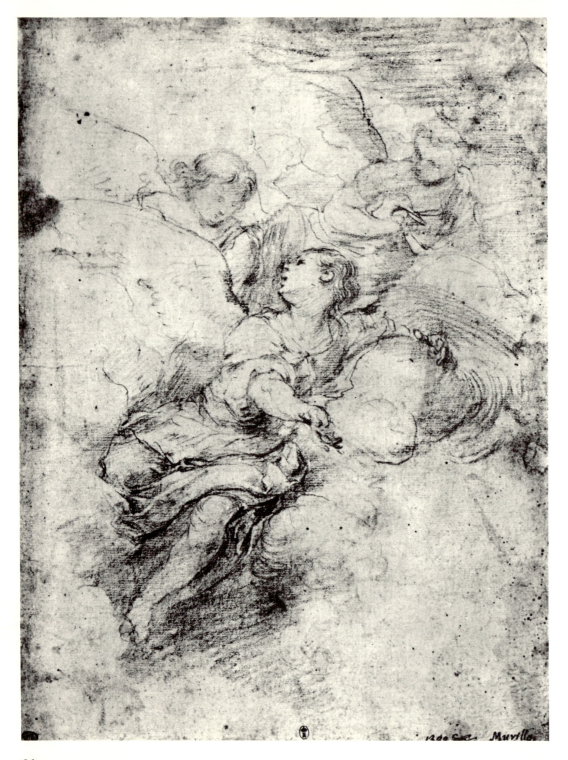

17 Angels

Paris, Cabinet des Dessins, Musée du Louvre 18.440.

285 x 212 mm.; black chalk. Inscribed in brown ink at lower right: *Murillo* and *1322*.

Provenance: P. Crozat (Lugt 2951).

Reference: Angulo 1974, p. 104.

This fine drawing was identified by Angulo as a study for angels in the large-scale *Vision of Saint Anthony of Padua*, painted in 1656 for the baptismal chapel in the Cathedral of Seville (fig. 50). In the painting, another angel's head appears between the two upper figures. A second study for the painting, this one of Saint Anthony, is discussed under cat. 16.

The existence of these two partial studies for a single painting again demonstrates the methodical and analytical procedure employed by Murillo in his preparatory process. They also show the somewhat looser manner of chalk drawing that he sometimes used.

18 Saint Mary Magdalene Renouncing the Worldly Life

Collection unknown.

Dimensions unknown; red chalk. Inscribed in brown ink at lower left corner: *Murillo fc.*

Provenance: J.C. Robinson (Lugt 1433).

This drawing, which was brought to my attention by Enriqueta Harris, is a study for the upper part of the Magdalene in a painting of the early 1650s (fig. 51). Although the picture has been catalogued as by an anonymous seventeenth-century Spanish painter, it is an authentic work of the early period. In a characteristic way, Murillo used the chalk medium to develop in detail the central figure in a composition. However, only the head has been highly finished here, the rest of the figure being depicted in a more cursory manner, a technique that is sometimes used by the artist.

The same inscription appears on cat. 27 and cat. 80.

Figure 51. Murillo,
Saint Mary Magdalene Renouncing the Worldly Life.
Richmond, Virginia Museum 53-21-2.
Oil on canvas, 135.3 x 108.6 cm.

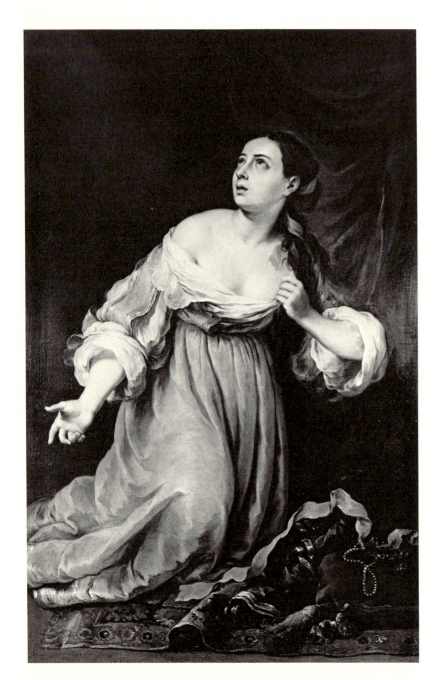

**19 Young Saint John the Baptist
Kneeling and Collecting Water in a Shell**

Vienna, Graphische Sammlung Albertina 13088.

178 x 138 mm.; black chalk. Small repaired loss in landscape to right of figure.

Provenance: Duke Albert of Saxony.

Reference: Curtis 1883, no. 332i.

The style and handling of this drawing are very close to cat. 17, which is also done in black chalk alone. Unlike the two-color chalk drawings, which are sedulously controlled and minutely detailed, this sheet has considerable movement and openness, especially in the landscape. Nevertheless, the firm delineation of the figure suggests that it was done around 1655 to 1670 rather than later, when the outlines are interrupted and impart a ragged appearance to the human form.

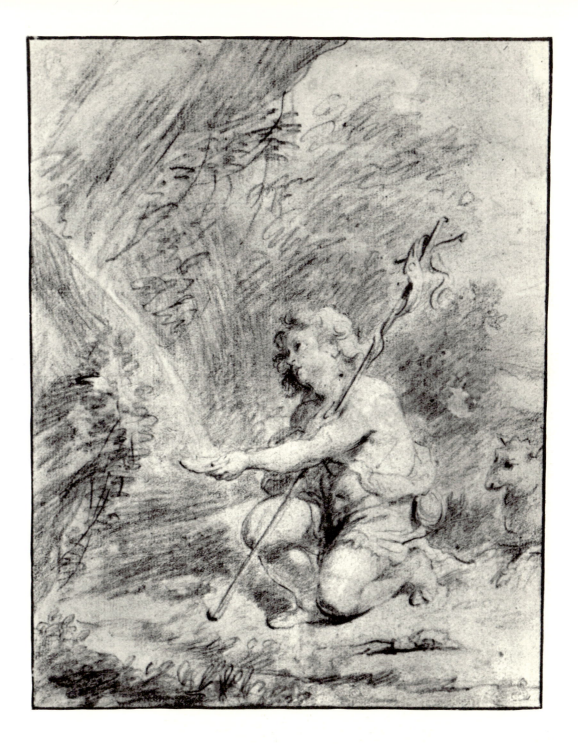

20 Head of a Man

London, British Museum 1895-9-15-886.

77 x 74 mm.; black chalk strengthened with light brown ink. Laid down. Inscribed in dark brown ink at lower right: *murillo*.

Provenance: H. Wellesley; J. Malcolm; J.W. Malcolm (donor to Museum, 1895).

Reference: Robinson 1876, p. 152, no. 435.

This tiny sheet is difficult to date, but there is no reason to doubt the traditional attribution. The chalk drawing of the hair, in particular, evinces Murillo's usual manner, especially in the use of close parallel lines, which are also applied to create shadows on the cheek and jaw. The forceful drawing of the collar helps to confirm the attribution.

Portrait drawings are unusual in Murillo's oeuvre, this being only one of three that are known. The other two (cat. 60 and cat. 87), however, show full-length poses and are done in a summary manner. Here the sitter's personality is effectively conveyed by the concentrated study of the head.

21 Saint Francis Receiving the Stigmata

Hamburg, Kunsthalle 38575.

149 x 147 mm.; red and black chalk. Laid down; stained and soiled; vertical crease.

Provenance: J. A. Echevarría; B. Quaritch (vendor to Museum, 1891).

Reference: Angulo 1974, p. 104.

Angulo tentatively related this drawing to a painting of the same subject (Angulo 1935, fig. 17), for which it is indeed a preparatory study. The sheet is not in good condition and it has been trimmed on all sides but the top, to judge from the appearance of the figure in the painting. If Murillo followed his usual practice in making preparatory studies in chalk, only Saint Francis as the central figure was included in the drawing. (The figure of Brother Leo seen in the right middle ground of the painting would have been omitted.)

On the basis of the painting's style, the drawing was done in the mid-1650s.

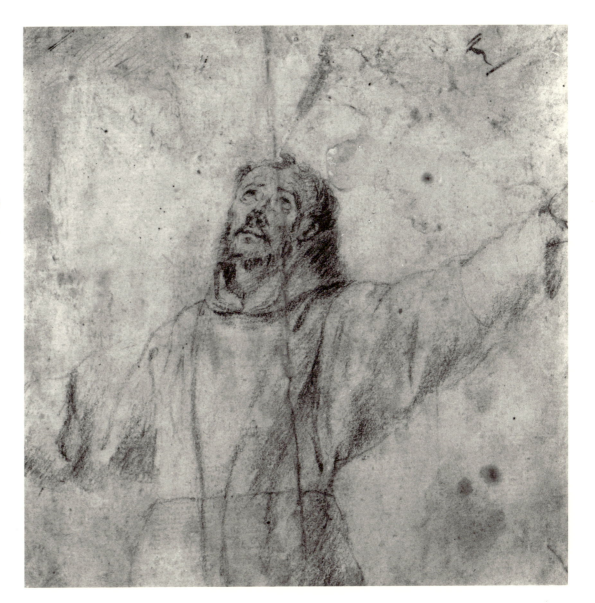

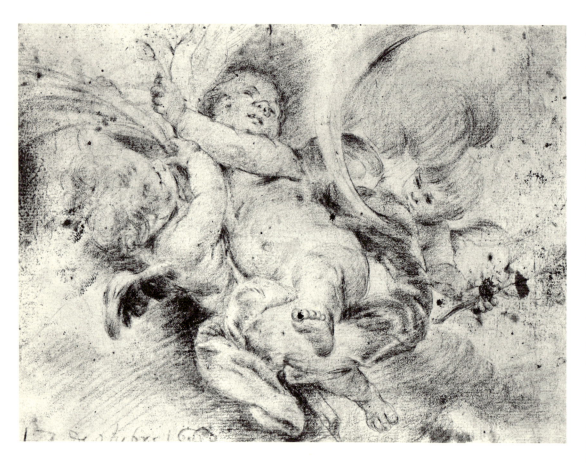

22 Putti for a Virgin of the Immaculate Conception

Hamburg, Kunsthalle 38596.

140 x 191 mm.; red and black chalk. Laid down. Dated in black chalk at lower left: *17 de otubre 1660.*

Provenance: possibly J. Rushout, 2nd Earl of Northwick, to C. Morse (Sotheby, July 4, 1873, lot 151) to Hogarth; J.A. Echevarría; B. Quaritch (vendor to Museum, 1891).

References: Mayer 1918, p. 114, fig. 7; Mayer 1920, pp. 131-32, repr.; Lafuente Ferrari 1937, p. 54 n. 3; Gradmann [1939], p. xv, no. 16, pl. 16; Gómez Sicre 1949, pl. 61.

Exhibition: Hamburg 1966, no. 165.

Although this drawing has often been published, the significance of its autograph date—October 17, 1660—has never been given full weight. There is, however, no reason to doubt either the date or the authenticity. The finished style and the characteristic combination of red chalk for flesh areas and black chalk for drapery are found in other drawings. Even the most unusual feature—the arbitrary truncations of the composition—is exactly paralleled in another study of putti (cat. 15). Hence, the sheet may be taken at face value as a work of 1660, preparatory to a Virgin of the Immaculate Conception, whose presence is implied by the crescent moon, one of the usual attributes.

A drawing in the Morse sale, described as "a highly finished study of angels, in black and red chalks, signed," and as having come from Lord Northwick's collection, may possibly have been this sheet.

23 Infant Christ Sleeping on a Cross

London, British Museum 1858-7-24-1.

94 x 138 mm.; red and black chalk. Laid down.

Provenance: Library, Seville Cathedral; A. Fitzherbert, Baron St. Helens (Sotheby, May 26, 1840, lot 127) to Rudd; purchased by Museum, 1858.

References: Trapier 1941, p. 36; Angulo 1974, p. 104.

The attribution to Murillo has been in force since the St. Helens sale, when it was described as follows: "The Infant Christ sleeping on his cross, a skull by his side; *a beautiful design.*" The appreciative phrase indicates the esteem in which these finished studies were held in the mid-nineteenth century.

The drawing is an excellent example of Murillo's highly worked chalk style. The figure is drawn primarily in red chalk, but strengthened in places with black chalk. Around the figure, black chalk has been subtly and carefully used to produce soft, filmy shadows. This concern with gentle atmospheric effects begins to appear in Murillo's paintings and drawings after 1660. In the absence of links to any known paintings, this sheet can be dated only approximately to the 1660s.

A drawing with a similar composition in the Biblioteca Nacional in Madrid (Barcia 347) is a copy.

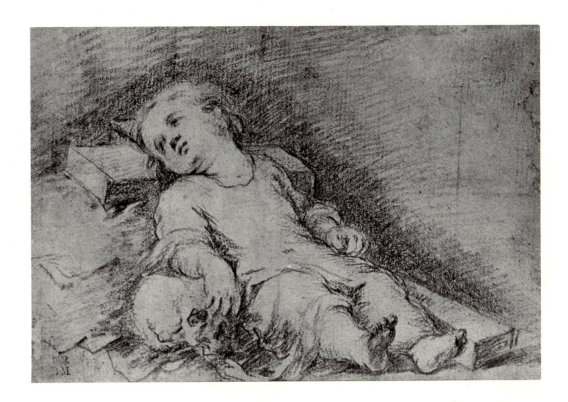

Figure 52. Murillo,
Virgin of the Immaculate Conception with Worshipers.
Paris, Musée du Louvre 1708.
Oil on canvas, 172 x 285 cm.

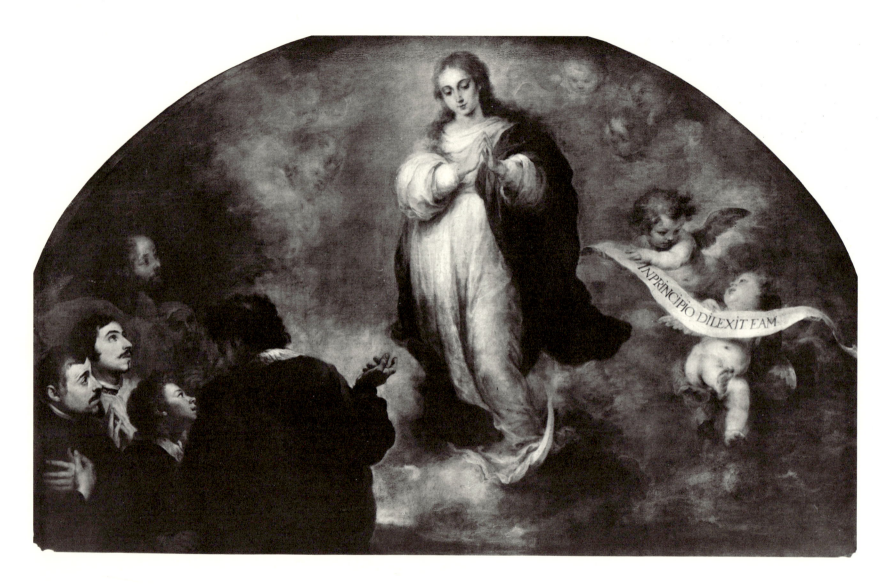

24 Virgin of the Immaculate Conception

Copenhagen, Statens Museum for Kunst, TU spansk magasin.

324 x 223 mm.; red and black chalk. Small repaired tear near head of Virgin; repaired tear along left margin. Signed in chalk at lower left corner: *Murillo f*; inscribed in brown ink at upper right corner: *18*.

Provenance: unknown.

Like cat. 25 and cat. 26, this two-colored chalk drawing is a preparatory study for a painting executed around 1665 for Santa María la Blanca. The painting, which hung originally at the head of a side aisle (see Angulo 1969, pp. 25-30) and is now in the Louvre (fig. 52), shows the Virgin of the Immaculate Conception in the center with worshipers at the left and two putti with a scroll at the right. The figure of the *Inmaculada* was transferred to the canvas with only slight changes, the most important being an elongation of the proportions and a softening of the facial features. In style, it is obviously a member of the group of finished chalk drawings that is datable around 1665 to 1670.

 For the number at the upper right, see cat. 11.

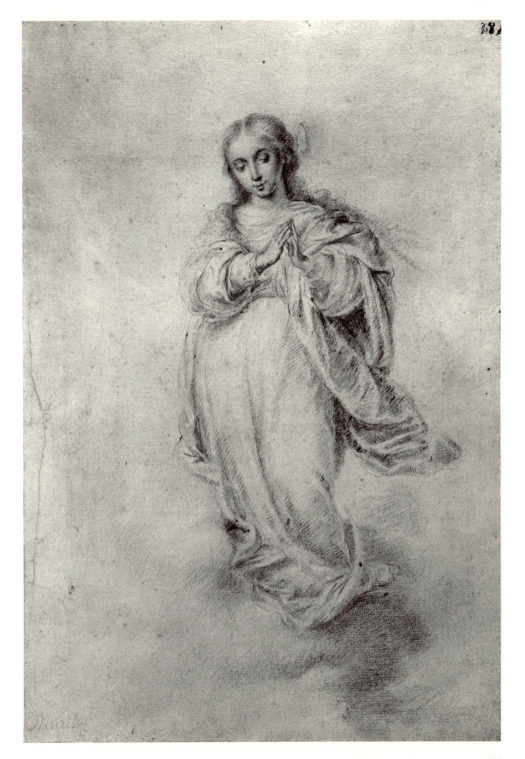

Figure 53. Murillo,
Young Saint John the Baptist with the Lamb.
London, National Gallery 176.
Oil on canvas, 165 x 106 cm.

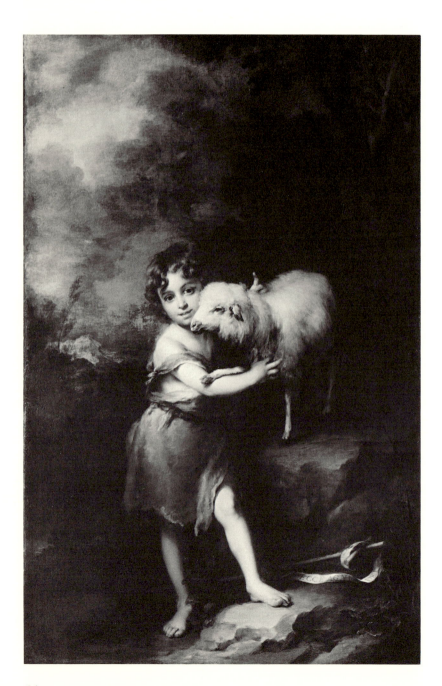

25 *Young Saint John the Baptist with the Lamb*

Norfolk, Va., Chrysler Museum 50.49.18.

305 x 216 mm.; red and black chalk. Signed in brown ink at lower left corner: $B^e. Mu^o$.

Provenance: Library, Seville Cathedral; A. Fitzherbert, Baron St. Helens (Christie, May 26, 1840, lot 132) to W. Buchanan; J. Rushout, 2nd Earl of Northwick, to C. Morse (Sotheby, July 4, 1873, lot 148) to Hogarth; A. Hert (vendor to Museum, 1950).

Exhibitions: Norfolk 1950, no. 50; "Drawings from the Collection of the Norfolk Museum," Cummer Gallery of Art, Jacksonville, Fla., August-September 1965 (no catalogue).

The catalogue of the St. Helens sale rightly described the drawing as a "sketch for Sir Simon Clarke's picture" (fig. 53; see Appendix 3, no. 132). This painting and its companion piece (fig. 54; see cat. 26) were probably executed in 1665 for an outdoor altar erected for the inaugural ceremonies of Santa María la Blanca in Seville (see Angulo 1969, pp. 40-42, for details of this commission and the problem of identifying the pictures). In the drawing, Murillo concentrated on his conception of the figure group, as he usually did in his finished chalk studies. The only significant change between the drawing and the painting occurs in the face of Saint John, which is broader and less appealing in the drawing. Indeed, the appearance of the face initially suggests that the drawing is a later copy. But the technique is identical with other members of this group of drawings.

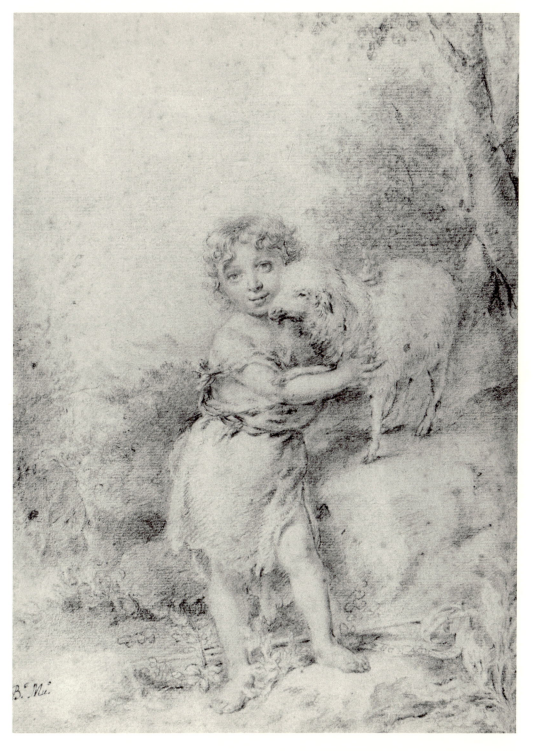

Figure 54. Murillo,
Christ Child as the Good Shepherd.
*England, collection of Charles Lane.
Oil on canvas, 152 x 109 cm.*

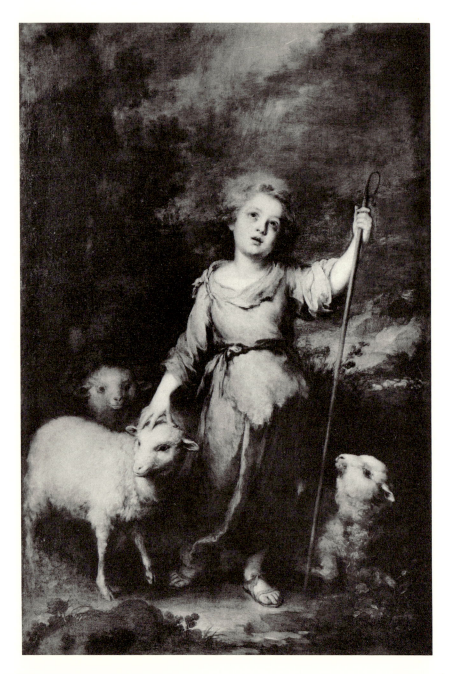

26 Christ Child as the Good Shepherd

Hamburg, Kunsthalle 38580.

309 x 212 mm.; red and black chalk. Laid down; numerous small stains; repaired loss in lower left corner.

Provenance: Library, Seville Cathedral; A. Fitzherbert, Baron St. Helens (Christie, May 26, 1840, lot 131) to W. Buchanan; possibly C.S. Bale (Christie, June 9, 1881, lot 2374) to Philpot; J.A. Echevarría; B. Quaritch (vendor to Museum, 1891).

Reference: Trapier 1966, p. 274, fig. 3.

This drawing, which forms a pair with cat. 25, was sold at the St. Helens sale as a "study for Sir Simon Clarke's picture" (fig. 54; see Appendix 3, no. 131). Trapier published the drawing in 1966 as "attributed to Murillo," but there is no doubt that it was done by him, together with cat. 25, as preparation for the altar erected in the square in front of Santa María la Blanca.

The painting presents small but interesting differences from the drawing. The configuration of trees at the left has been altered, so that only one tree is visible in the painting. The lamb's head at the lower right has been tilted upward. There is a dark area in the lower righthand corner formed by a rock, and a flock of sheep has been added in the right middle ground. These changes were effected in a small oil sketch (fig. 13; see Appendix 2, no. 6), which, however, still retains the unidealized facial type.

Figure 55. Murillo,
Saint Francis Rejecting the World and Embracing Christ.
Seville, Museo Provincial de Bellas Artes 93.
Oil on canvas, 283 x 188 cm.

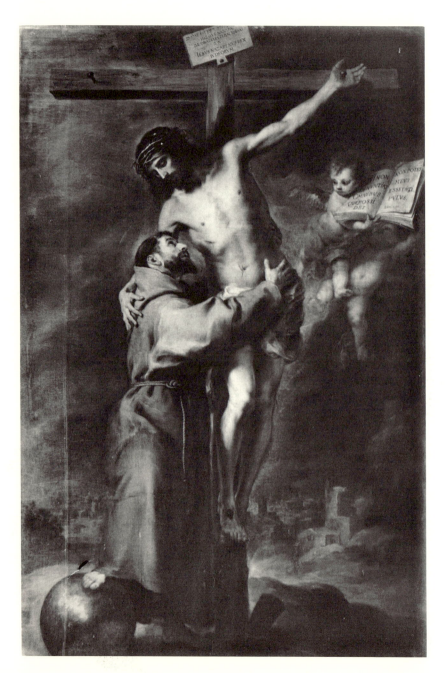

27 *Saint Francis Rejecting the World and Embracing Christ* (recto) and *Adoration of the Shepherds* (verso)

London, Courtauld Institute Galleries 4650.

339 x 226 mm. Recto: black chalk; inscribed in brown ink at lower left corner: *Murillo fc*. Verso: black chalk.

Provenance: J. Rushout, 2nd Earl of Northwick; G. Rushout, 3rd Earl of Northwick; Lady E.A. Rushout; E.G. Spencer-Churchill (Sotheby, November 1-4, 1920, lot 319); acquired by Museum, 1956.

Exhibition: *Newly Acquired Drawings* 1965-1966, no. 48.

The exhibition catalogue of 1965-1966 correctly identified the recto as a preparatory study for a painting originally in one of the side chapels of the church of the Capuchinos in Seville (fig. 55), executed in 1668 and 1669. The verso, which is unpublished, is undoubtedly the first sketch for a painting in another side chapel (fig. 56).

 The style of the recto is distinct from the other chalk drawings of the period and may appear initially to be a weak copy after the painting, or perhaps after a lost drawing by Murillo. The reason for the difference is explained by the fact that this is an underdrawing of the kind Murillo frequently made for his pen sketches. Obviously, the underdrawings were intended only as guidelines and were immediately covered by the precise work in pen. However, in a few sheets Murillo left part of the chalk underdrawing exposed, providing a basis for attributing this work. As examples, the sheep in cat. 90 and the figure in cat. 72 can be cited. These fragments show the very loose, undefined,

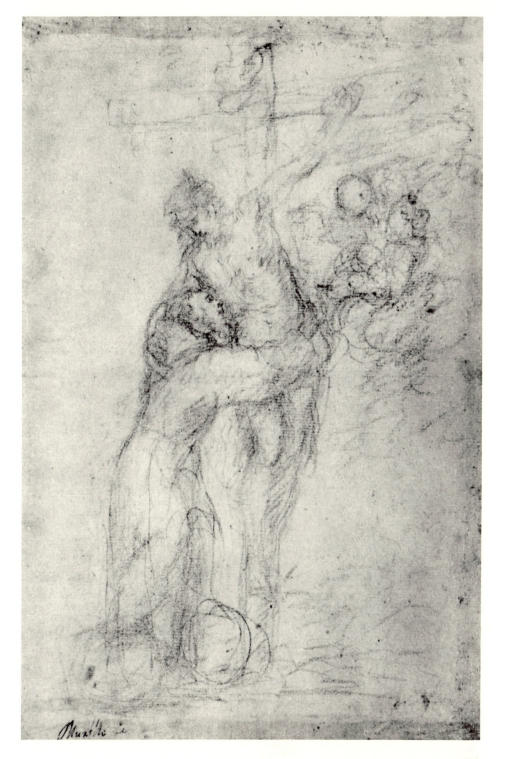

Figure 56. Murillo,
Adoration of the Shepherds.
Seville, Museo Provincial de Bellas Artes 92.
Oil on canvas, 283 x 188 cm.

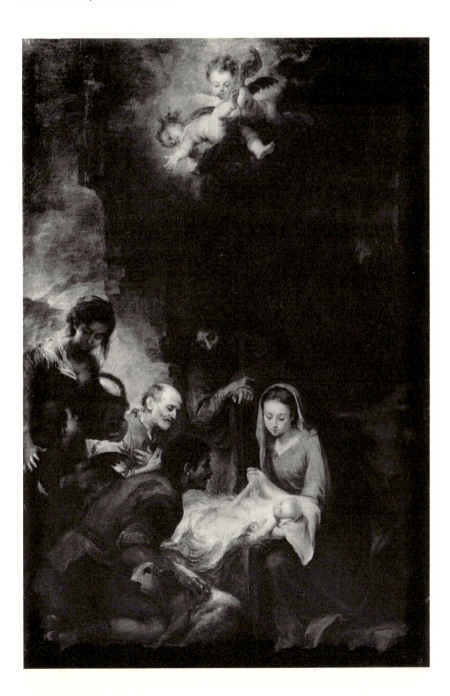

and allusive manner that was used in the under-drawing. Another close parallel is provided by the putti in a later and looser chalk drawing (cat. 58).

In addition, the drawing presents different solutions for the composition in a way that indicates a creator's, not a copyist's, mentality. For instance, the globe of the earth is placed under the saint's left foot as well as under the right. Also, the cross is shown in a diagonal as well as in a frontal position. In a subsequent drawing for the painting (cat. 28), Murillo decided between these alternative solutions and made other important changes as well.

A pen study for this composition, now lost, was sold in the St. Helens sale as lot 94. Two related oil sketches are mentioned by Curtis (1883, nos. 289 and 290).

The verso is done in an even looser style and is important for further demonstrating that Murillo made very sketchy drawings in the chalk medium. In this drawing, Murillo is, in a manner of speaking, thinking aloud; hence the rapid and tentative style. Most of the elements of the final composition are shown: the kneeling Virgin cradles the Infant's head, while Saint Joseph stands to the rear. A shepherd kneels at the far left, placing his hand on a rounded shape that will become a lamb. Just behind him, an upright figure is suggested, while at the immediate left another kneeling figure is barely rendered. The architectural background of a ruined building is depicted as a welter of scrawling lines.

Cat. 29 may possibly contain a study for the head of Saint Joseph.

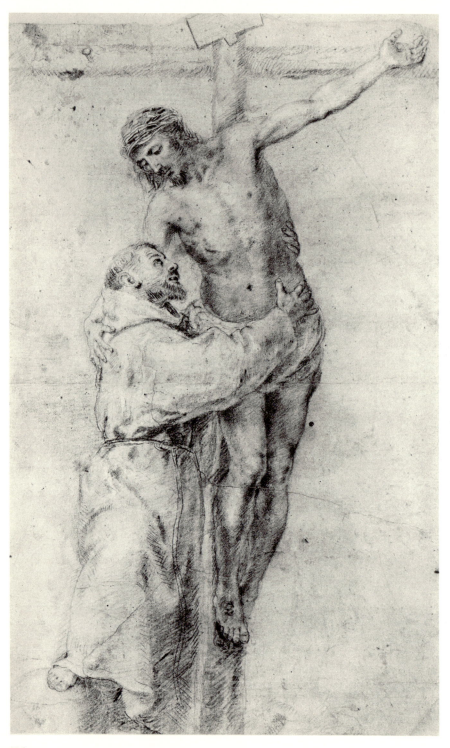

28 Saint Francis Rejecting the World and Embracing Christ

Hamburg, Kunsthalle 38597.

435 x 255 mm.; red and black chalk. Laid down; sheet is heightened at top by addition of strip 6 cm. wide; long diagonal repaired tear from right margin to shoulder of Saint Francis; small tear from globe to saint's right knee.

Provenance: J. A. Echevarría; B. Quaritch (vendor to Museum, 1891).

This large drawing, until now attributed to Murillo's school, is a later stage in the evolution of the composition first essayed in cat. 27. Here Murillo concentrated on the central figure group and arrived at the definitive solution. Saint Francis's face has been withdrawn from Christ's side, making possible an exchange of glances that heightens the emotional content. Saint Francis's gesture of renunciation is clarified by placing the right foot on the globe. These two studies for the painting of about 1668 (fig. 55) provide an excellent demonstration of Murillo's preparatory procedures.

The technique of the drawing is ambitious and chromatically complex. The body of Christ, whose pose closely resembles another *Christ on the Cross* (cat. 56), is drawn in red chalk. The torso is softly shaded with the side of the chalk, while the legs are shaded with the typical faint, narrowly spaced parallel lines. The saint's face, hands, and feet are in red chalk, his robe in black chalk over soft underdrawing in red chalk. Accents on the robe are provided by spiky lines laid over denser shadows, a technique that also appears in cat. 24, cat. 30, and cat. 31.

29 Studies of Heads

Vienna, Graphische Sammlung Albertina 13091.

230 x 336 mm.; red and black chalk. Laid down. Signed in brown ink at lower left: *Murillo f.*; inscribed in brown ink at lower right corner: *6.*

Provenance: E. G. Harzen to Archduke Charles of Saxony.

Fragmentary studies in the finished two-color chalk technique are rare in Murillo's oeuvre. However, the style of the drawing conforms perfectly to the several sheets that are known in this technique. In his usual manner, Murillo employed red chalk for the flesh areas and black chalk for the hair and beard. The small sketch at the right, which was left unfinished, shows how Murillo paid attention first to the expression and then added hair and beard afterward.

The head at the left follows a type that Murillo often chose for depictions of Saint Joseph. Given its frequent usage, it is difficult to relate the sketch definitively to any painting. The closest similarity is to the figure of Saint Joseph in the *Adoration of the Shepherds* painted for the Capuchinos of Seville in 1668 and 1669 (fig. 56), with which the drawing may be provisionally associated.

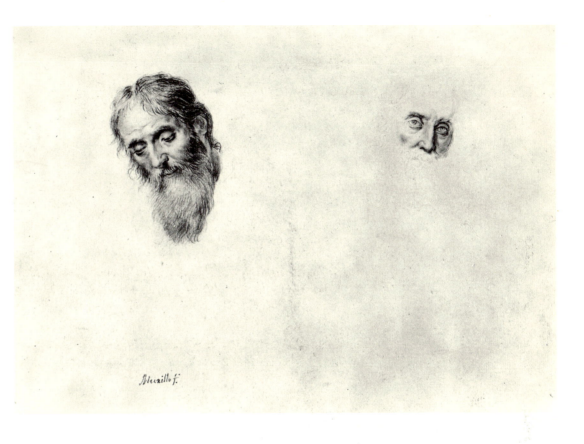

Figure 57. Murillo,
Saint Francis of Paula.
England, private collection.
Oil on canvas, 193 x 149.9 cm.

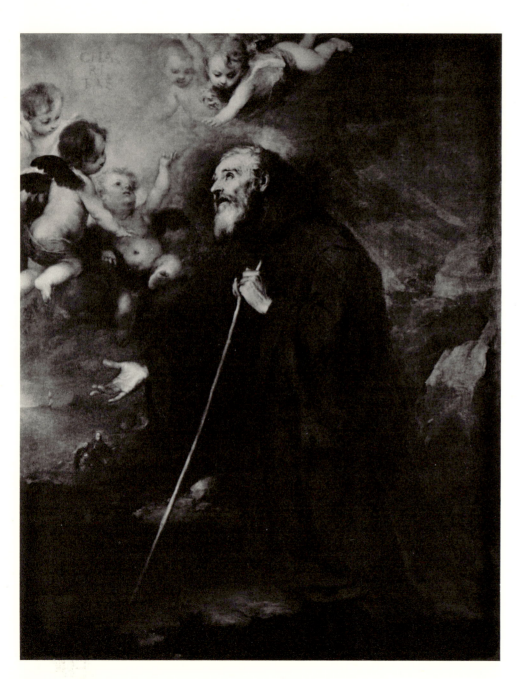

30 Saint Francis of Paula

London, British Museum 1850-7-13-2.

333 x 233 mm.; red and black chalk. Signed in brown ink at lower left: *Murillo*; inscribed at upper right: *29* or *49*.

Provenance: Graves (vendor to Museum, 1850).

This drawing is a preliminary study for a painting (fig. 57). In accordance with his usual practice, Murillo used red and black chalk to establish the definitive pose of the central figure, which appears in the painting exactly as it does here. Other parts of the composition are either omitted, such as the landscape background, or treated summarily, as are the three figures in the left background and the vegetation on the ground.

The treatment of the figure is typical of Murillo's meticulous and painstaking chalk technique. The face and hands, done in red chalk, are worked up by soft, delicate strokes, with occasional accents provided by heavier touches, as in the hair and in the beard (both in black chalk) where it meets the neck. The drapery is drawn in black chalk by means of thin parallel lines that softly fuse into areas shaded by the side of the crayon. Darker shadows are formed by small areas of heavy parallel lines and by tiny pockets of blended chalk, as at the bottom of the figure. Angulo (1961, p. 10) has dated the painting around 1670; the style of the drawing is not inconsistent with this date, but it could have been done at least as early as 1665.

For a discussion of the number in the upper right corner, see cat. 11.

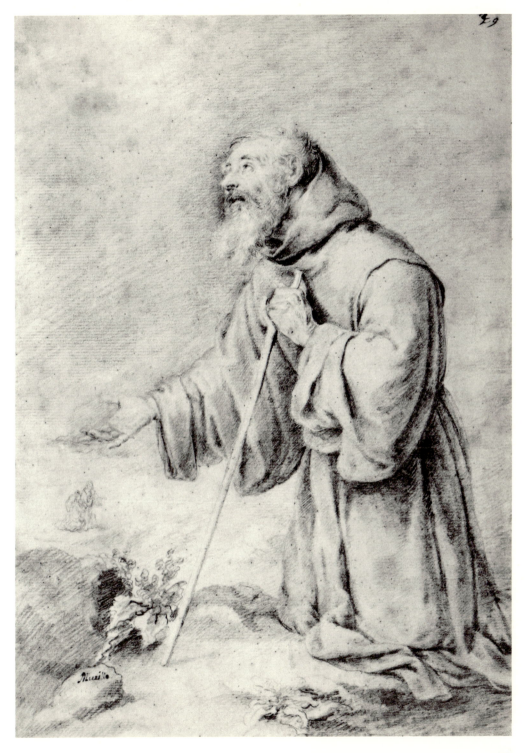

Figure 58. Murillo,
Penitent Saint Mary Magdalene.
Cologne, Wallraf-Richartz Museum 2540.
Oil on canvas, 139.5 x 118.5 cm.

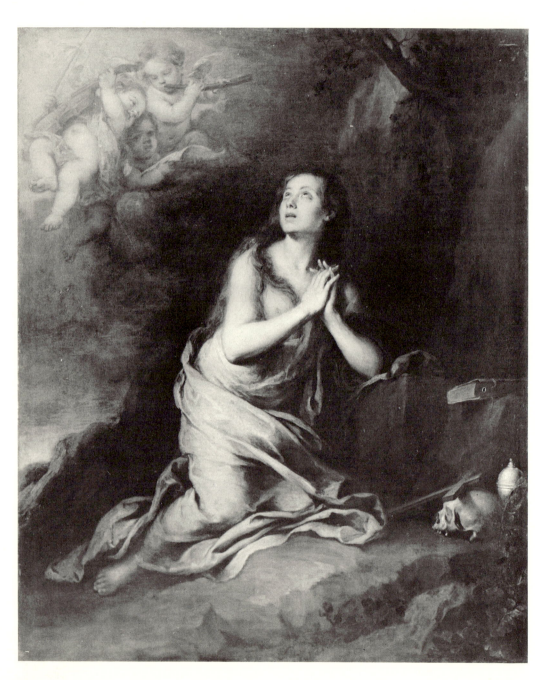

31 Penitent Saint Mary Magdalene

Madrid, private collection.

284 x 201 mm.; red and black chalk. Signed in brown ink at lower right: *Murillo f^e*.

Provenance: Library, Seville Cathedral; A. Fitzherbert, Baron St. Helens (Christie, May 26, 1840, lot 115) to W. Buchanan; J. Rushout, 2nd Earl of Northwick; C. Morse (Sotheby, July 4, 1873, lot 149) to Jervois; W. Stirling-Maxwell; Lt. Col. W. Stirling (Sotheby, October 21, 1964, lot 24) to Schidlof; Christie, March 11, 1975, lot 132; Christie, September 30, 1975, lot 115.

This superb chalk drawing, which has only recently reappeared, is a study for a painting (fig. 58). The painting is one of seven by Murillo that were in the possession of Giovanni Bielato [Violatto], a Genoese merchant who lived in Cádiz. At his death in 1674, the pictures were bequeathed to the Capuchin church in Genoa. The style of the surviving pictures in the group points to a date not far from the *terminus ante quem* established by Bielato's death. The sheet itself confirms a date around 1670 by its clear relationship to the number of finished two-color chalk drawings that can be dated from around 1665 to 1670.

A comparison of the painting with the drawing reveals a few subtle but important changes, notably the change in the figure's proportion. In the painting, the saint is taller and shown in a more upright posture. This version makes her appear as considerably more attractive. The additional height also permitted Murillo to emphasize the piece of drapery that sweeps across the Magdalene's torso, imparting greater movement and energy to the composition. The arrangement of the drapery folds on the ground is also more complex and active in the painting.

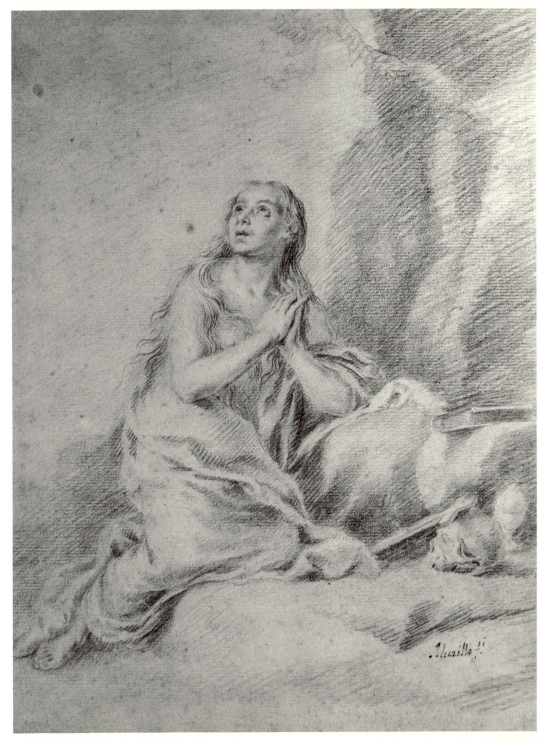

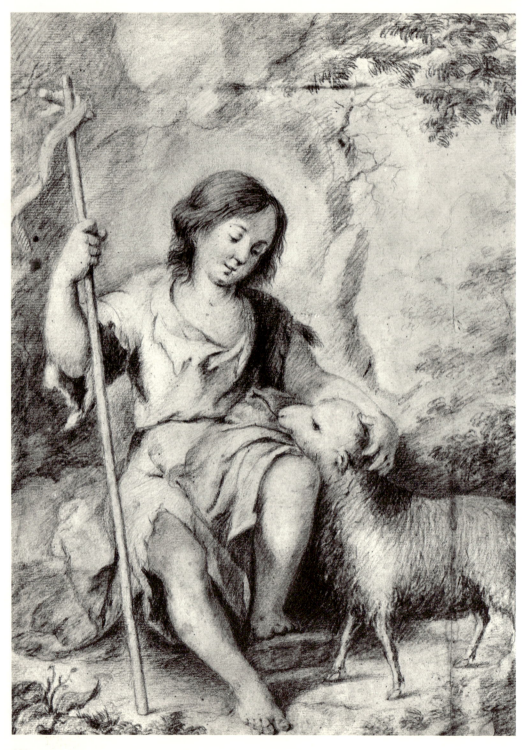

32 Young Saint John the Baptist with the Lamb, Seated in a Rocky Landscape

Hamburg, Kunsthalle 38584.

334 x 238 mm.; red and black chalk. Laid down; repaired crease in lower right corner and along top edge.

Provenance: possibly Library, Seville Cathedral; possibly A. Fitzherbert, Baron St. Helens (Christie, May 26, 1840, lot 116) to W. Buchanan; J.A. Echevarría; B. Quaritch (vendor to Museum, 1891).

Until now given to Murillo's school, this large sheet is one of the artist's most finished drawings. Both red and black chalk are used in all parts of the figure except for the drapery on the lap, which is entirely in red chalk. Although it may give the impression of a copy or school piece, the quality is superb and worthy of Murillo. His hand appears not only in the elaborate technique and masterful control of light and shadow, but also in small details such as the drawing of the right foot (compare with cat. 25 and cat. 28), the foliage (compare with cat. 25 and cat. 26), and the face of the lamb (compare with cat. 25 and cat. 26).

No related painting is known. The unusually high degree of finish, especially in the background, suggests that it may have been an independent drawing.

33 Saints Justa and Rufina

Bayonne, Musée Bonnat N.I. 1373.

211 x 156 mm.; pen and brown ink with brown wash over black chalk on brown-toned paper. Laid down; horizontal center crease; small losses in right and left margins; faded.

Provenance: L. Bonnat (Lugt 1714).

References: Sánchez Cantón 1930, vol. 5, pl. 420; Angulo 1961, p. 16.

Sánchez Cantón correctly identified this drawing as a preparatory study for the painting done in 1665 and 1666 for the high altarpiece of the Capuchinos in Seville (fig. 59). As was his usual practice, Murillo subsequently made a finished study in red and black chalk (see Appendix 3, no. 119) and finally a small oil sketch (fig. 11; see Appendix 2, no. 19). The oil sketch reveals two important changes. First, the crockery has been placed at the saints' feet, leaving only the Giralda to be held between them. Second, Saint Justa, at the left, holds a palm frond, an attribute that Murillo had considered and rejected in the drawing. The painting (fig. 59) follows the revised conception of the oil sketch, main differences being the addition of background and more pieces of earthenware in the lower right corner.

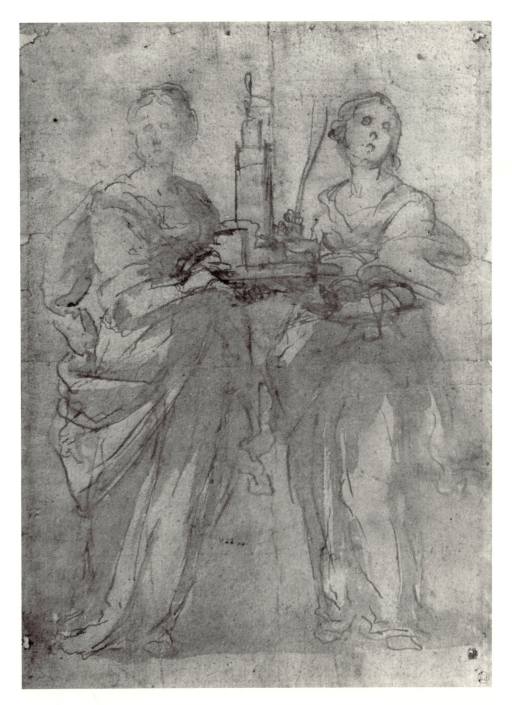

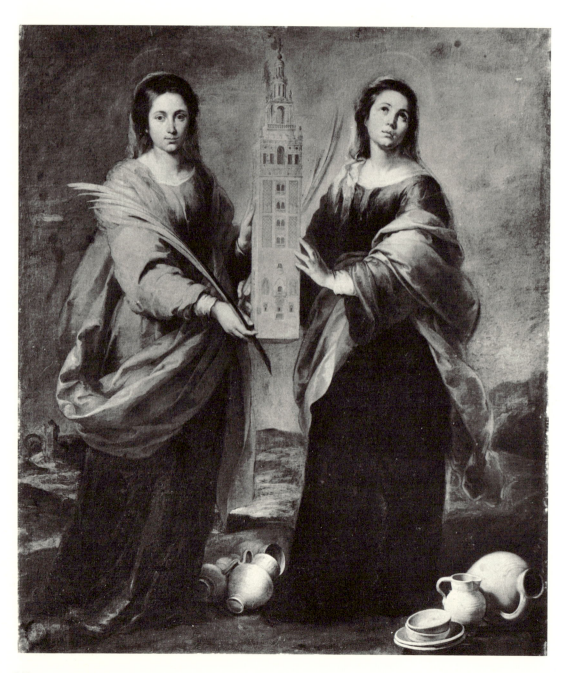

Figure 59. Murillo,
Saints Justa and Rufina.
Seville, Museo Provincial de Bellas Artes 81.
Oil on canvas, 200 x 176 cm.

34 Assumption of the Virgin

Hamburg, Kunsthalle 38570.

216 x 198 mm.; pen and brown ink with brown wash over black chalk on buff paper. Laid down. Inscribed by the Contemporary Collector in lower center margin: *Bartolome Murillo fat*.

Provenance: possibly Library, Seville Cathedral; possibly A. Fitzherbert, Baron St. Helens (Christie, May 26, 1840, lot 101) to W. Buchanan; C.S. Bale (Christie, June 9, 1881, lot 2376); J.A. Echevarría; B. Quaritch (vendor to Museum, 1891).

References: Mayer 1918, p. 112, fig. 3; Mayer 1934, repr. p. 16; Gradmann [1939], no. 15; Gómez Sicre 1949, pl. 62; Angulo 1962, pp. 234-36; Richards 1968, p. 238, fig. 4; Pérez Sánchez 1970, p. 85, pl. 28.

Exhibition: Hamburg 1966, no. 164, pl. 46.

This is the most frequently published of Murillo's drawings, and with good reason, for it is one of his best. The sense of movement through space and the play of light on the surface is communicated through the dazzling interaction of chalk, pen, and brush, and through the loose, open style of drawing. In date, it is close to *Saints Justa and Rufina* of about 1665 or 1666 (cat. 33).

Mayer and Pérez Sánchez have identified the drawing as a study for the *Assumption* in the Hermitage (Mayer 1913, pl. 167), but this is doubtful; the differences are much greater than are usually found between preliminary sketch and painting.

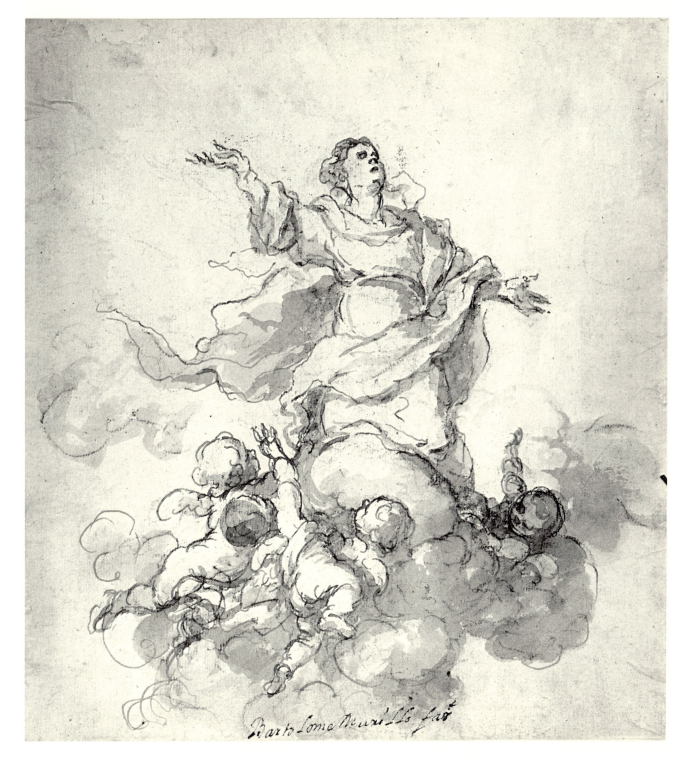

Bartolome Murillo fao[t]

113

Figure 60. Murillo,
Christ in Gethsemane.
Paris, Musée du Louvre 931.
Tempera on black marble, 36 x 28 cm.

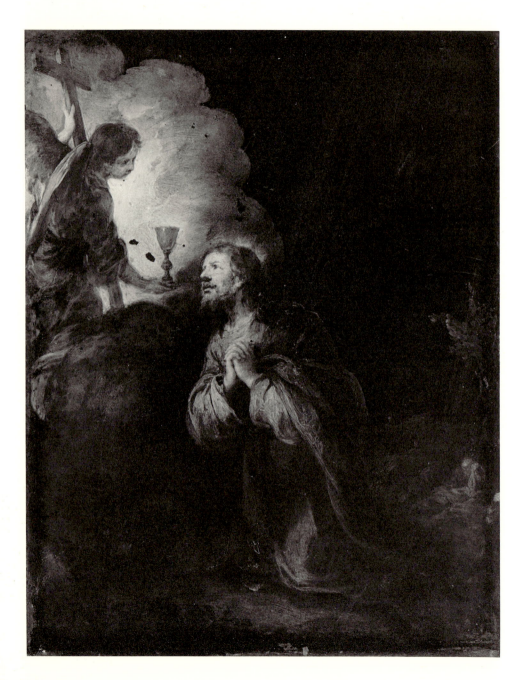

35 *Christ in Gethsemane* (recto) and *Kneeling Female Saint* (verso; not illustrated)

Madrid, Biblioteca Nacional B.348.

254 x 175 mm. Recto: pen and brown ink with light brown wash and some black chalk; lightly squared in black chalk; inscribed in pencil at lower margin: *Murillo*; illegible fragmentary inscription in pen at lower left margin. Verso: black chalk.

Provenance: V. Carderera (Lugt 432; donor to Library, 1867).

References: Barcia 1906, no. 348; Lafuente Ferrari 1937, p. 55, fig. 12.

Exhibition: Hamburg 1966, no. 169, pl. 48.

This is a typical drawing of the 1660s, the decade when Murillo's pen-and-wash drawings closely resemble the style of his paintings. The resemblance is the result of the liberal use of wash, which reproduces the soft, hazy atmosphere of the paintings. Line is used, as it is here, only to sketch the forms and to provide a loose framework for the patterns of wash. Sometimes the initial composition is quickly sketched in black chalk, although in this drawing its use is restricted to the group of three apostles under the tree at the left and to the distant view of Jerusalem. Only two datable pen-and-wash drawings from the period are known: cat. 34 and cat. 50. Both drawings were done at nearly the same time, between about 1665 and 1669, for the church of the Capuchinos in Seville, and thus are of limited value for establishing a chronology of the decade.

The grid in black chalk and the rounded frame seem to indicate that the *Christ in Gethsemane* was a preparatory study, but no large-scale picture of this subject is known. There is, however, a small painting on black marble (fig. 60) that reproduces the composition in reverse. Although the attribution has been questioned (Mayer 1913, pl. 255), it is in my view by Murillo. But the relationship between it and the drawing may be only indirect, that is to say, the painting may be a reduction of a large-scale composition.

The drawing on the verso appears to be by another hand.

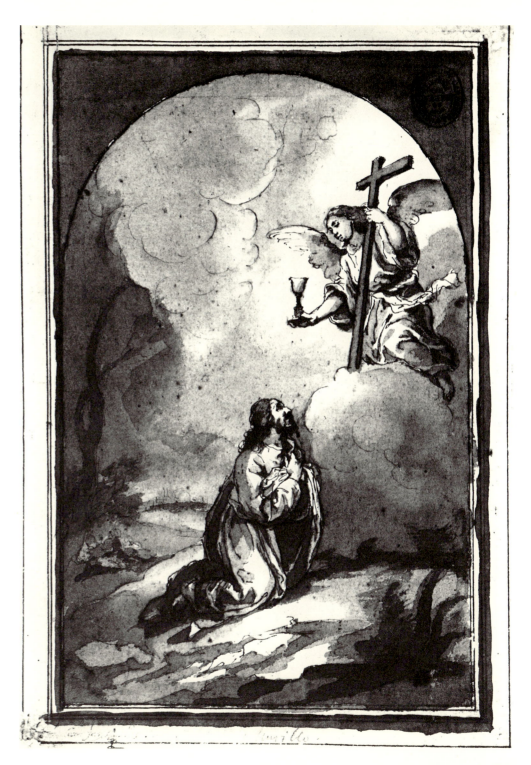

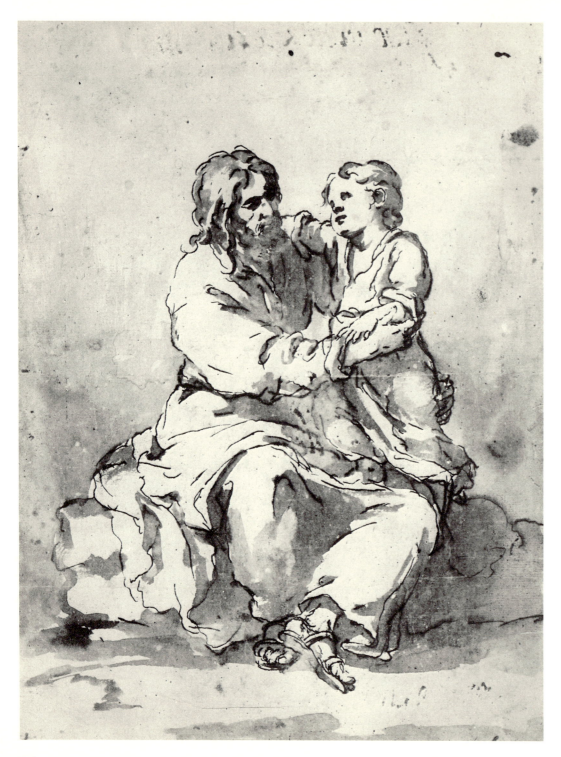

36 Saint Joseph and the Christ Child Seated

Atlanta, Ga., collection of Yvette Baer.

250 x 192 mm.; pen and brown ink with brown wash. Inscribed in pen on remains of old mount: *bartolome murillo f.*

Provenance: possibly C. Morse (Sotheby, July 4, 1873, lot 153).

Reference: Brown 1973, p. 33 n. 4.

Exhibition: Cambridge 1958, no. 12, pl. 12.

The attribution of this drawing to Murillo is virtually self-evident because of its resemblance to his characteristic later style of painting. In date, it belongs to a group that includes cat. 35-cat. 39, all of which were probably done in the later 1660s. Versions of the subject exist in painting, but none can be related to the drawing.

Two copies of this drawing are known (figs. 14 and 15). A third version of the subject was in the Louis Philippe collection (130 x 180 mm.; Paris, December 6, 1852, lot 597); its present whereabouts is unknown.

37 Saint Joseph and the Christ Child Walking

Madrid, Biblioteca Nacional B.349.

238 x 175 mm.; pen and brown ink with brown wash. Laid down.

Provenance: M. Castellano (to Library, 1880).

References: Sentenach 1896, vol. 2, pp. 28-32, repr.; Barcia 1906, no. 349; Mayer 1913, repr. p. xxi; Lafuente Ferrari 1937, pp. 55-56, fig. 13; Angulo 1975, p. 5.

The attribution of this typical pen-and-wash drawing is well established. Its date cannot be far from that of *Saints Justa and Rufina* (cat. 33), about 1665, although it is not as spirited a drawing. A comparison with a later version of the subject (cat. 68), which is looser and not as vigorous, also points to a date in the 1660s.

If this is so, then Mayer's assertion that the drawing is a preparatory study for the painting in the church of the Capuchinos in Cádiz, done around 1680, cannot be correct. The pose of the Child in the painting (which was executed by an assistant) is close to the drawing, but Saint Joseph is walking in the opposite direction. Furthermore, the Holy Dove and the seraphim are not found in the drawing.

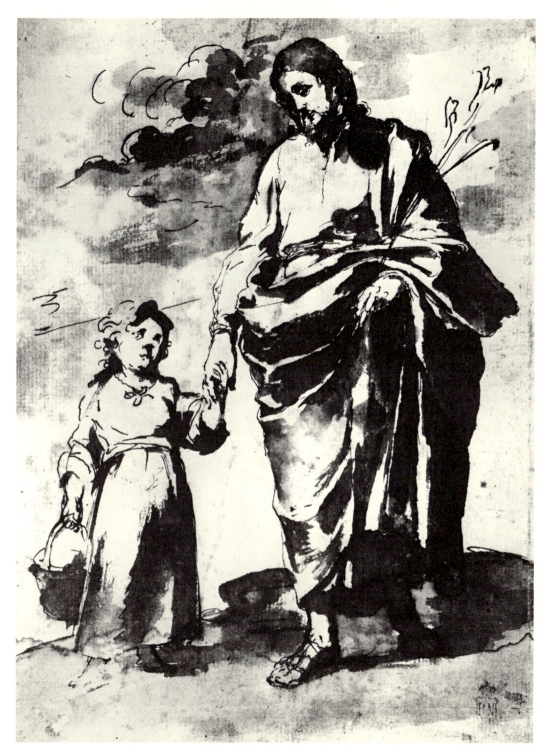

38 Virgin of the Immaculate Conception

New York, William H. Schab Gallery.

298 x 197 mm.; pen and light brown ink with light brown wash, over some black chalk. Horizontal crease; small repaired losses in clouds at lower right. Inscribed and dated in brown ink at lower left: *Bartolome Murillo 1664.*

Provenance: W. Mayor (Lugt 2799); Lord Nathan Rothschild; Eva, Countess of Rosebery (Sotheby, November 21, 1974).

References: Curtis 1883. no. 29; Angulo 1962, pp. 231-33; Brown 1973, p. 33 n. 4; Angulo 1974, p. 98 n. 3; U. of Kansas 1974, p. 53.

Exhibition: Grosvenor Gallery 1877, no. 1143.

This drawing is one of three with virtually the same composition (see also cat. 54 and U. of Kansas 1974, fig. 2 [Hispanic Society]). In recent years, there have been different opinions about their authenticity. Angulo in 1962 accepted cat. 38 as the original and classified the other two as copies. In 1973, I rejected the authenticity of cat. 38 and the Hispanic Society version, and considered only cat. 54 as original. In 1974, Smith (U. of Kansas 1974) published the Hispanic Society drawing, describing it as "among the artist's finest creations." Finally, in that same year, Angulo tentatively reversed his earlier judgment and accepted the Hispanic Society sheet, while rejecting cat. 38.

The confusion has arisen because Murillo virtually never repeated a composition in his drawings. Hence, the logical assumption is that only one of these three drawings can be authentic, especially because copies of his drawings by other hands are common. After reconsidering the problem, I now believe that both cat. 38 and cat. 54

were done by Murillo. I still regard the Hispanic Society drawing as a weak copy of cat. 38.

The relationship between cat. 38 and the Hispanic Society drawing is clear. The latter sheet is an exact repetition of cat. 38. Moreover, it attempts to copy the original line-for-line and shadow-for-shadow. The copyist's desire for complete fidelity in the end betrays him. His lines are weak and lifeless, the billowing drapery at the left is flat and unarticulated, and the lines and wash fail to produce a sense of relief in the folds. Or, to take another passage, the putto second from the left is a doughy, misdrawn creature. Also, the Virgin's hands are misshapen; their foreshortening is unconvincing. Everywhere the lines are without energy, the washes flat.

The relationship between cat. 38 and cat. 54 is more complex. In 1962, Angulo published a painting of the *Virgin of the Immaculate Conception* that reflects a lost original by Murillo to which these drawings are closely related. There are some minor differences between this painting and the drawings; for instance, the crescent moon points downward in the painting and the halo of stars is present only in cat. 38. Then there is one substantial difference: in the painting, the putti at the far left and far right hold attributes in their hands. They are omitted in cat. 38, but present in cat. 54. It is difficult to evaluate this fact. Does the absence of attributes in cat. 38 imply the work of a copyist who, by failing to observe these details, rendered meaningless the poses of the putti? Or does the presence of the attributes in cat. 54 indicate that it was done by a faithful copyist who, unlike the artist-creator, needed to put in everything he saw before his eyes? Perhaps the best way to resolve the question is to see whether the styles of these two drawings are compatible with other drawings by Murillo.

The style of cat. 38 appears to be convincing. Through the use of subtly differentiated washes, the shapes and shadows come alive. The play of light and shadow on the Virgin's drapery, for example, is masterful and helps to impart a sense of volume to both the mantle and the figure beneath it. The putti are confidently drawn, their firmly modeled bodies churning in movement.

Curtis associated this drawing with the so-called *Soult Inmaculada* in the Prado, but there is no connection. Angulo (1962) mistakenly believed that Curtis thought that cat. 38 was an oil sketch. Curtis simply used the term "a study." Otherwise his description conforms to this drawing.

The signature in the lower left corner somewhat resembles Murillo's handwriting, but is not close enough to permit a positive identification. The date, however, is plausible.

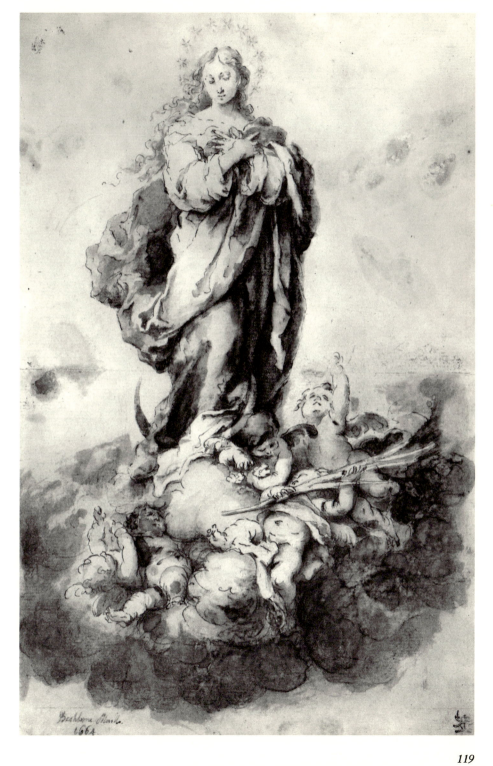

Bethlema Charil.
1664

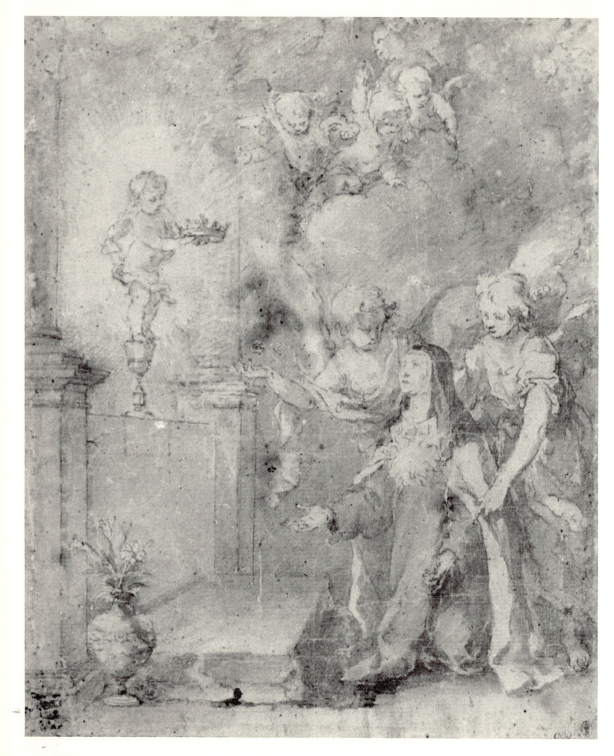

39 Vision of Saint Clare

Paris, Cabinet des Dessins, Musée du Louvre
ML 1100.

236 x 198 mm.; pen and brown ink with brown
wash over red and black chalk on brown-toned
paper. Numerous creases and small repaired tears;
unrepaired tear on saint's left arm; rubbed.

Provenance: J. I. de Espinosa y Tello de Guzmán,
3rd Conde del Aguila; J. Williams; F. H. Standish;
Louis Philippe (Paris, December 6, 1852, lot 599);
J. Boilly (Paris, March 19-20, 1868, lot 58) to
Museum.

References: *Catalogue . . . de la Collection
Standish* 1842, no. 432; Stirling-Maxwell 1848,
vol. 3, p. 1446; *Dessins du Musée du Louvre*
[1890s], no. 348; Rouchès 1939, no. 7, pl. 7;
Mirimonde 1963, pp. 278-79, fig. 16.

The traditional attribution of this drawing to
Murillo has never been questioned. Clearly, it is a
typical work of the 1660s and is closely related to
the numerous drawings in the "pictorial" style.
The angels, in particular, can be compared to the
ten drawings that compose the series of Angels
with the Instruments of the Passion (cat. 40-cat.
49).

 The subject was consistently identified as a
Vision of Saint Theresa until 1963, when
Mirimonde showed that it depicted the Vision of
Saint Clare.

40 Angel with Cross

Paris, Cabinet des Dessins, Musée du Louvre 18.437.

217 x 144 mm.; pen and brown ink with brown wash and white highlights over red and black chalk; borderline in red chalk. Small repaired loss in left forearm; slight abrasion on face. Inscribed in brown ink at lower right corner: *B. Morillo f.*

Provenance: J. I. de Espinosa y Tello de Guzmán, 3rd Conde del Aguila; J. Williams; F. H. Standish; Louis Philippe (Paris, December 6, 1852, lot 607) to Museum.

References: *Catalogue . . . de la Collection Standish* 1842, no. 441; Stirling-Maxwell 1848, vol. 3, p. 1447; Angulo 1974, pp. 98-99.

This sheet belongs to a unique series of ten drawings representing Angels with the Instruments of the Passion (for the others, see cat. 41-cat. 49). All are enclosed by a border in brown ink or red chalk, a formal device suggesting that the drawings were conceived as an independent series without the intention of producing a group of paintings. The medium is pen and brown ink with brown wash over red and/or black chalk. Each drawing is inscribed in brown ink in the lower right corner: *B. Morillo f.* Nine of the drawings have remained together and are in the Louvre. Their height varies between 197 and 220 mm.; their width, between 135 and 152 mm. The tenth drawing, the *Angel with Veronica's Veil* (cat. 43), is somewhat smaller, measuring 170 x 132 mm. But the top margin has obviously been trimmed, because the angel's head touches the upper edge of the paper. The technique, scale of the figure, and width of the sheet are entirely comparable, and it has the

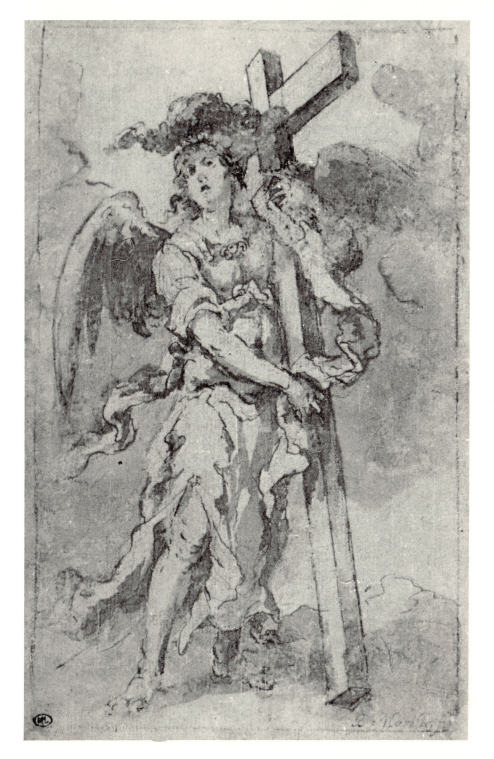

same inscription in the lower right corner. This inscription is found also on a drawing of the *Assumption of the Virgin* (cat. 57).

Angulo has dated the series to the late 1640s. However, it is clearly in Murillo's "pictorial" wash style and thus was done in the 1660s. Copies of five of the drawings, executed by the same hand, are known, suggesting that the series was once duplicated by a follower.

This sheet is the masterpiece of the series, despite its somewhat damaged appearance. It is the only drawing in which an angel wears a helmet and may have been intended to serve as the *tête de série*.

For a discussion of the iconography, see M. Weil, *The History and Decoration of the Ponte S. Angelo*, Pennsylvania State University Press, University Park, 1974, pp. 94-103.

41 Angel with Column and Scourge

Paris, Cabinet des Dessins, Musée du Louvre 18.430.

220 x 135 mm.; pen and brown ink with brown wash over black chalk on brown-toned paper; borderline in red chalk. Inscribed in brown ink at lower right corner: *B. Morillo f.*

Provenance: see cat. 40.

References: see cat. 40.

A copy is in a private collection in London.

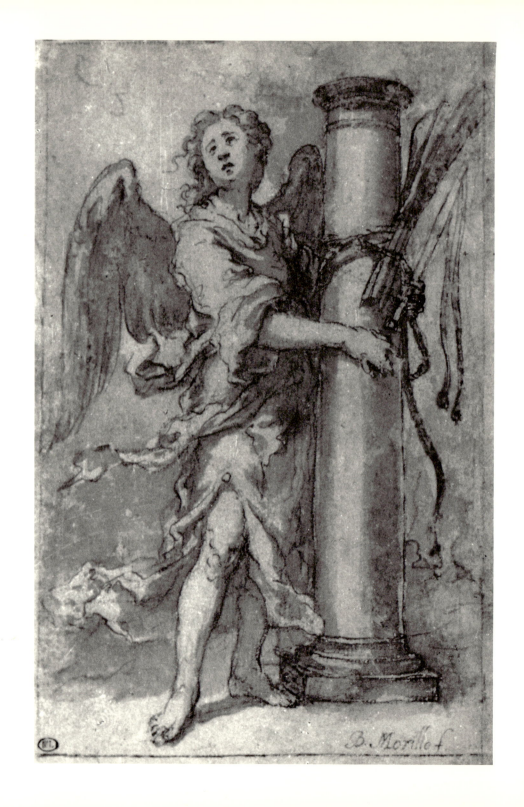

42 Angel with Hammer and Nails

Paris, Cabinet des Dessins, Musée du Louvre
18.433.

205 x 139 mm.; pen and brown ink with brown
wash over red and black chalk; borderline in red
chalk. Inscribed in brown ink at lower right
corner: *B. Morillo f.*

Provenance: see cat. 40.

References: see cat. 40.

A copy, formerly in the St. Helens collection (see
Appendix 3, no. 96), is now in the Public Library,
Museum and Art Gallery in Folkestone (42).

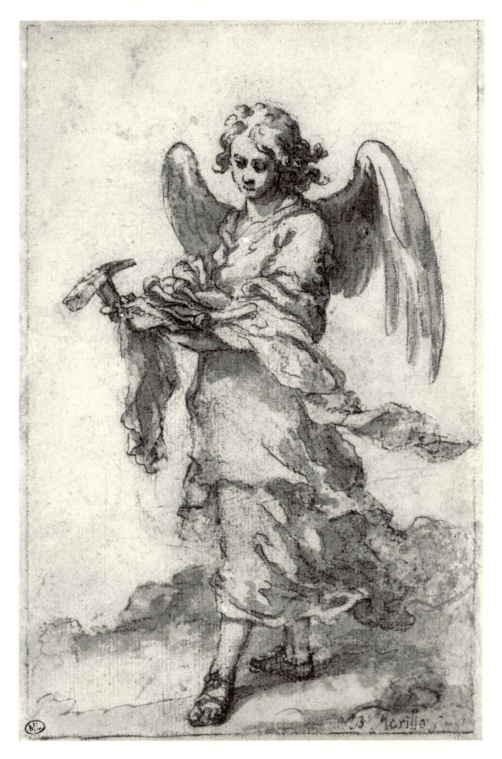

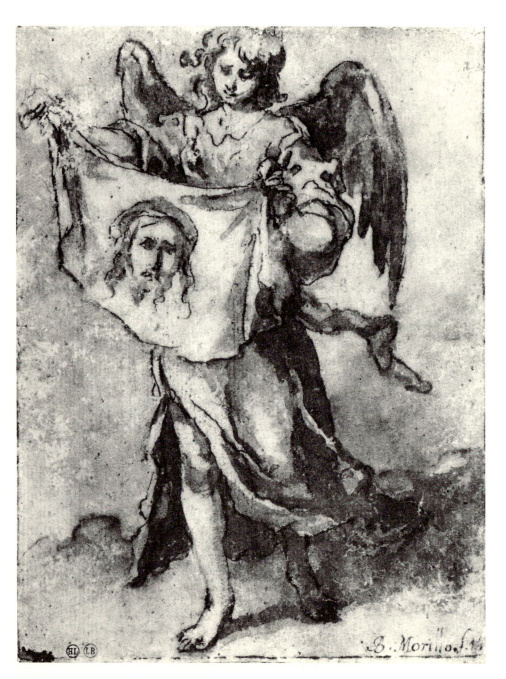

43 Angel with Veronica's Veil

Bayonne, Musée Bonnat N.I. 1374.

170 x 132 mm.; pen and brown ink with brown wash over traces of black chalk on brown-toned paper. Laid down; badly rubbed along left margin, lower right margin, and angel's right hand. Inscribed in brown ink at lower right corner: *B. Morillo f.* and *14*(?).

Provenance: see cat. 40 to Louis Philippe sale; then A. C. H. His de la Salle (Lugt 1332); L. Bonnat (Lugt 1714).

References: see cat. 40 and Hamburg 1966, no. 171.

A copy is in Hamburg (Kunsthalle 38626).

44 Angel with Banner

Paris, Cabinet des Dessins, Musée du Louvre 18.434.

220 x 144 mm.; pen and brown ink with brown wash over black chalk; borderline in brown ink. Inscribed in brown ink at lower right corner: *B. Morillo f.*

Provenance: see cat. 40.

References: see cat. 40.

45 Angel with Lantern and Ear of Malchus

Paris, Cabinet des Dessins, Musée du Louvre 18.435.

216 x 142 mm.; pen and brown ink with brown wash over black chalk; borderline in brown ink. Inscribed in brown ink at lower right corner: *B. Morillo f.*

Provenance: see cat. 40.

References: see cat. 40 and Angulo 1974, fig. 3.

A copy was on the English art market in 1971.

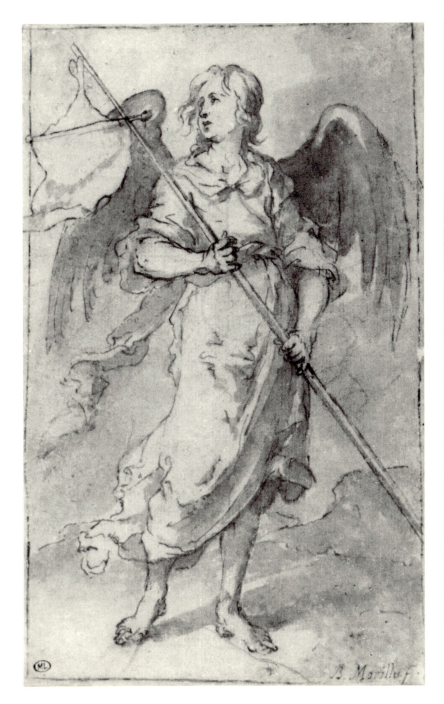 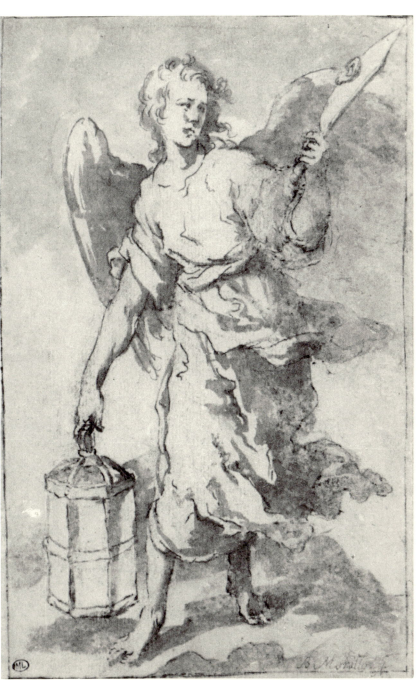

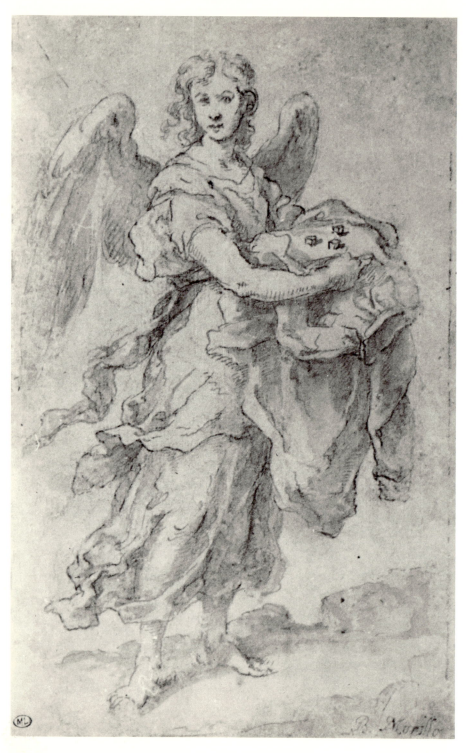

46 Angel with Dice and Garments

Paris, Cabinet des Dessins, Musée du Louvre 18.431.

215 x 140 mm.; pen and brown ink with brown wash over black chalk on brown-toned paper; faint borderline in brown ink. Inscribed in brown ink at lower right corner: *B. Morillo f.*

Provenance: see cat. 40.

References: see cat. 40 and Angulo 1974, fig. 1.

This drawing is one of two in the series in which short parallel pen strokes are used for interior shading.

47 Angel with Lance and Sponge

Paris, Cabinet des Dessins, Musée du Louvre 18.432.

216 x 152 mm.; pen and brown ink with brown wash over red and black chalk on brown-toned paper; faint borderline in red chalk. Inscribed in brown ink at lower right corner: *B. Morillo f.*

Provenance: see cat. 40.

References: see cat. 40.

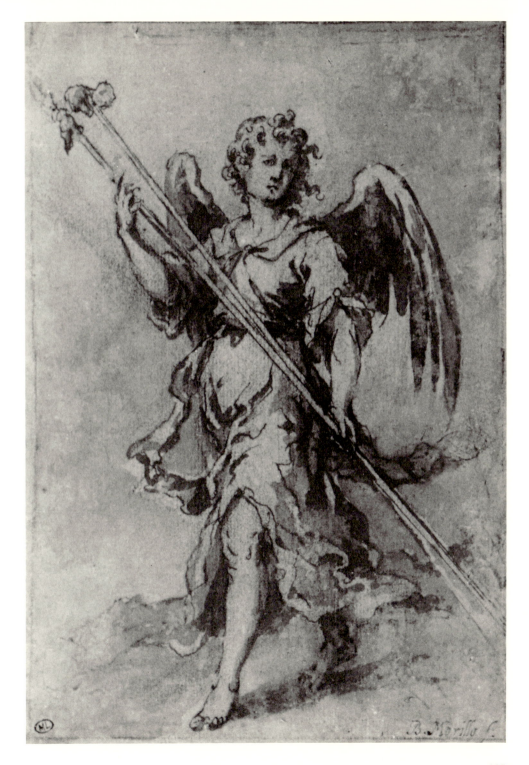

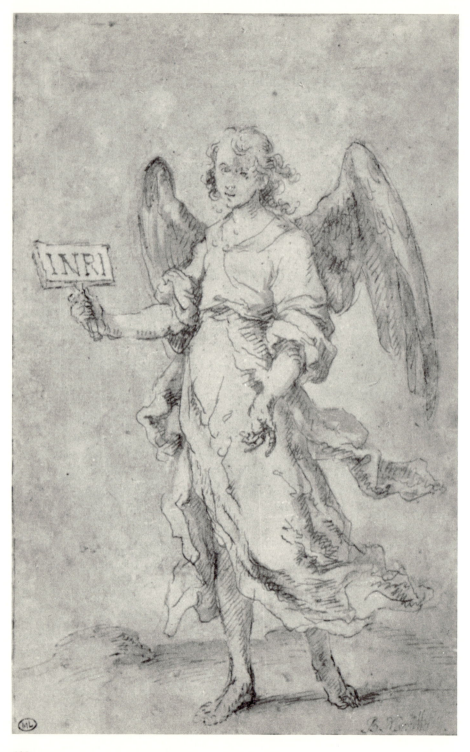

48 Angel with Superscription

Paris, Cabinet des Dessins, Musée du Louvre 18.436.

219 x 144 mm.; pen and brown ink with brown wash over black chalk on brown-toned paper; borderline in brown ink. Slight abrasions on face. Inscribed in brown ink at lower right corner: *B. Morillo f.*

Provenance: see cat. 40.

References: see cat. 40.

Unlike all but one other drawing in the series, this sheet is carried out in Murillo's "scratchy" style, in which internal modeling is done with short parallel pen strokes.

A copy from the St. Helens collection (see Appendix 3, no. 96) is in the Public Library, Museum and Art Gallery in Folkestone.

49 *Angel with Crown of Thorns*

Paris, Cabinet des Dessins, Musée du Louvre
18.438.

197 x 138 mm.; pen and brown ink with brown
wash over black chalk on brown-toned paper; bor-
derline in brown ink. Abrasions in face; numerous
small repaired losses in lower part of figure. In-
scribed in brown ink at lower right corner: *B.
Morillo f.*

Provenance: see cat. 40.

References: see cat. 40 and Angulo 1974, fig. 2.

Angulo noted the copy in the Hamburger
Kunsthalle (38631; 195 x 136 mm.) and another
sold at Weinmuller in Munich, March 9-10, 1939
(lot 336, pl. 30; 225 x 160 mm.).

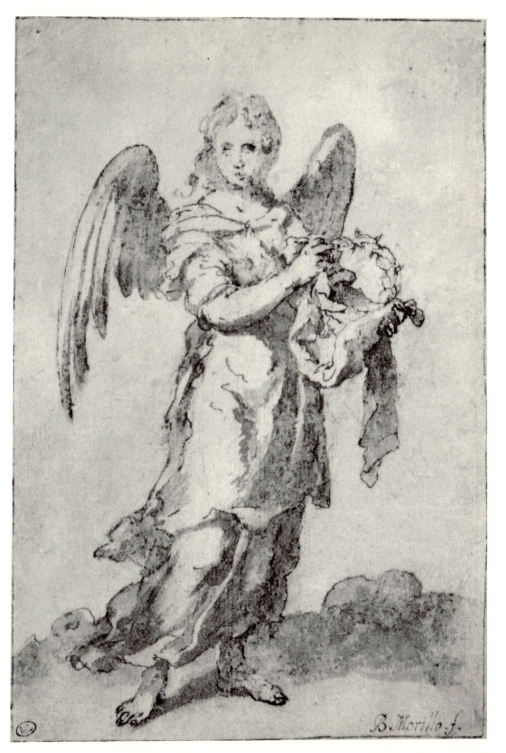

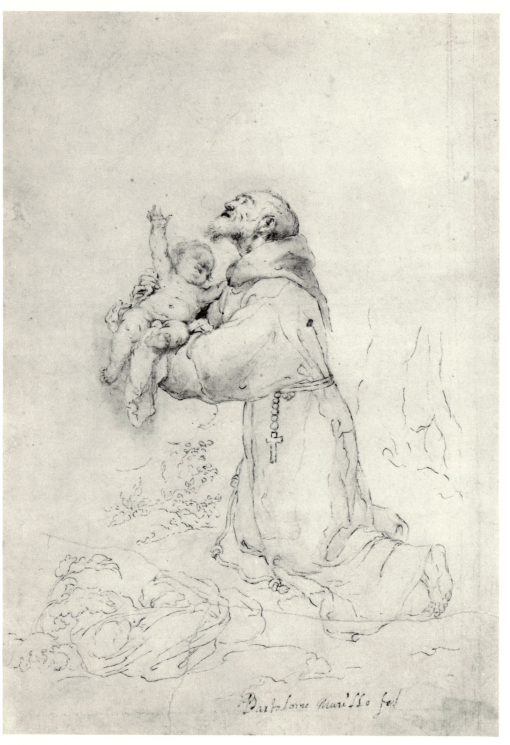

Bartolome Murillo fet

50 Vision of Saint Felix of Cantalice

New York, Pierpont Morgan Library I 110.

330 x 232 mm.; pen and brown ink with brown and white wash over black chalk. Fork-shaped repaired tear in lower quarter. Inscribed by the Contemporary Collector in brown ink at lower margin: *Bartolome Murillo fet.*; cross in black chalk at upper left corner.

Provenance: G. Reid; C. F. Murray to J. P. Morgan, 1910.

References: Murray 1905-12, vol. 1, no. 110; Lafuente Ferrari 1937, pp. 54-55, fig. 11; Trapier 1941, p. 35, fig. 25; Gómez Sicre 1949, pl. 67; Angulo 1961, p. 16; Brown 1973, p. 33, fig. 7.

Exhibitions: Hartford 1960, no. 79, pl. 9; Wichita 1967-68, no. 42, repr. p. 87; U. of Kansas 1974, no. 31, pl. 31.

This well-known drawing has long been recognized as a preparatory study for a painting once in a side altar in the church of the Capuchinos in Seville (fig. 61). The picture was executed in 1668 and 1669 (see Valencina 1908, pp. 26-39).

Smith (U. of Kansas, pp. 54-55) argues that the drawing was done after, rather than before, the painting. Her case rests on two observations: that the loaf of bread enfolded in the cloth in the lower left and the inchoate tree trunk at the right are not legible without reference to the painting, and that the light falling from the Virgin onto the head of Saint Felix is represented in the drawing, although the Virgin is not depicted. This argument assumes that Murillo made only one study for the picture, whereas it was not uncommon for him to make at least two or three. One method of preliminary study involved an initial sketch of the entire composition followed by separate elaboration of the component parts. In the partial studies, Murillo usually concentrated on a figure or figure group,

Figure 61. Murillo,
Vision of Saint Felix of Cantalice.
Seville, Museo Provincial de Bellas Artes 89.
Oil on canvas, 283 x 188 cm.

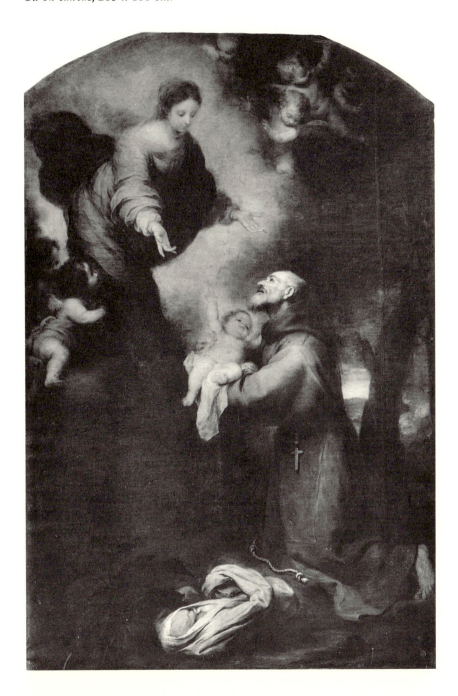

omitting the other parts of the composition. This procedure has been followed here and explains why minor details are summarily rendered. The lighting system would have been established also in an earlier stage, making it possible for the artist to employ it here without showing the source. Finally, drawings by Murillo after his paintings are rare; only one is known (cat. 14) and it reproduces the entire composition. Though the evidence is slight, it does indicate that Murillo was not in the habit of making drawn copies after his pictures.

In technique, the drawing shows more detailed pen work than the preceding pen-and-wash drawings of the 1660s. Saint Felix's head, face, and neck have been defined with short lines and flicks. For other drawings in this manner, see cat. 51-cat. 55.

The cross in black chalk at the upper left is discussed under cat. 11.

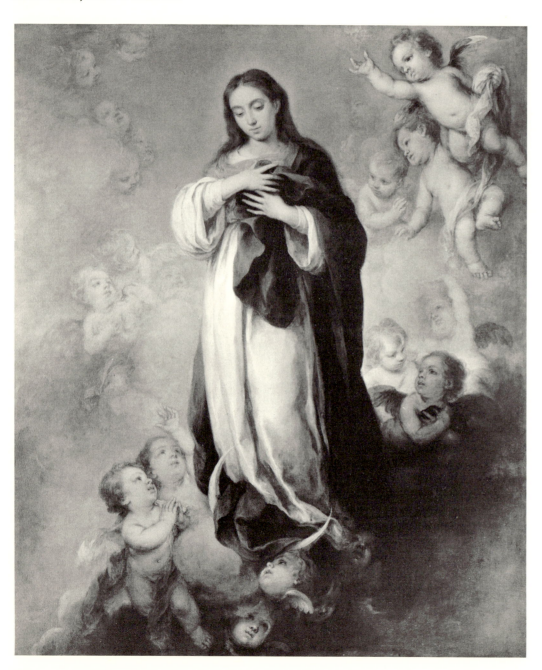

Figure 62. Murillo,
Virgin of the Immaculate Conception.
*Kansas City, Mo., William Rockhill Nelson Gallery
and Atkins Museum of Fine Arts 30-32.
Oil on canvas, 136.5 x 116.8 cm.*

51 *Virgin of the Immaculate Conception*

Paris, collection of H. E. Ambassador A. G. Leventis.

318 x 222 mm.; pen and brown ink with brown wash on brown-toned paper. Signed in brown ink at lower left corner: *Bartolome Murillo f^e*.; inscribed at upper right corner: *46*; cross in black chalk at upper left corner.

Provenance: C. F. Murray; M. de Inclán; H. Flaaten; anonymous (Sotheby, December 10, 1968, lot 44) to Colnaghi; P. G. Palumbo (Christie, March 19, 1975, lot 140, pl. 22).

Reference: Crombie 1969, p. 470.

Exhibition: Colnaghi 1969, no. 14.

Crombie noted that the drawing is a preparatory study for a painting (fig. 62). This picture, formerly in the collection of Lord Lansdowne, was given to the church of the Capuchinos by Giovanni Bielato in 1674. On the basis of style, it could not have been painted too much before that date.

The technique differs somewhat from other pen-and-wash drawings of the 1660s. Murillo made, in effect, a complete drawing in pen and ink, using the characteristic manner of hatching and cross-hatching known from earlier works. Then he added brown wash with more restraint than is usual in these drawings. Sheets having this technique include cat. 50-cat. 55.

The number written at the upper right indicates a provenance from a sketchbook; for discussion of this and of the cross in black chalk at the upper left corner, see cat. 11.

A copy by a follower was with Colnaghi in August 1937. It bears the unidentified collector's mark *G.F.* (Lugt 1151) in the lower right corner.

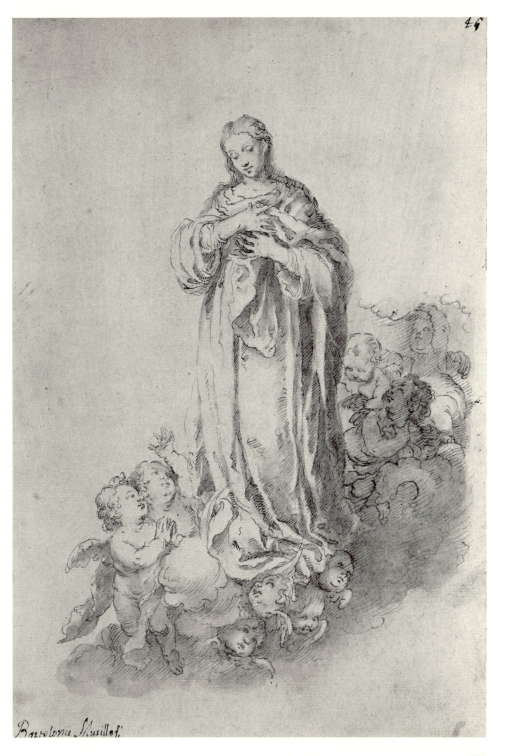

Bartolome Murillo

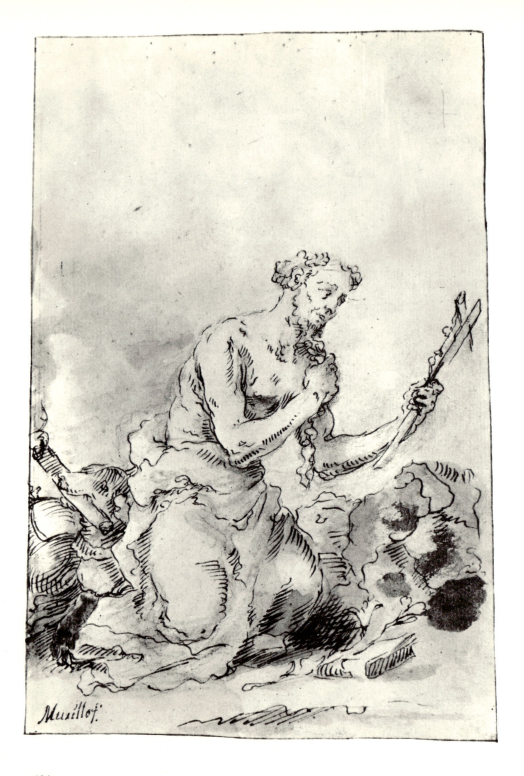

52 Penitent Saint Dominic

Vienna, Graphische Sammlung Albertina 13090.

225 x 150 mm.; pen and brown ink with brown wash over black chalk; borderline in brown ink. Laid down. Signed in brown ink at lower left corner: *Murillo fe*.; cross in black chalk at upper right corner.

Provenance: E. G. Harzen to Archduke Charles of Saxony.

This is an exemplary work of Murillo's "scratchy" style, in which modeling is carried out through numerous short parallel pen strokes. Drawings in this manner include cat. 51-cat. 55 and, to a lesser degree, the head of Saint Felix of Cantalice in cat. 50. Some of the sheets in the series of Angels with the Instruments of the Passion also exhibit the same characteristic.

The saint may be identified as Saint Dominic on the basis of the attributes that surround him, including the dog with the torch in his mouth and the book and lily. Representations of Saint Dominic as a penitent are unusual.

The cross in black chalk at the upper right is discussed under cat. 11.

53 Christ Carrying the Cross

Hamburg, Kunsthalle 38573.

277 x 191 mm.; pen and brown ink with rose wash over red chalk. Laid down. Inscribed in brown ink at lower left: *Murillo 1660.*

Provenance: possibly F. H. Standish; Louis Philippe (Paris, December 6, 1652, lot 601); J. A. Echevarría; B. Quaritch (vendor to Museum, 1891).

Reference: *Catalogue . . . de la Collection Standish* 1842, no. 434.

This belongs to a group of drawings that appears to have been done in the 1660s. Their technique differs, however, from the so-called pictorial style, in which wash is used freely to achieve the softer effects found in paintings of the period. In these drawings (cat. 50-cat. 55), shadows are supplied by short, energetic hatching and cross-hatching, and then heightened by wash. The technique is a development of Murillo's earliest pen style, but differs from drawings of the 1640s and 1650s because the lines are shorter and choppier, thus producing a somewhat rougher appearance.

The name and date do not seem to be autographic.

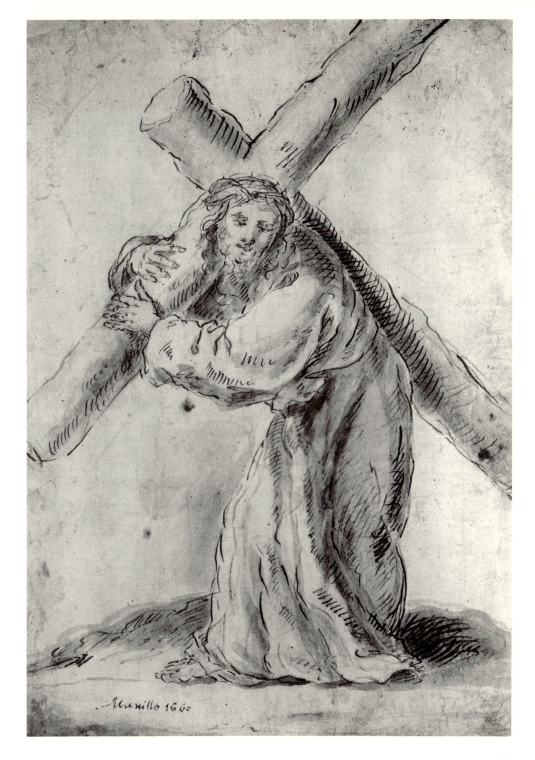

54 Virgin of the Immaculate Conception

New York, Pierpont Morgan Library I 111.

334 x 230 mm.; pen and brown ink with brown wash. Signed in brown ink at lower left corner: *Murillo fe.*; inscribed at upper right corner: *116*; cross in black chalk at upper left corner.

Provenance: R. S. Holford (Lugt 2243; Christie, July 11-14, 1893, lot 653) to C. F. Murray to J. P. Morgan, 1910.

References: Murray 1905-12, vol. 1, no. 111; Lafuente Ferrari 1937, p. 54, fig. 10; Trapier 1941, p. 36; Angulo 1962, pl. 1, fig. 3.

Exhibition: U. of Kansas 1974, no. 21, pl. 29.

The composition is closely related to cat. 38, a fact that led Trapier and Angulo to regard it as a copy. The style and technique, however, are both familiar from other examples (cat. 50-cat. 53 and cat. 55). In these drawings, wash plays only a supporting role because the shading is primarily indicated with pen strokes. Although the line is sketchier, the system of creating shadows within the forms is consistent with Murillo's manner as known from his earliest drawings. The virtual duplication of a composition in the same medium is highly unusual, but the quality and style of cat. 38 and cat. 54 allow no doubt as to their attribution. There are, moreover, small differences between them. In cat. 54, the putti in the far left and far right both hold branches aloft. Their absence in cat. 38 is less logical and consistent; also, the right leg of the putto with the palm branch is in a different position. Finally, the putto at the far right looks outward instead of upward, as he does in cat. 38. These changes help to make the Morgan sheet a more satisfying composition. They also serve to separate it from a drawing in the Hispanic Society, which is a direct copy, by a follower, of cat. 38. And the slightly more twisted

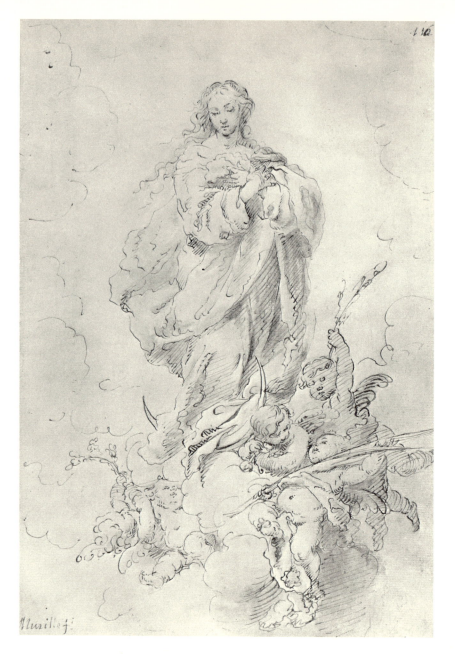

pose of the Virgin, coupled with the surface movement of the pen lines, give it more vitality and dynamism.

The number and the cross in black chalk at the upper corners are discussed under cat. 11.

55 Christ on the Cross

Princeton, The Art Museum, Princeton University 72-40.

335 x 236 mm.; pen and brown ink with brown wash over black chalk on brown-toned paper. Signed in brown ink at lower left: *Bartoe. Murio. fe.*; inscribed at lower right: *400.rs*; inscribed at upper left: *14*.

Provenance: J. Rushout, 2nd Earl of Northwick; G. Rushout, 3rd Earl of Northwick; Lady E.A. Rushout; E.G. Spencer-Churchill (Sotheby, November 1-4, 1920, lot 318, repr. opp. p. 57); B. Ingram (Lugt Suppl. 1405 on old mount); H. Shickman (vendor to Museum, 1972).

Reference: Brown 1973, fig. 1.

Exhibitions: U. of Kansas 1974, no. 30, pl. 30; Los Angeles 1976, no. 227, repr.

The technique of this drawing is related to cat. 50-cat. 54, in that the figure was fully rendered and modeled in pen and ink with some black chalk before the wash was added. However, the rich background atmosphere, so reminiscent of Murillo's paintings, is done entirely in subtly varied tones of brown wash.

 In 1930, Sánchez Cantón published a drawing of a Crucifixion as an original by Murillo (*Dibujos españoles*, vol. 5, pl. 418). However, as I noted in 1973, this drawing is a faithful copy of cat. 55. Sánchez Cantón also associated the composition with a *Christ on the Cross* then in the Czernin collection (now in San Diego, Museum of Fine Arts), but there is no direct relationship between the drawing and this painting.

 The number *14* inscribed at the upper left of cat. 55 indicates that this drawing was included in the sketchbook discussed under cat. 11.

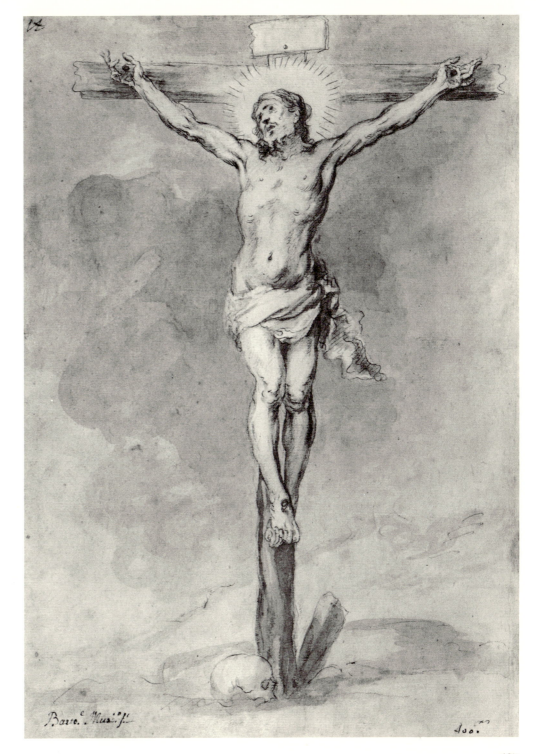

56 Christ on the Cross

London, collection of Brinsley Ford.

407 x 356 mm.; red and black chalk on buff paper. Inscribed on verso of mount: *"This magnificent and almost unique study by Murillo belonged to the celebrated Conde del Aguila [see* Handbook for Spain, *2nd ed., p. 62]. His collection of Spanish drawings afterwards passed into the hands of Julian B. Williams, our vice consul at Seville, and who was by far the best judge of Spanish art in Europe: it was given to me at Seville by him in 1831. Rich[d]. Ford."*

Provenance: J.I. Espinosa y Tello de Guzmán, 3rd Conde del Aguila; J. Williams; R. Ford.

References: Stirling-Maxwell 1847-48, vol. 3, p. 1446 and vol. 4, pl. 56; Waagen 1854, vol. 2, p. 224; Angulo 1974, p. 104.

Exhibitions: King's Lynn 1969, no. 32; London 1974, no. 167, pl. 8a.

This large sheet has been consistently attributed to Murillo by the distinguished collectors who have owned it since the late eighteenth century. In 1974, Angulo identified it as a preparatory study for a painting on copper of the *Crucifixion with the Virgin Mary and Saints John and Mary Magdalene* (fig. 63). The figure of Christ in the painting follows the drawing in all details except for the position of the loincloth, which billows out to the left.

The manner of execution conforms to Murillo's usual practice in two-color chalk drawings. The

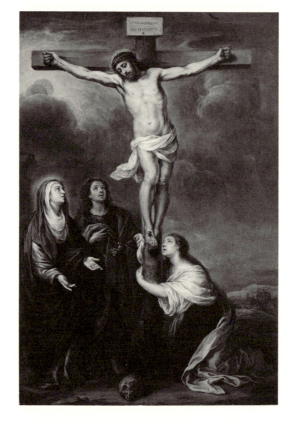

Figure 63. Murillo,
Crucifixion with the Virgin Mary
and Saints John and Mary Magdalene.
*Dallas, Meadows Museum,
Southern Methodist University 67.11.
Oil on copper, 61 x 42.1 cm.*

body is modeled with thin, closely spaced parallel lines in red chalk; black chalk is used for the shadows, the loincloth, the hair, and the cross. However, the technique reaches a high point of delicacy and refinement in this drawing. The softer handling, particularly in the face, indicates a date in the 1670s. The veiled expression that results from the smudging perfectly communicates Christ's restrained suffering.

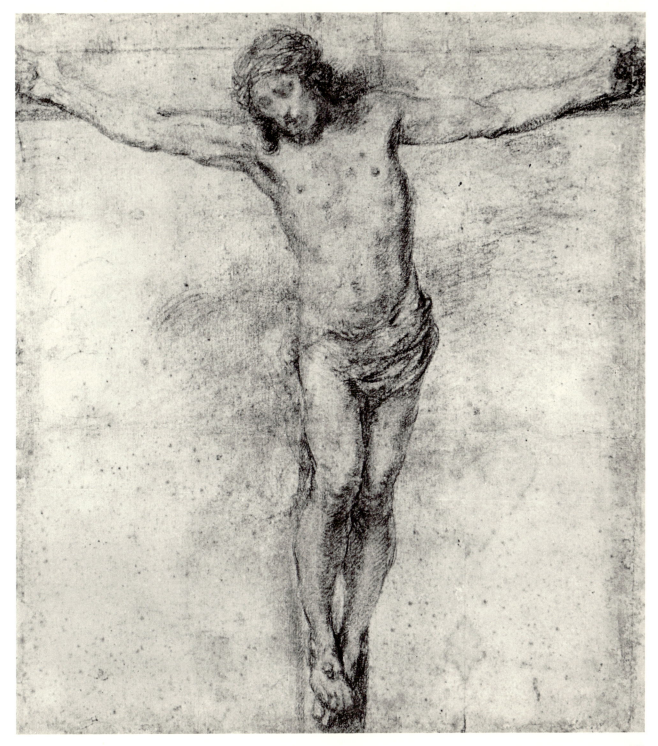

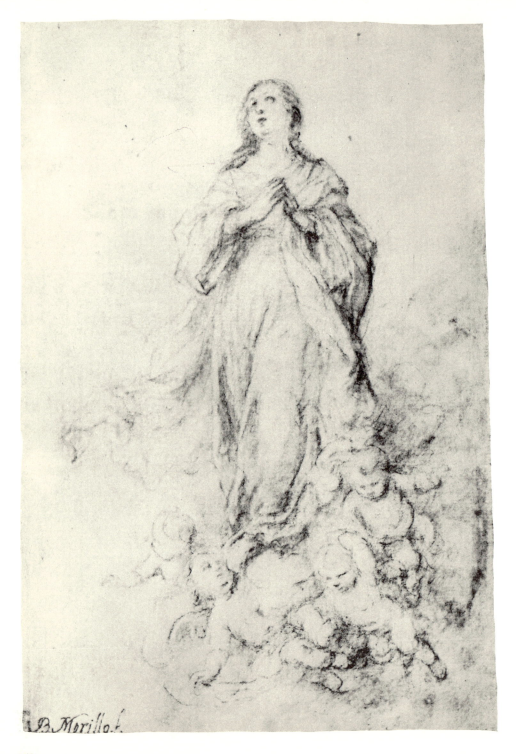

B. Morillo.f.

57 *Assumption of the Virgin*

Collection unknown.

215 x 151 mm.; red and black chalk. Inscribed in ink at lower left corner: *B. Morillo f.*

Provenance: Marqués de Argelita; F. Boix; R. Chaveau Vasconcell.

References: Sánchez Cantón 1930, vol. 5, pl. 421.

The soft handling of the chalk resembles the technique of cat. 56, suggesting a date in the early 1660s.

The subject of this drawing is somewhat ambiguous. The poses of the Virgin and the attendant putti initially suggest that it is an *Inmaculada*. However, none of the traditional attributes of the Virgin Immaculate is represented, not even the crescent moon, which almost always is present, even when other symbols have been omitted. It seems likely, then, that Murillo meant to show the Assumption of the Virgin, especially because the head and glance are directed upward. The omission of the apostles and God the Father, though unusual, occurs in the famous *Assumption* in the Hermitage, which is otherwise unrelated to the drawing. Although the drawing gives every appearance of having been a preparatory study, I know of no comparable painting.

The same inscription appears on the series of Angels with the Instruments of the Passion (cat. 40-cat. 49).

58 Saint Joseph and the Christ Child Walking

Hamburg, Kunsthalle 38583.

189 x 125 mm.; black chalk. Laid down; repaired tear in area of Joseph's chest. Signed in black chalk at lower left: *Bartholome murillo*.

Provenance: Library, Seville Cathedral; A. Fitzherbert, Baron St. Helens (Christie, May 26, 1840, lot 118) to W. Buchanan; J. A. Echevarría; B. Quaritch (vendor to Museum, 1891).

Exhibition: Hamburg 1966, no. 166.

In the 1966 Hamburg exhibition catalogue, the relationship to a painting (fig. 64) was noted and the suggestion made that the drawing was a copy by a member of the atelier. It is in fact a preparatory sketch for the picture and undoubtedly was executed by Murillo, probably in the later 1670s. Unfortunately, very few chalk drawings have survived from the last years of Murillo's life, making it difficult to characterize his development in this medium and to establish a chronology. In general, it may be said that the progressive loosening of style that is visible in the numerous pen-and-wash drawings also occurred in the chalk drawings. A very close relationship exists between the loose style of this drawing and cat. 61, which is indisputably a late chalk-and-wash drawing by Murillo. However, he still seems to have made highly finished drawings in the 1670s, as, for instance, a superb *Christ on the Cross* (cat. 56). But even here, the crisp lines of earlier years are deliberately blurred and smudged to produce a softer atmosphere.

The signature written in black chalk in the lower left corner appears, despite the use of an *h* in the first name, to be consistent in texture and color with the composition and may thus be regarded as autographic.

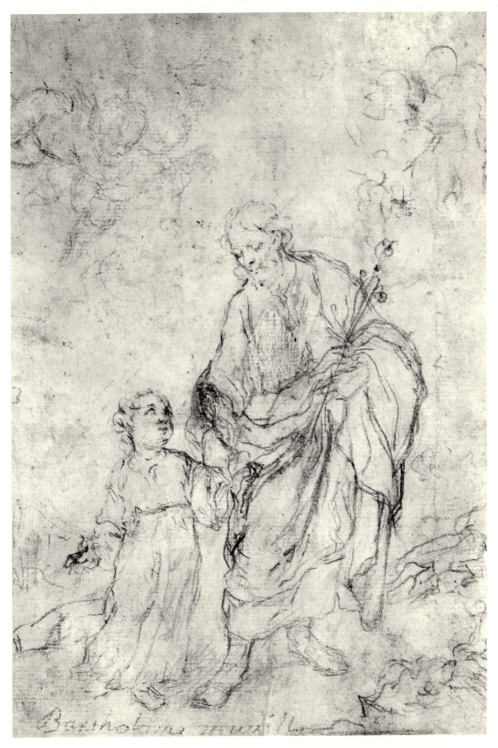

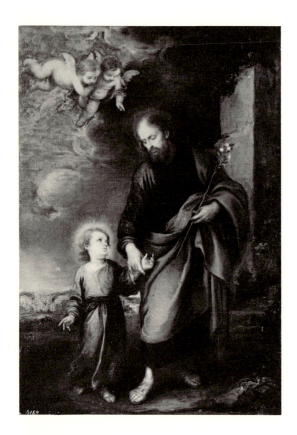

Figure 64. Murillo,
Saint Joseph and the Christ Child Walking.
Leningrad, Hermitage 366.
Oil on canvas, 73 x 52 cm.

59 *Virgin and Child*

Madrid, collection of A. Escrivá de Romani y de Senmenat, Conde de Alcubierre.

124 x 97 mm.; black chalk. Mounted on folio 38 of album of drawings. Inscribed in black chalk at lower left corner: *Murillo*.

Provenance: M. Tellez-Girón, Duque de Osuna (1814-1882); 1st Conde de Alcubierre.

This small drawing bears an old attribution to Murillo that seems to be correct. The date must be quite advanced because of the scrawling lines that imitate the pen drawings of the 1670s. However, the closest comparison is to *Saint Joseph and the Christ Child Walking* (cat. 58). The treatment of the Christ Child's head in both drawings is strikingly similar.

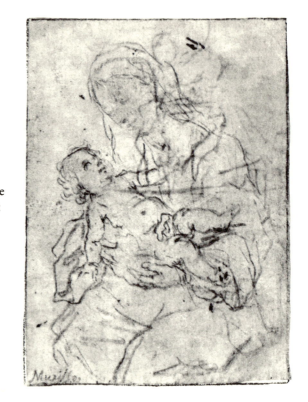

60 Standing Man

London, British Museum 1895-9-15-885.

112 x 68 mm.; black chalk. Laid down. Inscribed by the Contemporary Collector in brown ink: *Bartolome Murillo fat.*; inscribed in brown ink at upper left corner: *67*.

Provenance: J. Malcolm; J.W. Malcolm (donor to Museum, 1895).

Reference: Robinson 1876, p. 152, no. 434.

This small sheet, executed in a hasty manner, is not readily identifiable as a drawing by Murillo. Although the external evidence of the inscription by the Contemporary Collector, which appears only on authentic drawings, points to his authorship, the style is distinct from other known chalk drawings. Furthermore, the lack of sufficient comparative material in this period also makes it hard to substantiate Murillo's authorship. But the overall looseness and lack of definition is paralleled in the latest pen drawings. A comparison with another late portrait in a similar format, this one in pen and ink (cat. 87), may be helpful. In both drawings, Murillo has ceased to care about approximating natural appearances. The drawing style is almost crude. But the treatment of the right leg, with its loose zigzag line, and of the cape over the left shoulder is close in both drawings. Also, the pose is commonly found in Murillo's portraits.

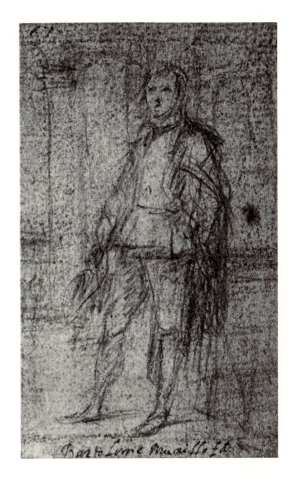

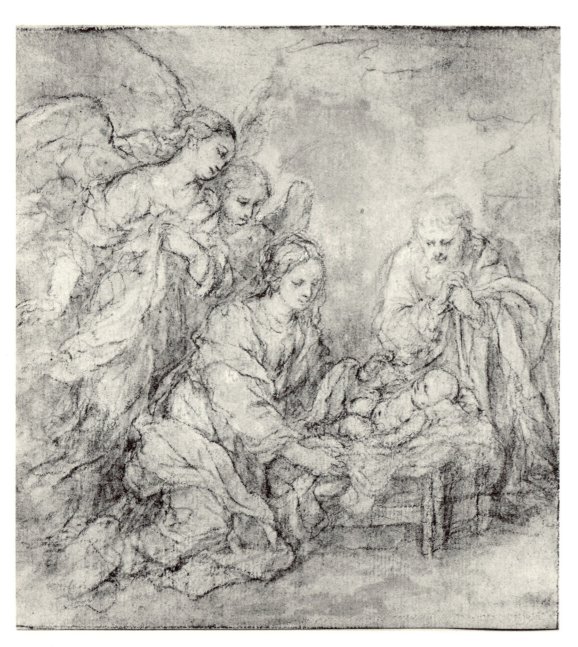

61 Virgin and Saint Joseph with Two Angels Adoring the Christ Child

London, British Museum 1895-9-15-891.

166 x 159 mm.; red chalk with brown wash and white gouache (oxidized) on light brown-toned paper.

Provenance: Library, Seville Cathedral; A. Fitzherbert, Baron St. Helens (Christie, May 26, 1840, lot 126) to Gibbs; J. Malcolm; J.W. Malcolm (donor to Museum, 1895).

Reference: Mayer 1915, p. 7, pl. 50.

The attribution of this magnificent drawing to Murillo is self-evident. Its mellow, warm atmosphere and benevolent figures coincide perfectly with Murillo's late style in painting.

The technique is somewhat unusual by virtue of the extensive use of white body color for both the highlights on the figures and shadows on the ground.

62 Vision of Saint Anthony of Padua

Paris, Cabinet des Dessins, Musée du Louvre RF 633.

171 x 246 mm.; brush and brown wash, pen and brown ink with white highlights over black chalk on brown-toned paper. Inscribed in brown ink at lower right corner: *Murillo*.

Provenance: possibly C. Morse (Sotheby, July 4, 1873, lot 145); A. C. H. His de la Salle (Lugt 1332-33; donor to Museum, 1878).

References: *Dessins du Musée du Louvre* [1890s], no. 347; Mayer 1915, p. 7, pl. 49; Gómez Sicre 1949, pl. 63 (detail of right half) and pl. 65 (detail of upper left corner).

This beautiful late drawing, as Mayer pointed out, is a study for a painting (fig. 65; for another version, see Edinburgh 1951, pl. 9). An oil sketch for the composition (Appendix 2, no. 32) has been recorded but is now lost.

The technique is exceptionally varied and unusual. Most of the drawing is done with brush and brown wash over black chalk, except for the two putti at the lower left, who are outlined with pen and ink. The background provided by the brown-toned paper produces a remarkably soft atmosphere into which the figures seem to dissolve.

Curtis (1883, under no. 243) mentions "an original study [for fig. 65] with pen and bistre heightened with white, on white paper, measuring 13 by 9¼ inches and signed," then in the collection of J.C. Robinson, London. This may have been another preparatory study for this picture.

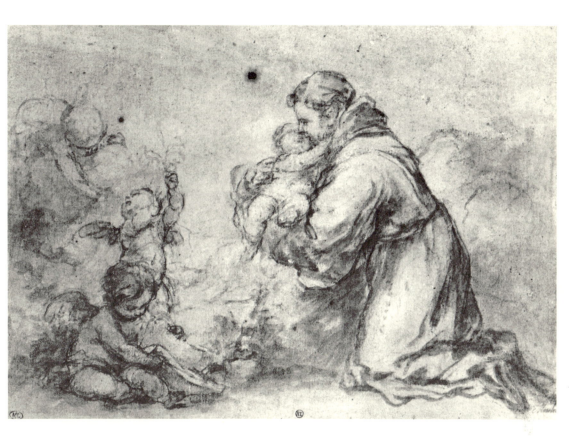

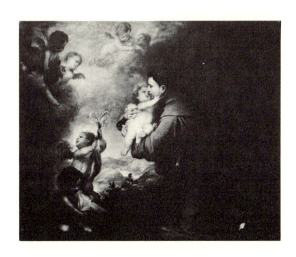

Figure 65. Murillo,
Vision of Saint Anthony of Padua.
Destroyed, formerly Berlin,
Kaiser Friedrich Museum 414.
Oil on canvas, 165 x 200 cm.

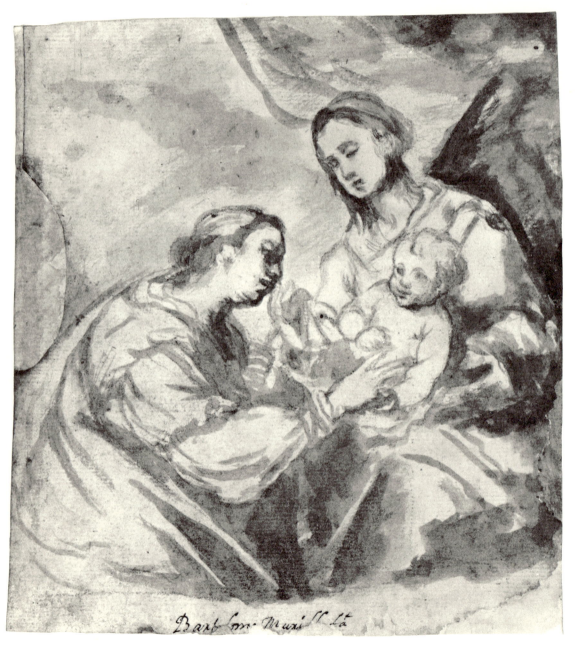

Bartolomé Murillo fat

63 *Mystic Marriage of Saint Catherine*

London, British Museum 1946-7-13-1157.

209 x 198 mm.; brush and green wash. Repaired semicircular loss at left margin; repaired tears in lower right margin and corner. Inscribed by the Contemporary Collector in brown ink at lower margin: *Bartolomé Murillo fa*[t].

Provenance: T. Phillipps; T.F.P. Fenwick (donor to Museum, 1946).

Reference: Popham 1935, p. 235.

This drawing is unusual on two counts—the use of green wash and the absence of underdrawing. However, the figure types and the wash technique leave no doubt about the attribution. The question of dating is difficult, but some passages, such as the Virgin's somewhat sagging face, the elongated hand of Saint Catherine, and the overall looseness of structure, point to the 1670s.

Popham thought the drawing might be a study for the picture in the Vatican. This painting appears to be a follower's replica of the painting in Lisbon (fig. 47; see cat. 14), which was done in 1655. In addition to the chronological discrepancy, the compositions are too dissimilar to posit a connection between them.

64 Saint Joseph and the Christ Child Walking

Paris, Cabinet des Dessins, Musée du Louvre 18.427.

258 x 188 mm.; brush and black wash and white gouache on brown paper; squared in black chalk. Inscribed in brown ink at lower right corner: *17*.

Provenance: unknown (acquired by Museum, 1827).

Reference: Baticle 1961, pp. 52 and 82, repr. p. 51.

The use of black wash and white body color is rare among Murillo's drawings, but the traditional attribution of this and a related sheet (cat. 65) need not be questioned. Not only are the figure types Murillesque, but reasonably close parallels can also be found in cat. 61 and cat. 62. All of these drawings imitate the soft atmospheric effects found in the paintings of the 1670s. The fusion of figures and space is accomplished by dissolving the linear structure with freely applied washes and by using toned papers. These drawings represent the successful culmination of Murillo's endeavors to create a painterly style of draftsmanship.

Of the two related drawings, this one appears to have been done first. The execution is sketchier, and the details of figures and landscape are less clearly defined. In the second drawing, the figure scale is increased to produce a more monumental effect.

Both this drawing and cat. 65 are squared for transfer, but no corresponding painting is known. The theme, a favorite of Murillo's later years, is repeated in cat. 58 and cat. 68.

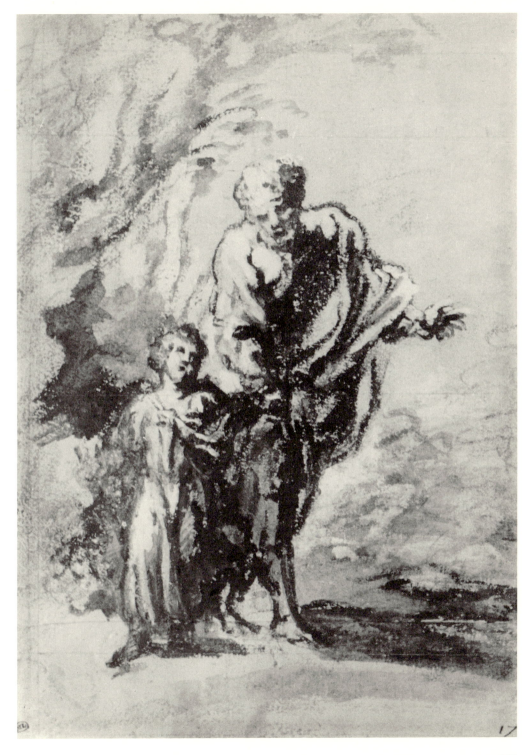

147

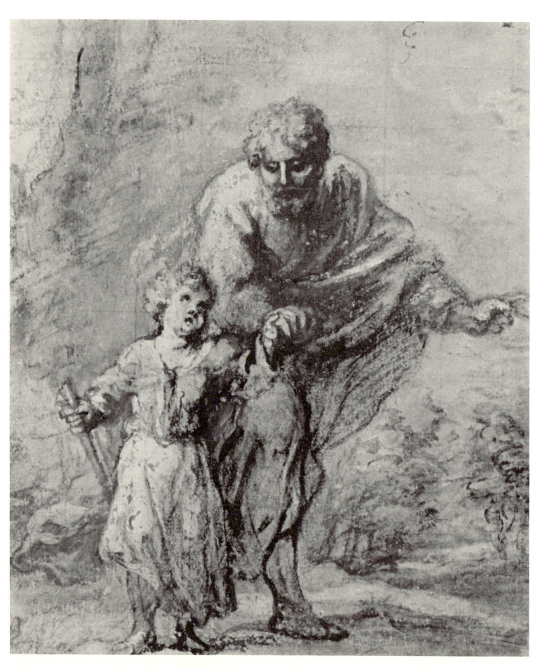

65 Saint Joseph and the Christ Child Walking

Paris, Cabinet des Dessins, Musée du Louvre 18.426.

251 x 124 mm.; brush and black wash and white gouache over black chalk on brown-toned paper; squared in black chalk. Inscribed on old mount: *B. Esteban Murillo*.

Provenance: unknown (acquired by Museum during French Revolution).

References: *Dessins du Musée du Louvre* [1890s], pl. 346; Leporini 1925, p. 69, pl. 212; Gómez Sicre 1949, pl. 66; *Disegni di grandi maestri*, suppl., Alinari, Florence, n.d., p. 22, no. 1457.

This drawing is related to cat. 64, under which it is discussed.

66 Infant Christ Sleeping on the Cross with Two Putti Above

Paris, Cabinet des Dessins, Musée du Louvre 18.428.

182 x 135 mm.; pen and brown ink with brown wash over red chalk; borderline in brown ink.

Provenance: J. I. de Espinosa y Tello de Guzmán, 3rd Conde del Aguila; J. Williams; F. H. Standish; Louis Philippe (Paris, December 6, 1852, lot 594) to Museum.

References: *Catalogue . . . de la Collection Standish* 1842, p. 78, no. 427; Stirling-Maxwell 1848, vol. 3, p. 1446; Curtis 1883, p. 181, no. 157; London, Royal Academy 1962, no. 108; Pérez Sánchez 1970, pp. 91-92, fig. 28.

Curtis identified this drawing as a preparatory study for a painting (fig. 66), which follows it without significant changes. The style of both suggests a date in the early 1670s.

Figure 66. Murillo,
Infant Christ Sleeping on the Cross
with Two Putti Above.
Sheffield, Graves Art Gallery 73.
Oil on canvas, 365.8 x 274.3 cm.

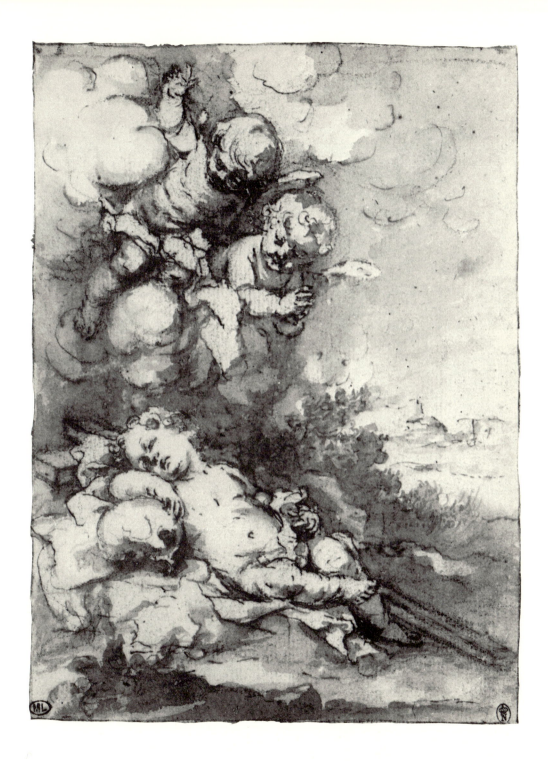

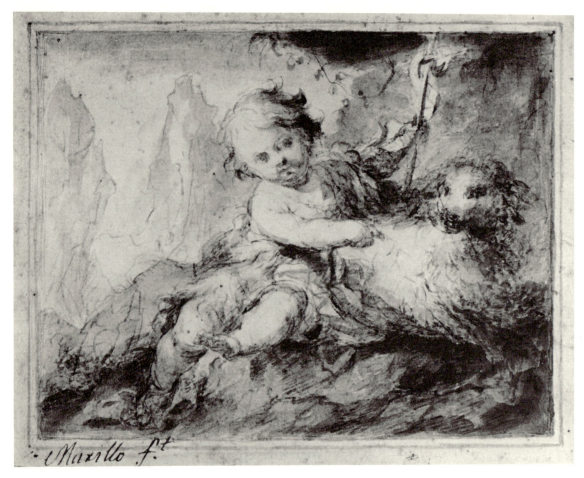

67 Infant Saint John the Baptist with a Lamb

New York, Metropolitan Museum of Art 63.5 (Rogers Fund).

117 x 142 mm.; pen and brown ink with gray wash; borderlines in gray-brown ink. Inscribed at lower left: *Murillo ft*.

Provenance: J. Rushout, 2nd Earl of Northwick; G. Rushout, 3rd Earl of Northwick; Lady E. A. Rushout; E. G. Spencer-Churchill (Sotheby, November 1-4, 1920, lot 321, repr. opp. p. 56) to Savin; J. E. Huxtable; J. Pape; Miss Winfield; Colnaghi to Museum, 1963.

The straggly lines and painterly washes connect this drawing with cat. 61 and cat. 62, and indicate a date in the 1670s. The comparison of Saint John with the putto in the lower left of the *Vision of Saint Anthony* (cat. 62) is especially telling. By framing the little composition with a double borderline, Murillo invites the viewer to regard it as an independent work.

68 Saint Joseph and the Christ Child Walking

Paris, Cabinet des Dessins, Musée du Louvre 18.429.

249 x 171 mm.; pen and brown ink with brown wash over black chalk; borderline in brown ink. Inscribed in brown ink at lower right: *Morillo*.

Provenance: J. I. Espinosa y Tello de Guzmán, 3rd Conde del Aguila; J. Williams; F. H. Standish; Louis Philippe (Paris, December 6, 1852, lot 598) to Museum.

References: *Catalogue . . . de la Collection Standish* 1842, no. 431; Stirling-Maxwell 1848, vol. 3, p. 1446; Angulo 1974, pp. 100-101, fig. 28.

This drawing typifies a recurrent problem in the study of Murillo's preliminary sketches. The theme of Saint Joseph and the Christ Child Walking occurs frequently in Murillo's paintings and drawings. It has therefore been tempting to relate drawings to paintings when, in fact, there is no genuine connection between them. The confusion has arisen because the subject as Murillo conceived it did not admit of great variations. Nonetheless, Murillo did alter the formula in small ways, a practice that he also observed in his treatment of other subjects that he often repeated (e.g., the Virgin of the Immaculate Conception and the Seated Virgin and Child). Therefore, apparently minor variations between a drawing and a painting cannot be dismissed as unimportant. A true preparatory drawing almost always forecasts the poses and the accessories, both animate and inanimate, with considerable fidelity. Changes were made, of course, but always in the direction first set out in the initial drawing.

To return to this case, Angulo has posited a relationship to a painting in a private collection (see

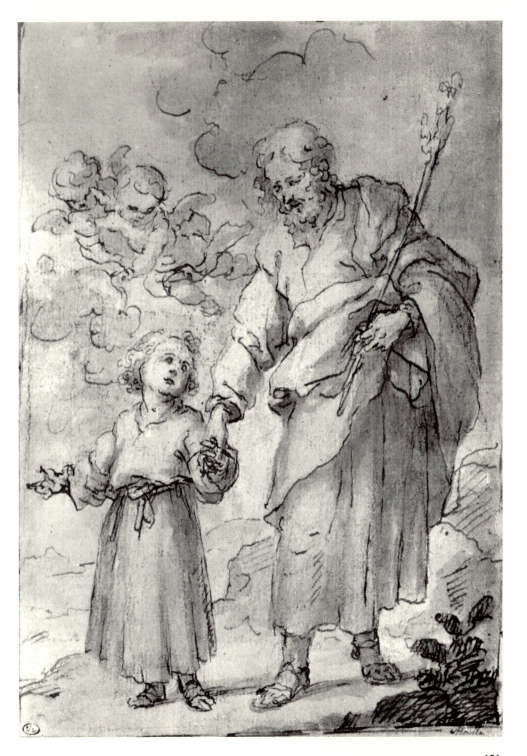

Angulo 1961, fig. 23) and also to a painting in the
Hermitage (fig. 64). Neither is convincing. In the
painting in the private collection, for instance, the
putti are missing and Christ strides forward with
his right foot, imparting a movement to the com-
position that is absent in the drawing. The putti
are present in the Hermitage painting, but they are
set in different poses. And the movement of the
figures is from left to right, not vice versa as in the
drawing. Fortunately, a preparatory drawing for
this painting has survived (cat. 58), permitting us
to see in what close detail it establishes the com-
position to be followed in the painting. Cat. 68 is
not related to any known work.

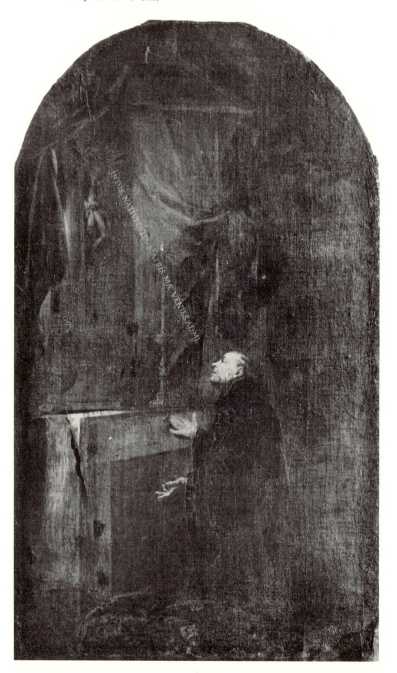

Figure 67. Murillo,
Saint Thomas of Villanueva
Receiving the News of His Impending Death.
Seville, Museo Provincial de Bellas Artes 299.
Oil on canvas, 130 x 75 cm.

69 Saint Thomas of Villanueva Receiving the News of His Impending Death

London, collection of Brinsley Ford.

205 x 110 mm.; pen and brown ink with brown wash over black chalk; borderline in brown ink. Repaired tear in upper left corner; foxed. Inscribed by the Contemporary Collector in ink at lower margin: *Bartolome Murillo. fa*[t].

Provenance: R. Ford.

References: Angulo 1962, p. 236, pl. 2; Harris 1964, p. 337.

This drawing is a preparatory study for a painting (fig. 67). As Angulo ("Los pasajes de Santo Tomás de Villanueva . . . ," 1973) has shown, the painting was part of an altarpiece, with scenes from the life of the saint, commissioned by the monastery of San Agustín. The date of the commission is undocumented, but on the basis of the other surviving pictures in Munich, Cincinnati, and Pasadena (Norton Simon Museum of Art), the date in the late 1670s suggested by Curtis and Mayer (1913) seems correct. Certainly the style of the drawing would confirm this dating. Compared with pen-and-wash drawings of the 1660s, the lines are slacker and thinner, and at some points even have a tremulous quality. The wash, too, is more even and transparent so that the contrasts are minimized. In style it is very close to cat. 70-cat. 74, which form a homogeneous group.

The differences between painting and drawing are slight. In the painting, the saint's hands gesture toward the Crucifixion, from which a written message of the saint's impending death emanates. The episcopal hat has been removed from the altar. As Harris suggested, the drawing, which is framed by lines and a wide margin, was perhaps intended to be presented to the client for approval.

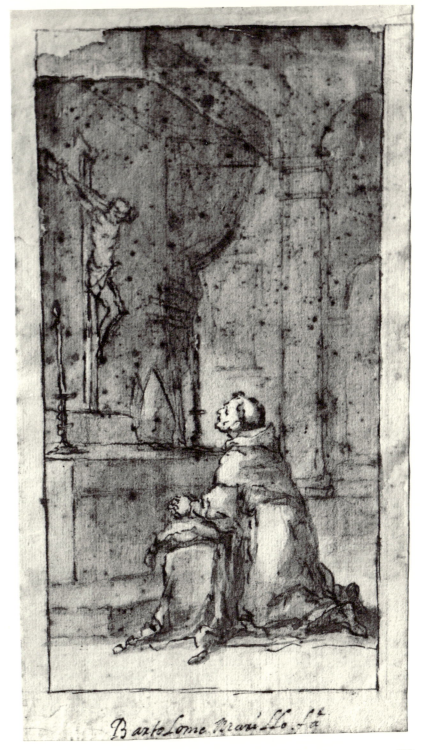

70 Caritas Romana

Rotterdam, Museum Boymans-van Beuningen S-8.

200 x 180 mm.; pen and brown ink with brown wash over black chalk. Inscribed by the Contemporary Collector in brown ink at lower center margin: *Bartolome Murillo. fa* [t].

Provenance: Library, Seville Cathedral; A. Fitzherbert, Baron St. Helens (Christie, May 26, 1840, lot 103) to Heath; F.W. Koenigs (Lugt Suppl. 1023a on verso) to D. van Beuningen (donor to Museum, 1941).

References: Harris 1964, fig. a; Pérez Sánchez 1970, p. 85, pl. 29; Hernández Díaz 1974, pp. 81-88.

In an excellent article, Harris has shown that the drawing is a preparatory study for a painting destroyed by fire at the Philadelphia Academy in 1845. The composition is preserved in an engraving of 1809 by Tomás López Enguídanos, who sold the painting to the Philadelphia collector Richard Warsam Meade. (The eventful history of the painting in the nineteenth century is reconstructed by Guerra Guerra 1954.) Hernández Perera (1959) notes the source of the composition in prints by van Caukerken and A. Voet after a painting by Rubens in the Hermitage. Harris also suggests that Murillo used a print after the Rubens picture by Panneels. Recently, Hernández Díaz has advanced the hypothesis that a version of the Murillo painting in a private collection in Bilbao is the missing original. Judging from the reproduction in his article, the picture seems clearly to be a copy.

In style, the study belongs to a group of pen-and-wash drawings that were done in the later 1670s (cat. 69-cat. 74). These sheets are characterized by slacker, often very short lines; within certain passages, a tremulous quality can be observed. With increasing frequency, details are omitted or highly abbreviated.

An oil sketch for the painting is in the collection of J. O'Connor Lynch (fig. 12; see Appendix 2, no. 17). It is identical to the sketch catalogued by Curtis (1883, no. 402a) as an "old copy."

A copy of the drawing is in the Real Academia de San Fernando, Madrid (Pérez Sánchez 1967, p. 166).

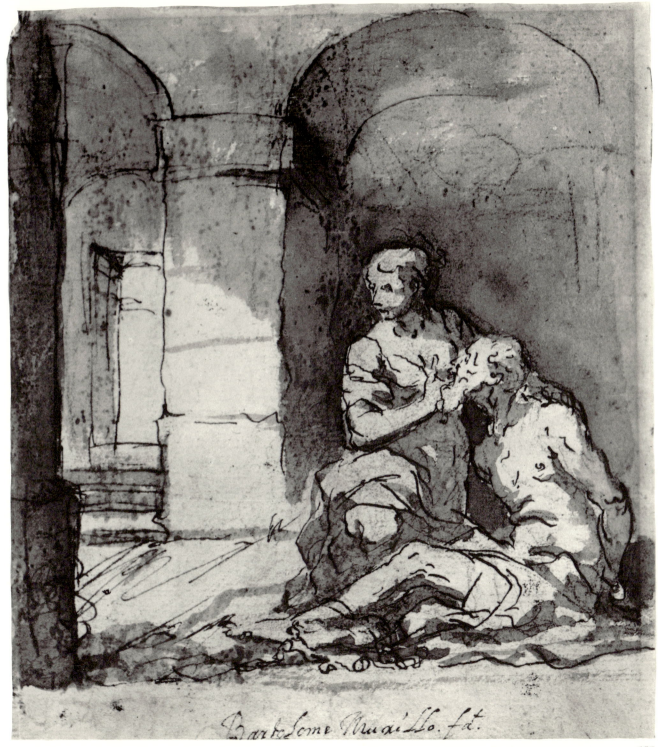

Bartolome Murillo. ft.

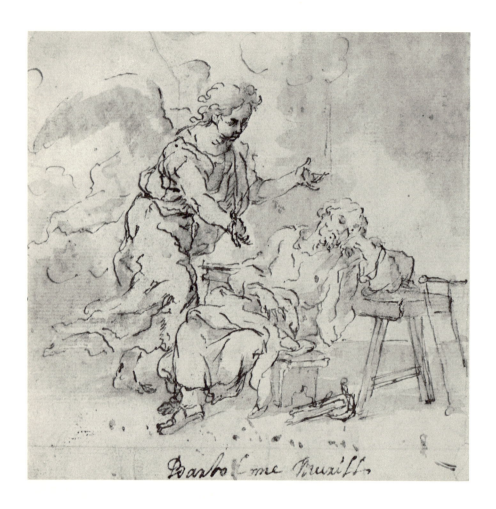

Bartolome Murillo

71 Dream of Joseph

Cambridge, Fogg Art Museum, Harvard University 1969.30 (anonymous gift).

120 x 123 mm.; pen and brown ink with brown wash over black chalk. Inscribed by the Contemporary Collector in brown ink at lower center margin: *Bartolome Murillo*.

Provenance: R. Ederheimer; R. Minturn (lender to Museum, 1915); acquired by Museum, 1969.

References: Angulo 1961, p. 16; U. of Kansas 1974, p. 49; Angulo 1974, p. 99, fig. 11; Brown 1975, p. 63.

Exhibition: "Original Drawings by Old Masters," R. Ederheimer Gallery, N.Y., December 1913, no. 78.

In 1974, Angulo drew attention to a painting by a follower, formerly in the Museum of Bob Jones University, that reproduces the composition of this drawing with minor differences. As he noted, it is impossible to know whether the copyist was using a lost painting or this drawing as his model. However, it is worth pointing out that a *Dream of Joseph* on copper by Murillo was listed in the 1709 inventory of his son Gaspar's estate. A painting in the Salamanca sale (Paris, January 25, 1875, lot 24) is identical to the one in the Bob Jones University collection.

A copy, a drawing formerly in the C. S. Bale collection (Sotheby, June 9, 1881, lot 2375), has appeared recently at Sotheby's (November 26, 1970, lot 32, pl. 1). It is based more closely on the ex-Bob Jones University painting than on the Fogg drawing, which suggests that the latter may have been the initial preparatory study.

Smith (U. of Kansas 1974) expressed reservations about the attribution that are groundless, given the close relationship to other drawings of this period.

72 Boy with Dog and Half-Length Female Figure

Frankfurt, Staedelisches Kunstinstitut 13656.

176 x 129 mm.; pen and brown ink with brown wash over black chalk; female figure faintly drawn in black chalk. Inscribed in brown ink at lower right: *Bartolome Murillo fet*; inscribed in brown ink at upper left: *130*.

Provenance: R.P. Goldschmidt (Lugt 2926 on verso; Prestel, Frankfurt, October 4-11, 1917) to Museum.

References: *Stift und Feder* 1926, pl. 39; Angulo 1969, p. 782, pl. 534, fig. 5.

Angulo published a painting by a follower, from the collection of Lord Elgin, that shows the composition of a boy and dog in reverse, though with some notable differences. Perhaps the copyist was working from a painting for which the drawing was a preparatory study.

A second figure is present on the sheet, sketched faintly in black chalk in the vague manner common to underdrawings. Angulo read the passage as two figures, but it seems to be a single figure with the head sketched in two positions. The figure is out of scale with the rest of the drawing, making it difficult to know if it was conceived as part of this composition.

The style is similar to cat. 68-cat. 71, and therefore the drawing dates in the late 1670s.

The inscription is different from that of the Contemporary Collector.

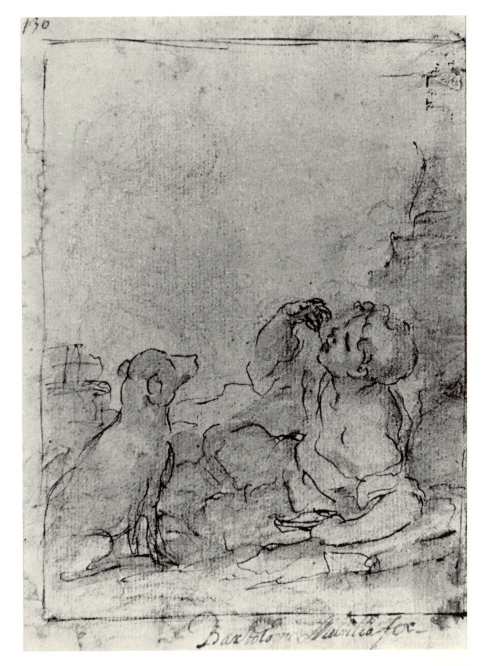

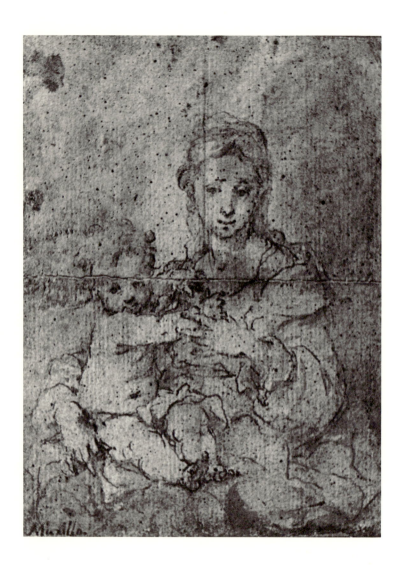

73 Virgin and Child

Madrid, collection of A. Escrivá de Romani y de Senmenat, Conde de Alcubierre.

132 x 102 mm.; pen and brown ink with brown wash over faint traces of red and black chalk. Repaired horizontal tear. Mounted on folio 70 of album of drawings. Inscribed in brown ink at lower left: *Murillo*.

Provenance: M. Tellez-Girón, Duque de Osuna (1814-1882); 1st Conde de Alcubierre.

Reference: Angulo 1974, pp. 99-100, fig. 31.

As Angulo noted, this drawing is a preparatory study for an etching that has long been attributed to Murillo. The etching, which reverses the composition of the drawing but otherwise follows it without variation, is difficult to attribute with certainty, but it is possible that it could have been done by the artist. Angulo also postulated a relationship to the *Virgin of the Rosary and Infant Christ* in the Dulwich College Picture Gallery, but the painting and drawing are sufficiently different as to be considered independent works.

The date of this drawing is indicated by its relationship to the group of pen-and-wash drawings done in the 1670s (cat. 69-cat. 72 and cat. 74).

74 Infant Saint John the Baptist with a Lamb

Paris, Cabinet des Dessins, Musée du Louvre 18.439b.

119 x 102 mm.; pen and brown ink with brown wash.

Provenance: unknown.

Reference: Angulo 1974, p. 106, fig. 25.

In his recent publication, Angulo attributed this small sheet to Murillo and noted its similarity to cat. 88 and cat. 90, dating all three to a "relatively early date." The grouping of these three drawings is entirely plausible, but their style seems to point to a late moment in Murillo's life. The threadlike lines and the avoidance of detail are characteristics of the 1670s. So, too, is the marvelous sense of economy that allows the artist to realize the foreshortened seated pose with only a few straggly lines.

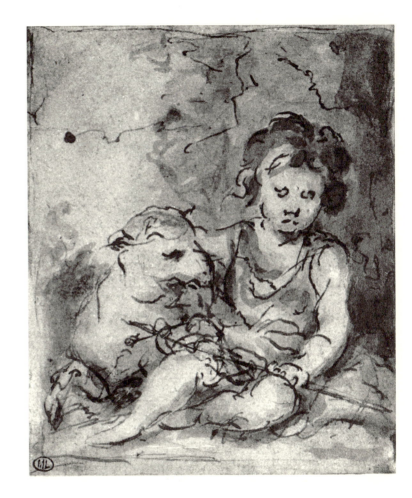

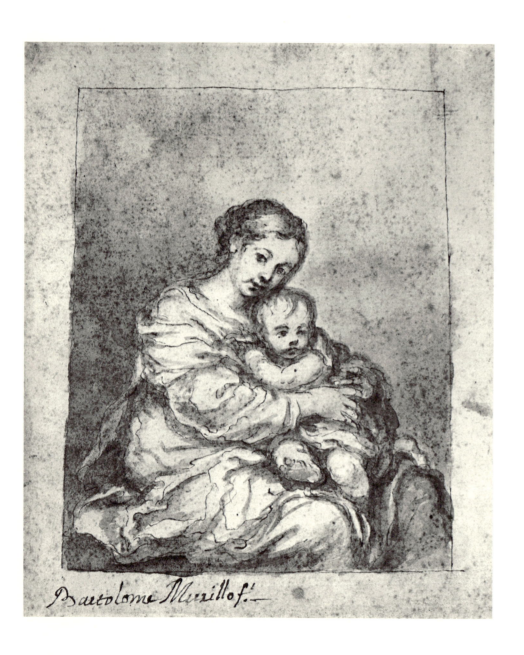

75 Virgin and Child

The Netherlands, collection of Mrs. C. van der Waals-Koenigs.

170 x 143 mm.; pen and brown ink with brown wash over traces of black chalk. Signed in brown ink at lower left: *Bartolome Murillo fe*.

Provenance: F. Koenigs.

The style of this drawing indicates a date in the 1670s, particularly when it is compared with cat. 68-cat. 74, with which it shares a tremulous linear structure over which patches of wash have been applied in a painterly manner.

In some respects, the composition resembles that of a painting in the Norton Simon Museum of Art, Pasadena (Mayer 1913, pl. 50). However, the style of the painting points to a date in the 1650s, thus making it impossible to consider the drawing as its preparatory sketch. Nevertheless, the similarity between the two works is remarkable. In all probability, the painting served as the inspiration for the drawing.

The full signature and the wide margin between the borderline and the edge of the paper indicate that the drawing may have been conceived as an independent work.

This and the following drawing (cat. 76) were discovered by A. W. F. M. Meij, Curator of Drawings at the Museum Boymans-van Beuningen, who kindly brought them to my attention.

76 Putti

The Netherlands, collection of Mrs. C. van der Waals-Koenigs.

328 x 225 mm.; pen and brown ink with brown wash over black chalk. Signed in brown ink at lower left: *Bartoe. Murio. fe*.; inscribed in black ink at upper left: *11*. Verso: signature repeated as on recto; inscribed in black ink: *10*.

Provenance: A. Fitzherbert, Baron St. Helens (Lugt 2970 in lower left corner, partly trimmed); F. Koenigs.

This splendid drawing is surely a preparatory study for a Virgin of the Immaculate Conception, as yet unidentified. Similar groupings of putti are often found in paintings of this subject. And two of the three putti in the lower right hold attributes of the Virgin Immaculate—the palm leaf and the olive branch. In fact, the putto with the palm leaf closely resembles his counterpart in the *Inmaculada* from El Escorial (Prado 972), although there is no other connection.

The compositional method used in the drawing is particularly revealing because it vividly confirms Murillo's habit of working out parts of a painting separately before combining them into a whole.

The signature is identical to the one on cat. 55. The numbers on the recto and verso indicate a provenance from the sketchbook discussed under cat. 11. Although the collector's mark indicates that the drawing surely was in the collection of St. Helens, it does not seem to have been included in the 1840 sale. Only one lot corresponds with this subject: lot 93, "Sketches of Angels," which was purchased by Anderdon and is now in the British Museum (see cat. 11). Comparison of the two drawings shows that cat. 76 is looser and more nervous in style, and thus was done later in Murillo's career.

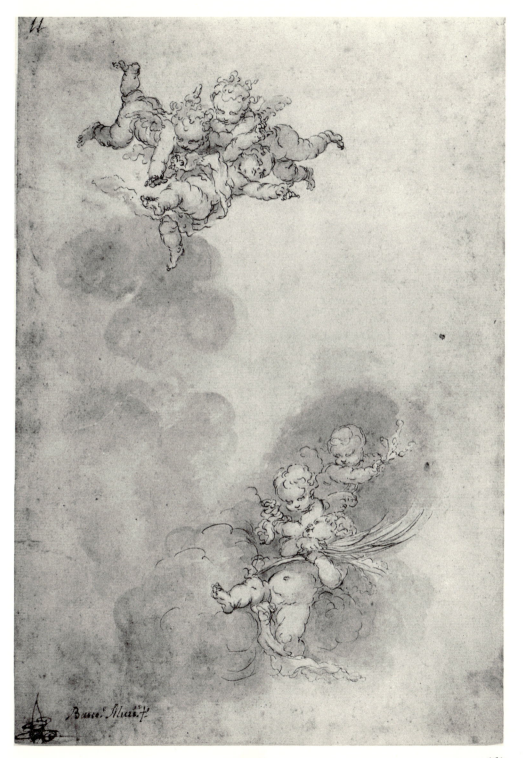

Figure 68. Murillo,
Virgin and Child in Glory Adored by Saints Felix of Cantalice,
John the Baptist, Justa, and Rufina.
London, Wallace Collection P3.
Oil on canvas, 71 x 52 cm.

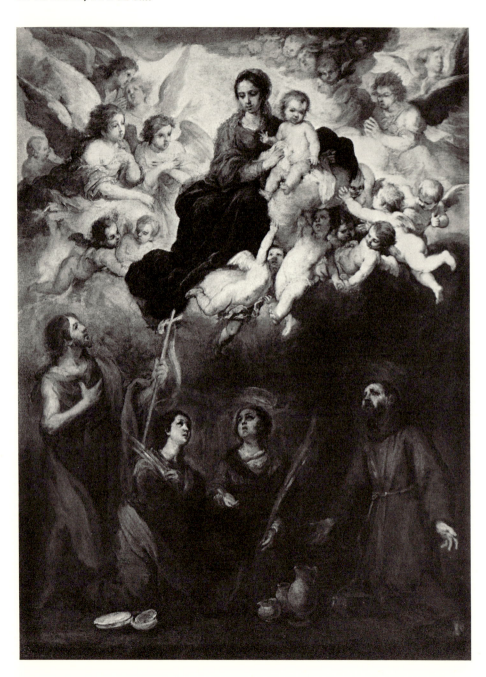

77 *Saints Felix of Cantalice, John the Baptist, Justa, and Rufina*

New York, private collection.

150 x 210 mm.; pen and brown ink. Inscribed in brown ink at lower left corner: *murillo*.

Provenance: C. Morse (Sotheby, July 4, 1873, lot 146) to W. Stirling-Maxwell; J. Stirling-Maxwell; A. A. de Pass; Royal Institute of Cornwall, Truro (Christie, November 30, 1965, lot 176, repr.) to Y. ffrench.

References: Truro 1936, p. 17, no. 121; Frölich-Bum 1965, repr.; *Wallace Collection* 1968, pp. 208-9.

Exhibition: U. of Kansas 1974, no. 28, pl. 28.

The Wallace Collection catalogue draws attention to the relationship of this drawing to an oil sketch (fig. 68; see Appendix 2, no. 8). Angulo (1961, p. 19) questioned the authenticity of the oil sketch, but it is clearly a typical work. The drawing shows only the lower zone of the composition; the Virgin and Child with putti and angels appear above the saints in the oil sketch. However, this type of partial study occurs frequently in Murillo's drawings. The numerous differences in pose between drawing and oil sketch are of a kind commonly encountered in other drawings and related sketches. Given Murillo's usual working procedures, it is probable that a large-scale painting of this composition was finally made.

In style, the drawing can be placed provisionally in the later 1670s and belongs to a group of closely related works (cat. 78-cat. 85). These drawings show the characteristic techniques of hatching and cross-hatching rendered in a much freer manner than earlier. Outlines are drawn with broken, jerky strokes and then the shading is done in a series of blunt, loose, hatching strokes, interconnected by loops. The details of face, hands, and feet are even more abstractly drawn.

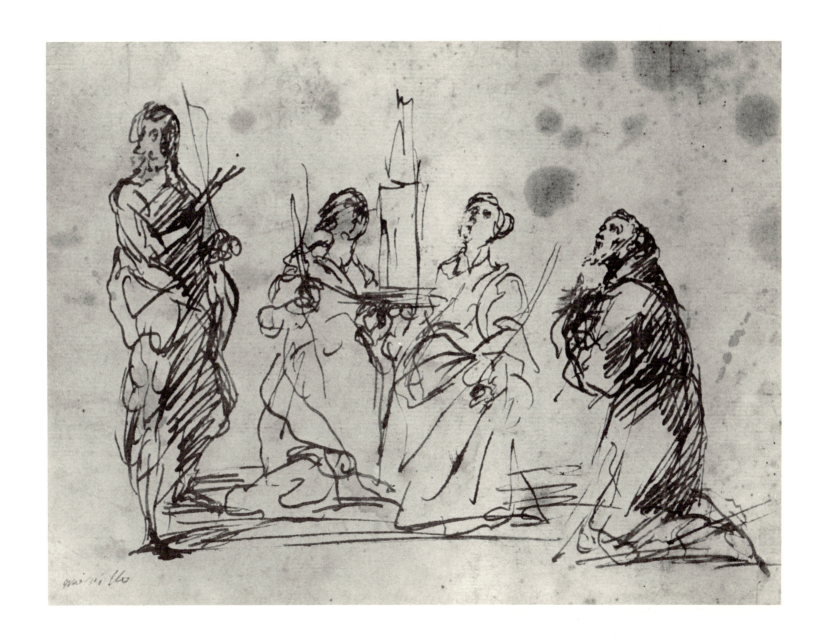

163

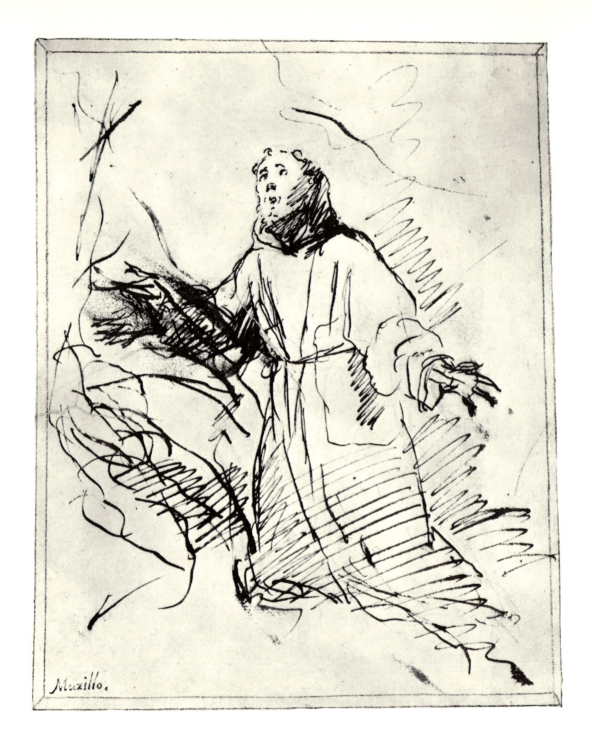

78 Saint Francis Kneeling

Madrid, collection of A. Escrivá de Romani y de Senmenat, Conde de Alcubierre.

261 x 200 mm.; pen and brown ink over faint traces of black chalk; double borderline in black chalk. Small repaired tear on left center margin and along saint's right side. Mounted on folio 67 of album of drawings.

Provenance: M. Tellez-Girón, Duque de Osuna (1814-1882); 1st Conde de Alcubierre.

Reference: Angulo 1974, p. 105, fig. 19.

Angulo, who first published the drawing, considered it to be an early work and related it specifically to *Brother Juniper and the Beggar* (cat. 1). However, the hasty, scrawling style is commonly found in Murillo's latest pen drawings, as in, for example, cat. 77 and cat. 79-cat. 85. Thus, the drawing should be dated in the 1670s. Angulo also thought that cat. 78 was a preparatory study for an oil sketch (see Appendix 2, no. 9). Although the oil sketch is clearly a late work, its relation to the drawing is not completely certain. In the drawing, Saint Francis appears to be kneeling in a rocky setting of a sort commonly used for penitent saints. In front of him is a high rocky outcrop with a makeshift crucifix on it. The oil sketch, on the other hand, clearly represents the Stigmatization of Saint Francis and is set in a flat landscape.

79 Virgin and Child

Cleveland, Cleveland Museum of Art 68.66 (Mr. and Mrs. Charles G. Prasse collection).

214 x 154 mm.; pen and brown ink with light brown wash over black chalk with touches of red chalk. Inscribed in brown ink at upper right corner: *Murillo*.

Provenance: J. de Mons; F. Mont; Mr. and Mrs. C. G. Prasse (donors to Museum, 1968).

References: Richards 1968, p. 235, fig. 1; Angulo 1974, p. 105, fig. 18.

Exhibitions: U. of Kansas 1974, no. 26, pl. 26; Los Angeles 1976, no. 226, repr.

The attribution of this drawing and its relation to the *"Santiago" Madonna and Child* (fig. 69) was first noted by Richards. In the painting, the Christ Child's head is turned to the viewer in order to draw the spectator into the intimate scene. Another pose of the Virgin's head is lightly sketched in black chalk to the left of the group.

The style is very close to cat. 77 and cat. 78, although the use of wash is unusual in this type of sketch. The customary procedure for this group was to sketch rapidly an initial idea in chalk, then to clarify it with the peculiarly choppy style of pen and ink. The addition of wash, however, is very effective and makes this sheet one of the finest among the late works.

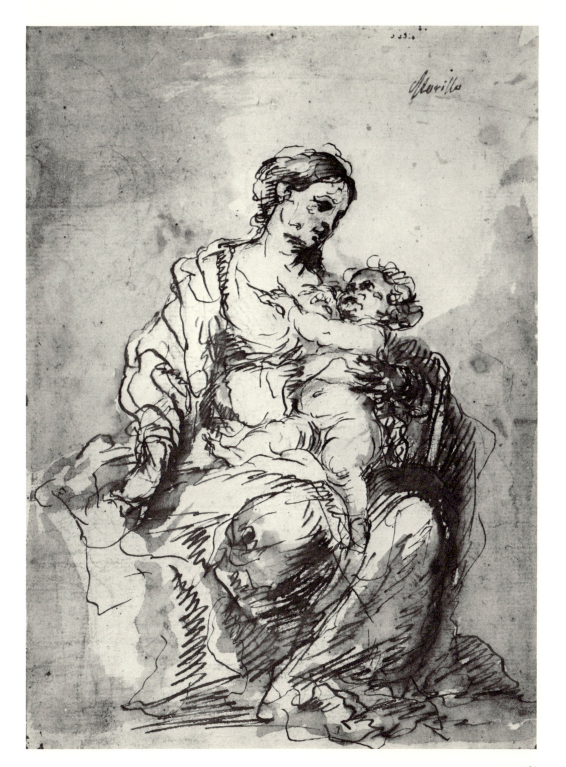

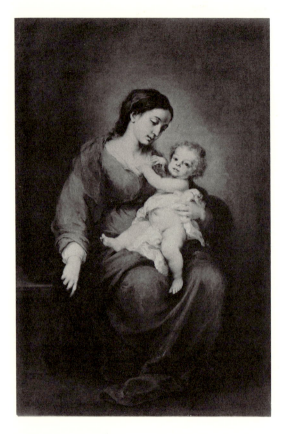

Figure 69. Murillo,
"Santiago" Madonna and Child.
New York, Metropolitan Museum of Art
(Rogers Fund) 43.13.
Oil on canvas, 209.6 x 154.3 cm.

80 *Standing Figure with Staff*

Madrid, collection of A. Escrivá de Romani y de Senmenat, Conde de Alcubierre.

200 x 150 mm.; pen and light brown ink with light brown wash. Mounted on folio 38 of album of drawings. Inscribed in brown ink at lower left: *Murillo fc.*

Provenance: M. Tellez-Girón, Duque de Osuna (1814-1882); 1st Conde de Alcubierre.

Reference: Angulo 1974, pp. 105-6, fig. 20.

Angulo first published the drawing and identified it as a preliminary study for the *Saint John the Baptist* painted in 1665 and 1666 for the Capuchinos, Seville. The attribution is correct but the identification of the subject with the Seville *Saint John* cannot be sustained. This figure wears a hat and carries a staff with a round object fastened at the top, whereas in the painting Saint John is bareheaded and has his hands clasped alongside his shoulders. Furthermore, the lamb, an ever-present attribute in Murillo's representations of Saint John the Baptist, is not shown in the drawing. Possibly it is meant to represent Saint James Major. In any case, the style of the drawing is later than 1670.

 The same inscription appears on cat. 18 and cat. 27.

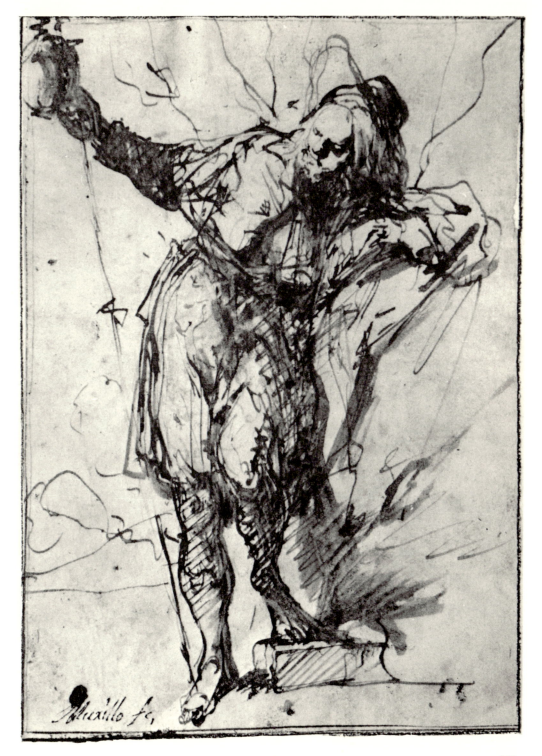

167

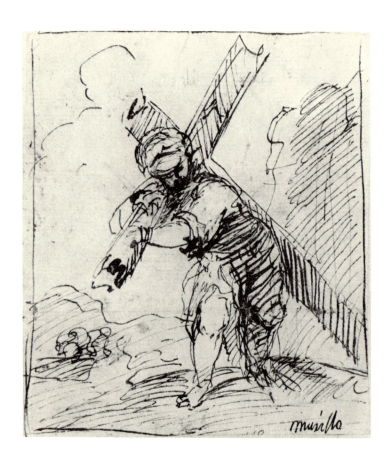

81 *Christ Child Carrying the Cross* (recto) and *Head of Child with Crown* (verso; not illustrated)

London, Courtauld Institute Galleries 152.

110 x 99 mm. Recto: pen and brown ink; signed in brown ink at lower right: *Murillo*; fragmentary number in bottom right margin. Verso: pen and brown ink.

Provenance: W. Stirling-Maxwell; J. Stirling-Maxwell; R. Witt.

References: *Hand-list* 1956, p. 161; Angulo 1974, p. 106.

Despite the inscription, the drawing was attributed to Ribera until Angulo recently assigned it to Murillo and dated it to the late period. A comparison with other drawings of the later 1670s, especially cat. 77-cat. 80, confirms this dating.

The subject is unusual. Pictures of Christ bearing the cross in a landscape are not commonly found in Seville during the seventeenth century and less to be seen are pictures of this subject that show him as a young child. The theme can be related, however, to the growing interest in representations of the Infant Christ that developed in Sevillian devotional art in the second half of the seventeenth century.

On the verso is a small sketch, not mentioned by Angulo, that appears to be by another hand.

82 Young Saint John the Baptist Standing with the Lamb

Hamburg, Kunsthalle 38571.

146 x 109 mm.; pen and brown ink with brown wash over black chalk. Laid down; repaired loss in lower left corner.

Provenance: J. A. Echevarría; B. Quaritch (vendor to Museum, 1891).

Until now catalogued as a school piece, this drawing can be attributed to Murillo and dated to his late period. The use of a thick-pointed pen is found in many drawings of this date. Also typical are the rough, energetic strokes used for shadows, which are here further fortified by brown wash. The zigzag shading on the saint's left leg is repeated in the left leg of *Man Holding a Hat* (cat. 87), as is the brisk, short hatching on the forehead. Another usual mannerism is the loose definition of hands and feet.

Saint John the Baptist appears as the subject in nine drawings by Murillo, or in about one-tenth of his known work.

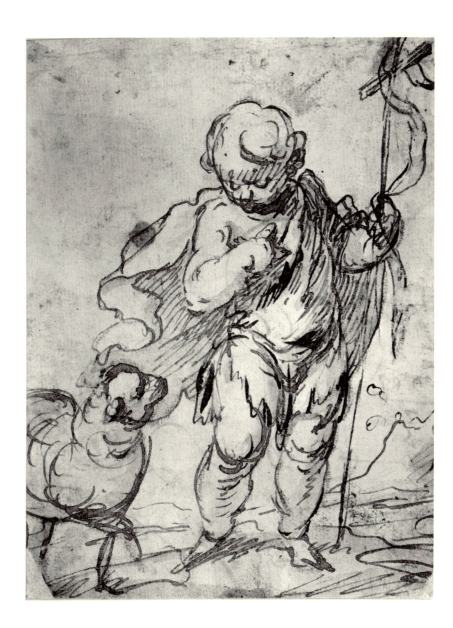

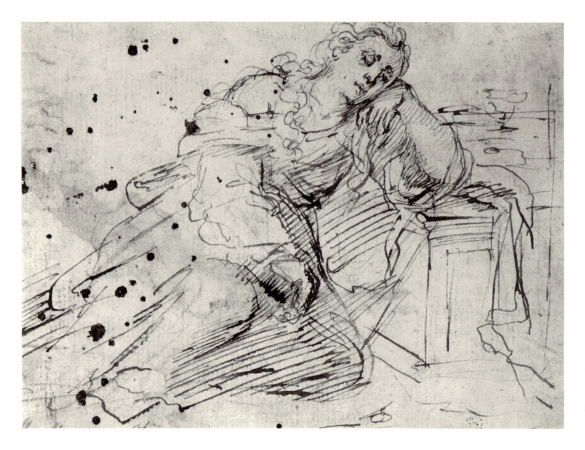

83 Saint Mary Magdalene Sleeping

Hamburg, Kunsthalle 38581.

115 x 158 mm.; pen and brown ink over black chalk. Laid down.

Provenance: J. A. Echevarría; B. Quaritch (vendor to Museum, 1891).

Reference: Angulo 1974, p. 102, fig. 16.

Angulo recently attributed the drawing and connected it with the figure of the sleeping woman in *Dream of the Patrician* in the Prado, painted for Santa María la Blanca in 1665. Although somewhat weaker than many drawings of the period, particularly in the face, it still seems to belong to the group of late drawings. The typical "crumpled" line, especially in the drapery hanging from the table, and the oversized, roughly drawn hands are entirely characteristic.

The relationship to the painting is, however, doubtful. Not only is the style too advanced for the date of the painting, but the subject is clearly Saint Mary Magdalene (and so listed by the Museum), as indicated by the sketchy but legible jar of unguents that is a traditional attribute.

84 Young Virgin
of the Immaculate Conception

London, British Museum 1946-7-13-1156.

234 x 149 mm.; pen and brown ink. Laid down. Inscribed by the Contemporary Collector in brown ink at lower center margin: *Bartolome Murillo. fat*.

Provenance: T. Phillipps; T. F. P. Fenwick (donor to Museum, 1946).

References: Popham 1935, p. 234, no. 2; Angulo 1969, p. 783; U. of Kansas 1974, p. 51.

This version of the Immaculate Conception is unusual because of the Virgin's young age. Although Francisco Pacheco (*Arte*, vol. 2, p. 210) counseled painters to show the Virgin Immaculate as a girl of twelve or thirteen years, this advice was not often followed. Among Murillo's work only one comparable example is known: an oil sketch in the Louvre (see Appendix 2, no. 16). Angulo denies the authenticity of this oil sketch, but it fully conforms to the style of other works in this format and medium. However, the relationship between the two is somewhat questionable. While the pose of the Virgin is similar, the arrangement of the putti is entirely different, exceeding the usual margin of difference between an early and later conception of a single composition.

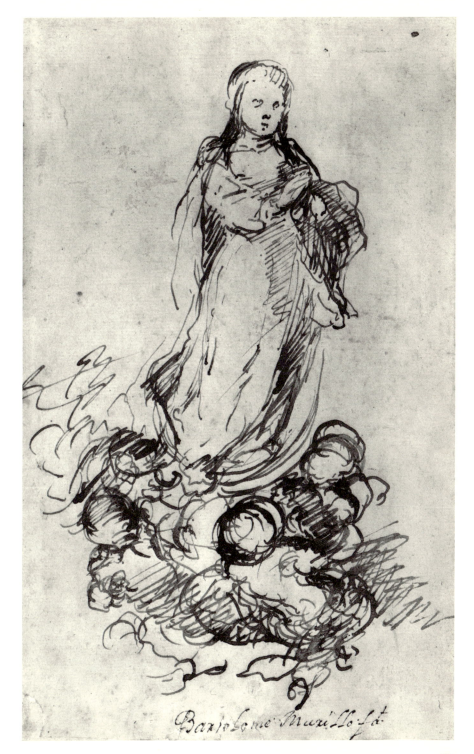

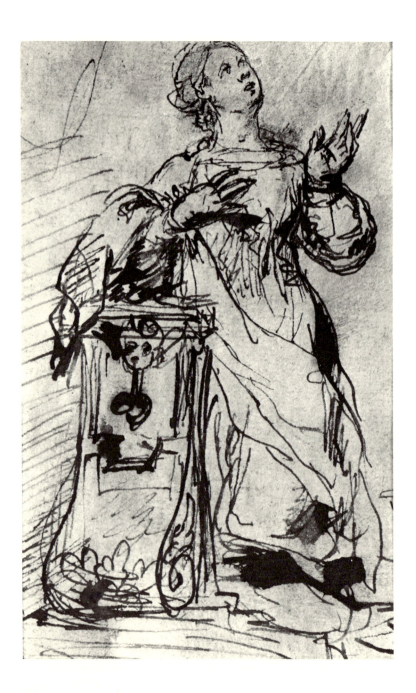

85 Virgin Annunciate

Madrid, Biblioteca Nacional 16.39, no. 47.

117 x 100 mm. (bottom), 117 x 75 mm. (top);
pen and brown ink over black chalk.

Provenance: unknown; acquired by Library, 1940.

Until now attributed to Alonso Cano, this drawing
is a late work by Murillo. Although the typical,
hurried manner of shading is minimally employed,
other characteristics—the facial type; the enlarged,
roughly drawn hands; and the heavy, broken out-
line—are features of Murillo's late style. The small,
dark areas of shadow that punctuate the form,
made entirely by pen without wash, are also com-
monly found in the drawings of the later 1670s.

86 Penitent Saint Peter

London, British Museum 1946-7-13-1155.

186 x 152 mm.; pen and brown ink. Signed in brown ink at lower left: *Murillo f.* and *19*.

Provenance: T. Phillipps; T. F. P. Fenwick (donor to Museum, 1946).

References: Popham 1935, p. 234, no. 1; U. of Kansas 1974, p. 51.

The traditional attribution, followed by Popham, is correct. The style is very close to cat. 84, cat. 85, and cat. 87, especially in the use of small dark areas of shadow and the loose, stringy line.

Murillo painted this subject several times, including a once-famous version done for the Hospital de los Venerables Sacerdotes in Seville in 1678. This important picture has recently come to light again (see Angulo 1974, pp. 156-60), but it is not related to this drawing, although the date might be considered appropriate.

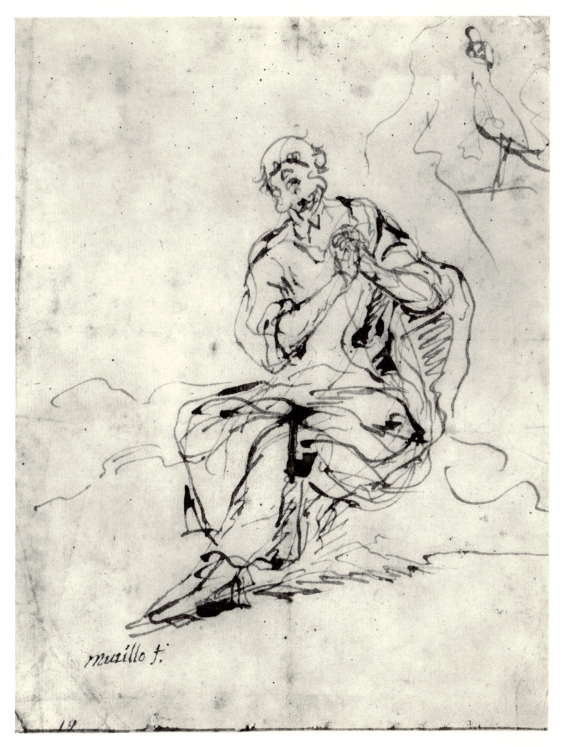

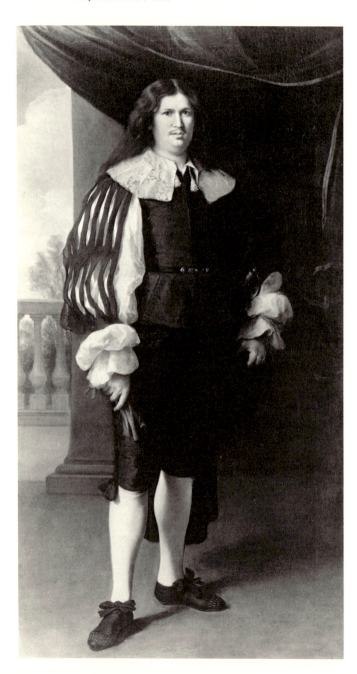

Figure 70. Murillo,
Man Holding a Hat.
New York, Cintas Foundation (now on loan to the Cummer Gallery of Art, Jacksonville, Fla.). Oil on canvas, 203 x 114 cm.

87 *Man Holding a Hat*

New York, Metropolitan Museum of Art 65.66.12 (Rogers Fund).

144 x 101 mm.; pen and brown ink. Inscribed by the Contemporary Collector at lower margin: *Bartolome Murill[o]*.

Provenance: J. Isaacs (Sotheby, January 28, 1965, lot 181) to Museum.

References: Angulo 1974, p. 107, fig. 29; Brown 1975, p. 63.

Exhibition: U. of Kansas 1974, no. 27, pl. 27.

Although Angulo associated this drawing with a painting formerly in the collection of F. Kleinberger (Mayer 1914, repr. opp. p. 232), it is closer to a portrait in the collection of the Cintas Foundation (fig. 70; *P.B.*). Both portraits show a gentleman standing in a doorway with a low balustrade, holding gloves in one hand and a hat in the other. A swag of drapery hangs in the upper right corner. Although the Cintas portrait differs in some respects from the drawing, it is considerably closer to it than the ex-Kleinberger portrait. The subject in the Cintas painting has the heavy build of the man in the drawing, whereas the other sitter is taller and thinner. He faces to the right, while the man in the ex-Kleinberger portrait faces to the left. There are also much closer similarities in costume. The Cintas figure has a cloak draped over the left arm, which falls toward the floor behind the left leg. The same arrangement of the cloak is visible in the drawing, but not in the ex-Kleinberger portrait, where it is worn at the shoulder. Also, the subjects of the Cintas portrait and the drawing wear a broad collar, while the other man wears the narrow *golilla*. Finally, the drapery swag in the two related works covers a wide area of the background as opposed to that in the other portrait, which is looped around a column.

There are differences, to be sure, between the Metropolitan Museum drawing and the Cintas Foundation painting. In the painting, the right foot is forward and the left is back. Also, the hat and glove are held in opposite hands. But the overall relationship is sufficiently close to imagine that these details could have been changed in the course of refining the composition. Furthermore, the style of the Cintas portrait indicates a date in the 1670s, which is compatible with the approximate date of the drawing.

88 Christ Child
as the Good Shepherd, Standing

Munich, collection of Family S.

130 x 104 mm.; pen and brown ink over black chalk; double borderline in brown ink. Inscribed by the Contemporary Collector in brown ink at lower center: *Bartolome Murillo fat*. Verso: fragmentary text of a letter.

Provenance: W. Stirling-Maxwell, Lt. Col. W. Stirling (Sotheby, October 21, 1963, lot 24).

References: Angulo 1961, p. 15, fig. 33; Angulo 1974, p. 106; U. of Kansas 1974, p. 51.

When Angulo first published this drawing, he associated it with cat. 1 and therefore dated it to Murillo's early period. It now seems clear, however, that the sheet was executed near the end of Murillo's career. In this, and the following drawings in this catalogue, the pen-and-ink style becomes ever more summary and abstract. Although some characteristic mannerisms survive, notably the zigzag hatching and the "crumpled" line, the style acquires a ragged quality that comes from hasty execution and avoidance of detail. The nervous calligraphy of these drawings virtually destroys volume, with the result that the forms become rather flat. Certain passages, such as the configuration in the left background, are so undefined as to be illegible. They are little more than broken, erratic lines, seemingly suspended in space. This manner must have evolved in the last few years of Murillo's life, as can be judged from the one datable drawing of the group (cat. 94).

89 Two Putti on Clouds

London, Courtauld Institute Galleries 153.

79 x 105 mm.; pen and brown ink. Laid down; repaired losses in left and right margins. Inscribed in brown ink at lower right corner: *murillo*.

Provenance: W. Stirling-Maxwell; R. Witt (Lugt Suppl. 2228b on mount).

References: *Hand-list* 1956, p. 161; U of Kansas 1974, p. 51.

The summary, abstract style of this small sheet indicates a date in the late 1670s. Typical characteristics of this period are the abbreviated hands and feet, the hasty execution of facial features, and the wiry, gnarled lines of the righthand putto.

 Murillo frequently used pairs of putti as accompaniments to the Virgin of the Immaculate Conception. Given the fact that these two figures seem to be directing their attention upward and beyond the limit of the sheet, it seems reasonable to assume that they were made as studies for a composition of this subject.

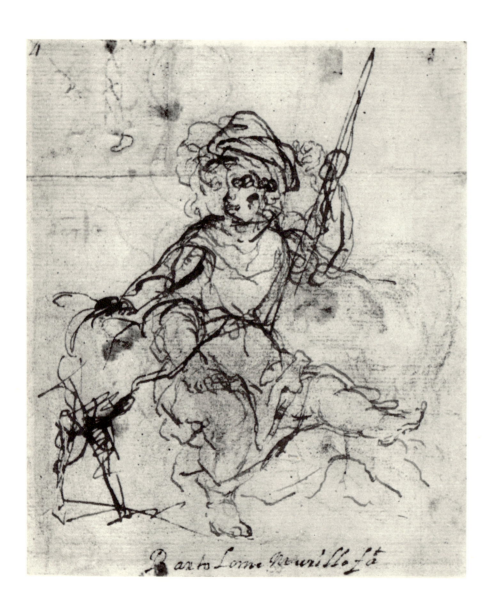

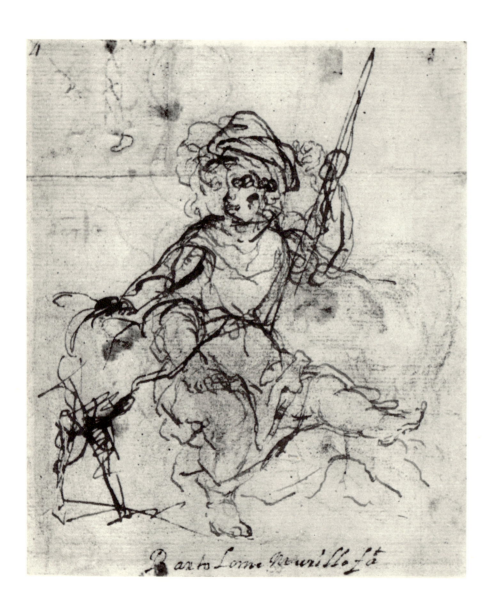
Bartolome Murillo fat.

90 Christ Child
as the Good Shepherd, Seated

Munich, collection of Family S.

134 x 118 mm.; pen and brown ink over black
chalk. Inscribed by the Contemporary Collector in
brown ink at lower center: *Bartolome Murillo fa*[t].
Verso: numbers.

Provenance: W. Stirling-Maxwell; Lt. Col. W.
Stirling (Sotheby, October 21, 1963, lot 24).

References: Angulo 1961, pp. 15-16, fig. 34;
Trapier 1966, p. 274; Angulo 1974, p. 106; U. of
Kansas 1974, p. 51.

In his article of 1961, Angulo identified this as a
preparatory sketch for the famous painting in the
Prado (962). In 1974, he reiterated this statement
and, on the basis of the painting's style, dated the
drawing to an early period. However, he also pub-
lished a second version of the subject (cat. 91) and
raised the possibility that both drawings repre-
sented a second version of the theme, based partly
on the Prado canvas but independent of it. The
latter hypothesis is the more plausible.

The Munich drawing, the first of the two, relates
to the painting in the Prado only in the pose of the
legs; otherwise it is clearly different. In this ver-
sion, Murillo was experimenting with alternatives
for various parts of the composition. Christ's head
is drawn twice, once leaning to the left, once held
upright. The right arm is shown in two positions:
resting on the knee and on the back of a sheep.
Murillo also tried out two positions for the left
arm, one touching the hat, the other holding a
staff. Finally, a second sheep, drawn in black
chalk, is placed at the right. In the second drawing,
these alternatives are resolved.

The important point to note is that whatever the
indecisions recorded here, a composition different
from the Prado painting was being constructed

(see cat. 91). Christ is meant to wear a hat, giving him a more rustic appearance. The shepherd's crook is to be held by the left, not the right hand. And a sheep is placed at the left rather than the right. For these reasons, these two drawings and the Prado painting must be regarded as separate conceptions.

Furthermore, the style of the drawing is very advanced. The harsh angularity and violent rhythms of the early style are nowhere in evidence. Rather, the loose, scrawling manner of the late years is employed.

91 Christ Child as the Good Shepherd, Seated

Paris, Cabinet des Dessins, Musée du Louvre 18.439.

150 x 118 mm.; pen and brown ink with brown wash over black chalk. Repaired loss in lower right corner. Inscribed in brown ink at upper right: *bartolome murillo*.

Provenance: unknown.

References: Trapier 1966, fig. 2; Angulo 1974, p. 106, fig. 24.

This is the second version of the composition found in cat. 90. Here the choices are made among the alternatives posed in the first drawing. Christ now holds the shepherd's crook upright in his left hand while his right hand rests on the neck of a sheep. At the right, the single sheep has been replaced by a view of the flock in the middle ground. Finally, a wooded setting is indicated at the left of the composition.

An oil sketch of this composition is mentioned by Curtis (1883, no. 326), though mistakenly identified as Saint John the Baptist.

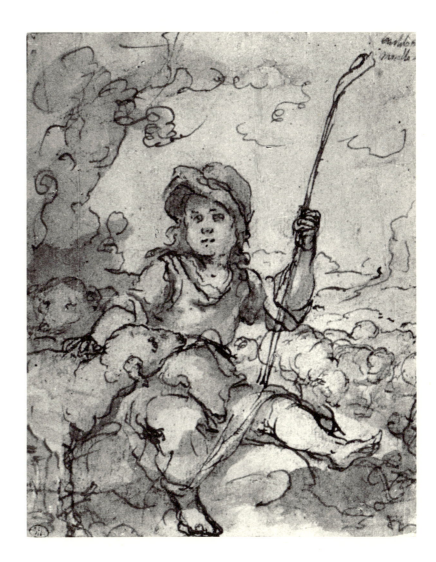

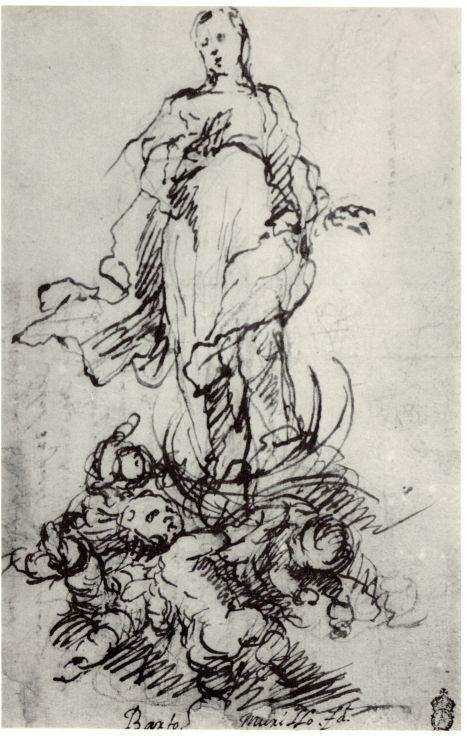

Barto. Murillo Fa.

92 Virgin of the Immaculate Conception

London, collection of Lord Clark of Saltwood.

193 x 130 mm.; pen and brown ink over black chalk. Repaired losses in upper right and left corners, in lower left corner, and in center lower margin. Inscribed by the Contemporary Collector in brown ink at lower margin: *Barto* [*lome*] *Murillo. fa*[t]. Verso: fragment of autograph letter from Francisco de Zurbarán to Murillo.

Provenance: J. Rushout, 2nd Earl of Northwick; G. Rushout, 3rd Earl of Northwick; Lady E.A. Rushout; E.G. Spencer-Churchill (Sotheby, November 1-4, 1920, lot 316); A.G.B. Russell (Lugt Suppl. 2770[a]; Sotheby, May 22, 1928, lot 118).

References: Mayer 1936, p. 47; Angulo 1962, pp. 233-36, repr.; Richards 1968, p. 238, fig. 5; Pérez Sánchez 1970, p. 92, fig. 29; U. of Kansas 1974, p. 51.

Exhibition: London, Royal Academy 1938, no. 479.

The drawing is on the other side of a fragmentary letter from Francisco de Zurbarán to Murillo, which was discovered and published by Angulo. The letter was written from Madrid and bears a partial date, September 27, 1[...]. Zurbarán spent the last years of his life in Madrid, so it was presumably between 1658 and 1664 that he wrote the letter, which discusses a sum of money to be paid by and to persons whose names are missing from the sheet. It might, then, be supposed that the drawing would be dated in the fifties or early sixties, but the style clearly points to a date in the 1670s and probably late in that decade. The broad manner of drawing and the absence of detail noticeable in the face and hands are found here and in related sheets (cat. 88-cat. 94). The discrepancy between the date of the letter and that of the

drawing can only be explained by imagining that Murillo retained the letter in his possession until, realizing at last that its purpose was done, he used it for this sketch.

93 Annunciation

London, private collection.

138 x 109 mm.; pen and brown ink over black chalk. Loss at upper left corner. Mounted on album sheet numbered 128, with copy of cat. 41 on verso. Inscribed by the Contemporary Collector in brown ink at lower margin: *Bartolome Murillo. fat.*

Provenance: unknown.

References: Young 1973, fig. 65; U. of Kansas 1974, p. 51.

Young dated this drawing to around 1660, but a date at least fifteen years later is more consistent with its style. The rapid movement of the pen results in a highly abstract style of drawing, culminating in the groups of putti above, which are little more than a tangle of wiry lines. Young also sought to connect the drawing to paintings of the *Annunciation* in the Prado (970) and the Hermitage (346), but there are no significant points in common between either of them and the drawing.

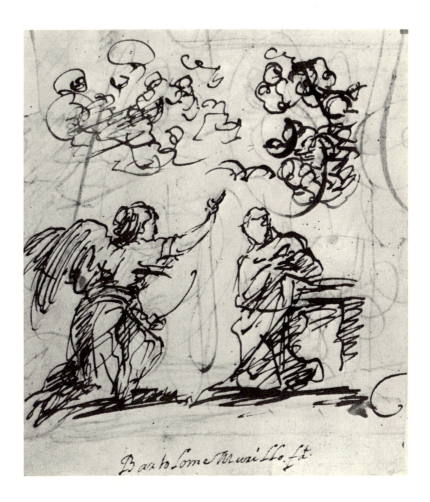

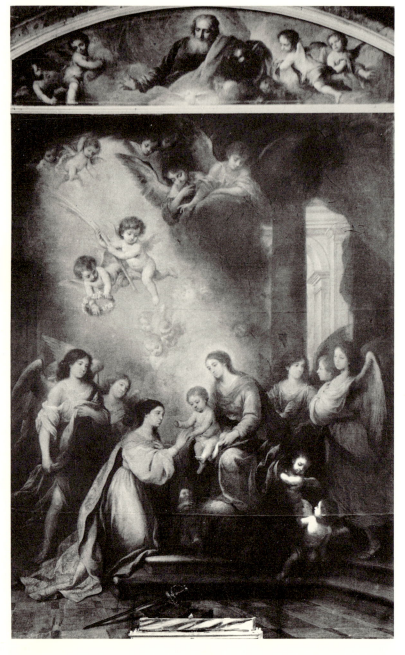

94 *Mystic Marriage of Saint Catherine* (recto) and *Virgin and Child Appear to a Franciscan Friar* (verso)

London, collection of Mortimer Brandt.

133 x 96 mm. Recto: pen and brown ink with brown wash. Verso: pen and brown ink; signed in brown ink: *La erre* and initials *B.M.* in florid script.

Provenance: S. Meller; A. Schmid; V. Bloch (Sotheby, May 13, 1964, lot 19).

References: Angulo 1961, pp. 14-15, fig. 31; Angulo 1974, pp. 97-98; U of Kansas 1974, p. 51.

Angulo published this drawing in 1961 and related the recto to the painting for the high altar of the church of the Capuchinos in Cádiz (fig. 71). This commission, Murillo's last documented work, was begun around 1680 and finished by an assistant after his death in 1682. According to Palomino, Murillo was fatally injured in a fall from the scaffolding erected to paint the picture. However, Angulo (1975, p. 4) has recently discovered that Murillo attended a meeting of the Hermandad de la Caridad in Seville a week before he died, thus disproving Palomino's novelesque version of his demise. There is even reason to doubt that Murillo went to Cádiz at all to paint the pictures for the altarpiece. The documentation adduced by Ambrosio de Valencina (1908, pp. 96-103) refers only to the trips made to Seville by the Guardian of the Monastery, P. Valverde, never to the fact that Murillo accompanied him. The paintings, which are on canvas, could have been done in Seville and transported to Cádiz. This hypothesis is strengthened by the fact that Murillo seems to have done little if any of the painting himself. Angulo is almost certainly right when he attributes

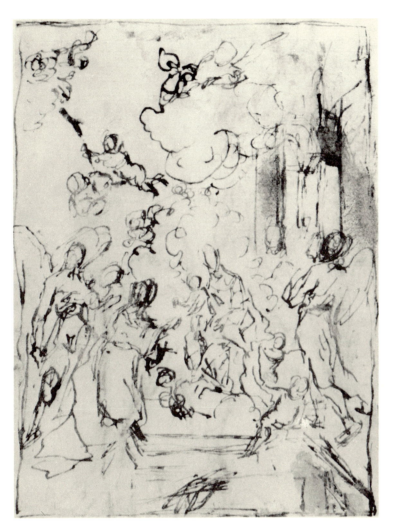 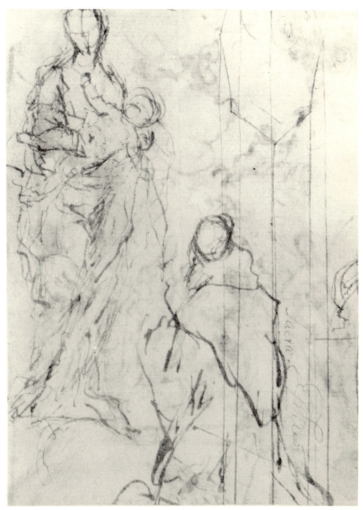

the execution of the entire altarpiece to Murillo's assistant, Francisco de Meneses Osorio.

The preparatory drawing is highly abstracted, perhaps in part because Murillo was not entirely able to control the movements of his hand. Despite the ragged forms and hasty annotations, the composition is legible and appears quite close to the final form. However, in order to guide his assistant, Murillo made an oil sketch (fig. 10; see Appendix 2, no. 33) that was followed in all but the smallest details. The main changes are the position of the arms of the angel at the far left and the addition of two putti in the upper right corner and two cherubim above the angels in the clouds.

The verso shows a Capuchin or Franciscan friar before a standing Virgin and Child. Angulo tentatively identified the subject as the Vision of Saint Felix of Cantalice, but the absence of attributes does not permit a definite identification. While Saint Felix would have been appropriate for the church of the Capuchinos, no picture of him was ultimately executed for this commission. The verso also contains a short inscription, apparently in Murillo's hand, followed by his initials. It reads, "*La erre*," or "I made a mistake." Perhaps this refers to the fact that he had composed a subject that was not required for the altarpiece.

A second pen-and-ink drawing for this picture is mentioned by Curtis (1883, no. 264) as having been in the collections of the painter A.R. Mengs and the art critic Paul Lefort. It measured 280 x 200 mm. and was sold as lot 154 in the Lefort sale (Paris, January 28, 1869).

The drawings in cat. 88-cat. 94 are closely related in style, all having been done in the later 1670s.

95 Peasants on Mules, Before a Ruined Gate, Speaking to a Man and Boy (not illustrated)

Collection unknown.

216 x 133 mm.; "pen and wash with touches of crayon." Inscribed by the Contemporary Collector: *Bartolome Murillo fat.*; inscribed at upper left corner: *16*.

Provenance: possibly C. Morse (Sotheby, July 4, 1873, lot 153); H. Huth; J. Tregaskis.

Exhibition: London, J. Tregaskis 1915, no. 354, repr.

Although I know this drawing only from the poor photograph in Tregaskis's catalogue, the attribution seems plausible. In addition, the inscription of the Contemporary Collector lends some weight to the attribution.

Genre scenes are rarely found among Murillo's drawings, although they consitute the most celebrated group of his paintings. The composition of this work is unusually ambitious and recalls, perhaps even more forcefully than do the paintings, Murillo's debt to the *bamboccianti*.

CHECKLIST OF REJECTED ATTRIBUTIONS

This list contains drawings that in my opinion have been attributed incorrectly to Murillo. Attributions to Murillo are legion; as one of the best-known Spanish artists, his name is inscribed on an enormous number and variety of drawings. Therefore, I have restricted the list to drawings that have been published and reproduced as by Murillo. Also to be considered rejected attributions—with the exception of drawings in the catalogue section of this volume—are all drawings now given to Murillo in the following collections: Boston, Museum of Fine Arts; Frankfurt, Staedelisches Kunstinstitut; Hamburg, Kunsthalle; London, British Museum; London, Courtauld Institute Galleries; Madrid, Biblioteca Nacional; New York, Metropolitan Museum of Art; Paris, Musée du Louvre; and Vienna, Graphische Sammlung Albertina.

x-1 Chantilly, Musée Condé
Virgin and Child Appearing to a Monk
See Gómez Sicre 1949, pl. 64; Sánchez Cantón 1964, pl. 56.

x-2 Frankfurt, Staedelisches Kunstinstitut 13655
Young Saint Thomas of Villanueva Giving Away His Clothes
See *Stift und Feder* 1926, pl. 38.
A copy of a painting in the Cincinnati Art Museum (1927.412).

x-3 Hamburg, Kunsthalle 38582
Liberation of Saint Peter
See Hamburg 1966, no. 176, pl. 47.

x-4 Hamburg, Kunsthalle 38595
Birth of the Virgin
See Mayer 1918, fig. 4.
A partial copy of a painting in the Louvre (1710).

x-5 London, British Museum 1920-12-45
Vision of Saint Anthony of Padua
See Mayer 1915, pl. 5.
An eighteenth-century drawing.

x-6 Madrid, Biblioteca Nacional B.345
Miracle of the Loaves and Fishes
See Mayer 1915, pl. 48; Lafuente Ferrari 1937, pl. 5, fig. 8.
A copy of a painting in the church of the Hermandad de la Caridad, Seville.

x-7 Madrid, Biblioteca Nacional B.353
Virgin and Child Appearing to Saint Francis
See Madrid 1927, pl. 39.
Possibly by Cerezo.

x-8 Madrid, Biblioteca Nacional B.354
Galloping Horse and Rider
See Sánchez Cantón 1964, pl. 52.
A study by Carreño de Miranda for *Saint James Defeating the Moors*, Szépmüvészeti, Budapest.

x-9 Madrid, Biblioteca Nacional B.356
Head of a Man
See Sánchez Cantón 1964, pl. 53.
Possibly by Carreño.

x-10 Madrid, collection of Conde de Alcubierre
Virgin and Child
See Angulo 1974, p. 104, fig. 13.

x-11 Madrid, Museo Cerralbo
Standing Man
See Mayer 1913, repr. p. xviii.
Italian, sixteenth century.

x-12 Madrid, Museo del Prado F.A. 86
Holy Family
See Sánchez Cantón 1930, vol. 5, pl. 415.
Reattributed by Pérez Sánchez 1972, p. 106, to an anonymous follower.

x-13 Madrid, Museo del Prado F.A. 87
Infant Saint John the Baptist
See Sánchez Cantón 1930, vol. 5, pl. 417.
Reattributed by Pérez Sánchez 1972, p. 106, to an imitator.

x-14 Madrid, Museo del Prado F.D. 37
Head of a Man
See Sánchez Cantón 1930, vol. 5, pl. 416.
Reattributed by Pérez Sánchez 1972, p. 106, to Carreño.

x-15 Madrid, Museo del Prado F.D. 1625
Immaculate Conception
See Sánchez Cantón 1930, vol. 5, pl. 423.
Reattributed by Pérez Sánchez 1972, pp. 82-83, to Claudio Coello.

x-16 Madrid, Museo del Prado F.D. 1625a
Two Putti
See Sánchez Cantón 1930, vol. 5, pl. 424.
Reattributed by Pérez Sánchez 1972, p. 161, as anonymous.

x-17 Madrid, Museo del Prado F.D. 2220
Standing Monk
See Sánchez Cantón 1930, vol. 5, pl. 422.
Reattributed by Pérez Sánchez, 1972, pp. 160-61, as anonymous.

x-18 New York, Hispanic Society of America A3301
Immaculate Conception
See Sánchez Cantón 1964, pl. 55; U. of Kansas 1974, fig. 2.
A copy; see also cat. 38, above.

x-19 New York, Metropolitan Museum of Art 80.3.494
Vision of Saint Anthony of Padua
See Sánchez Cantón 1930, vol. 5, pl. 419.

x-20 Paris, art market
Presentation of Christ
See Angulo 1974, p. 107, fig. 8.
A follower.

x-21 Paris, Musée du Louvre 896
Monk Reading, Surrounded by Angels
See Rouchès 1939, pl. 3.
A follower.

x-22 Paris, Musée du Louvre 18.430
Immaculate Conception
See Mirimonde 1963, fig. 14.

x-23 Paris, Musée du Louvre 18.433
Sleeping Man
See Sánchez Cantón 1964, pl. 60.

x-24 Paris, Musée du Louvre 18.441
Saint Anthony of Padua
See Baticle 1961, repr. p. 53.

x-25 Collection unknown, formerly Boix collection, Madrid
Christ on the Cross
See Sánchez Cantón 1930, vol. 5, pl. 418.
A copy; see also cat. 55, above.

x-26 Collection unknown, formerly Boix collection, Madrid
Saint Joseph and the Christ Child
See Sánchez Cantón 1930, vol. 5, pl. 414.
A follower.

x-27 Collection unknown, formerly Vivant Denon collection, Paris
Saint Francis of Assisi
See Denon, *Monuments* 1829, vol. 3, repr. p. 237.

This list is necessarily partial and preliminary. Murillo's oil sketches have long been considered as copies and thus have tended to disappear from sight. Yet their importance for understanding Murillo's art is so great that it seems desirable to begin the task of rediscovering them. Curtis lists about seventy or eighty works that may be regarded as sketches, although often his entries do not supply sufficient information to make a distinction between a small painting and an oil sketch. Neither does he pass judgment on the authenticity of many of the works he lists. In the checklist, I have recorded basic information on over thirty sketches that I have seen either in the original or in good photographs. Whenever possible, I have given a reference to a published reproduction. Otherwise, photographs were consulted in the Witt Library, Courtauld Institute of Art, London; and in the Platt Collection, Department of Art and Archaeology, Princeton University.

It is not always easy to determine the point at which an oil sketch becomes a small painting. The criteria used here to govern admission to the list are twofold, degree of finish and size. Murillo's oil sketches average around 30 cm. in height, although some are as large as 60 cm. Their execution is obviously hasty and unfinished, especially in the face and hands.

Only the principal references are given in the entries. Provenance is given when it postdates the information found in Curtis, or when the work is not listed by Curtis. All the works are on canvas.

Collections Known

1 England, private collection
Moses and the Miracle of the Waters
32.9 x 74.6 cm.

Provenance: Viscount Ednam (Christie, July 1, 1966, lot 75) to Agnew.

References: Curtis 1883, no. 15; Calvert 1907, p. 156; "Notable Works of Art Now on the Market," *Burlington Magazine* 110 (December 1967), pl. 11.

A study for a painting of 1666-1670 in the church of the Hermandad de la Caridad, Seville; see fig. 9, above.

2 Leningrad, Hermitage 369
Holy Family
23 x 18 cm.

References: Curtis 1883, no. 138; Mayer 1913, pl. 56.

3 Lockinge (Berks), collection of C.L. Loyd
Virgin of the Immaculate Conception
36 x 27.3 cm.

Provenance: Lady Wantage; A.T. Loyd.

References: Curtis 1883, no. 35; Parris 1967, no. 48, fig. 48.

A study for a painting in the Detroit Institute of Arts. A copy is in the Bayerisches Staatsgemaldesammlungen.

4 Lockinge (Berks), collection of C. L. Loyd
Virgin and Child in Glory

36 x 25.3 cm.

Provenance: Lady Wantage; A. T. Loyd.

References: Curtis 1883, no. 80; Parris 1967, no. 47, fig. 47.

A study for the *"Vierge Coupée,"* Walker Art Gallery, Liverpool.

5 London, Dulwich College Picture Gallery 276
Adoration of the Magi

38 x 27 cm.

Provenance: N. Desenfans; F. Bourgeois.

Reference: Curtis 1883, no. 125a (as copy?).

Related to a painting in the Ehrich sale, American Art Association, April 18-19, 1934, lot 46.

6 London, Dulwich College Picture Gallery 272
Christ Child as the Good Shepherd

44.5 x 31.5 cm.

Provenance: N. Desenfans; F. Bourgeois.

Reference: Curtis 1883, no. 173f or g.

See fig. 13 and cat. 26, above.

7 London, Dulwich College Picture Gallery 275
Two Putti Contemplating the Crown of Thorns

9.5 x 25.7 cm.

Provenance: N. Desenfans; F. Bourgeois.

Reference: Curtis 1883, no. 236f.

8 London, Wallace Collection P3
Virgin and Child in Glory Adored by Saints Felix of Cantalice, John the Baptist, Justa, and Rufina

71 x 52 cm.

References: Curtis 1883, no. 116; *Wallace Collection* 1968, p. 208.

See fig. 68 and cat. 77, above.

9 London, Wellington Museum 68
Saint Francis of Assisi Receiving the Stigmata

51.7 x 46 cm.

Provenance: Royal Palace, La Granja.

Reference: Wellington 1901, vol. 1, p. 138.

See cat. 78, above.

10 Madrid, Museo del Prado 997
Prodigal Son Receives His Inheritance

27 x 34 cm.

Provenance: Royal Palace, Madrid, in 1814.

Reference: Curtis 1883, no. 183.

This and the following three entries are studies for paintings in the collection of A. Beit, Blessington. Another set of these sketches was sold in the Louis Philippe sale (Curtis 1883, nos. 184a, 186a, 188a, and 191a).

11 Madrid, Museo del Prado 998
Departure of the Prodigal Son

27 x 34 cm.

Provenance: Royal Palace, Madrid, in 1814.

Reference: Curtis 1883, no. 186.

12 Madrid, Museo del Prado 999
Prodigal Son Feasting

27 x 34 cm.

Provenance: Royal Palace, Madrid, in 1814.

Reference: Curtis 1883, no. 188.

13 Madrid, Museo del Prado 1000
Prodigal Son Feeding Swine

27 x 34 cm.

Provenance: Royal Palace, Madrid, in 1814.

Reference: Curtis 1883, no. 191.

14 New York, Metropolitan Museum of Art
(bequest of Harry G. Sperling)
Christ on the Cross

49 x 32 cm.

Provenance: D. Loftus, 18th Baron Hastings; B.E.
Delaval, 19th Baron Hastings; G. Mainers, 20th
Baron Hastings; A.E. Delaval, 21st Baron
Hastings; R. Abdy; H. Sperling.

Reference: Curtis 1883, no. 218.

A study for a painting in the Prado (966).

15 Pamplona, collection of M. Bandrés
Saint Felix of Cantalice

27 x 35 cm.

References: Curtis 1883, no. 278b (?); Goya
1955, p. 67, no. 7.

16 Paris, Musée du Louvre 1941-440
Immaculate Conception

35 x 25 cm.

Provenance: Gortazar; Mazzarredo; Napoleon IV.

See cat. 84, above.

17 Scarsdale, N.Y., collection of J. O'Connor
Lynch
Caritas Romana

31.1 x 40.6 cm.

References: Curtis 1883, no. 402a (as "old
copy"); Binghamton 1969, pl. 38.

See fig. 12 and cat. 70, above.

18 Strasbourg, Musée des Beaux-Arts de la Ville
596
Saint Thomas of Villanueva Distributing Alms

47 x 33 cm.

Provenance: acquired by Museum, 1910.

Reference: *Catalogue des Peintures Anciennes*
1938, no. 307.

A study for a painting executed in 1668 and 1669
for the church of the Capuchinos, Seville (now in
Museo Provincial de Bellas Artes, Seville).

19 Tokyo, National Museum of Western Art P-376
Saints Justa and Rufina

34 x 24 cm.

Provenance: J. Stirling-Maxwell.

Reference: Angulo 1964, pp. 278-79, fig. 9.

See fig. 11 and cat. 33, above.

Collections Unknown
(listed by subject category)

OLD TESTAMENT APOCRYPHA

20 *Angel of Tobias*

30.5 x 22 cm.

Provenance: H. Seymour; Museum of Saint Gall;
J. Böhler; T. Harris.

References: Curtis 1883, no. 236; London 1938,
repr. p. 55.

LIFE OF CHRIST

21 *Holy Family in Joseph's Workshop*
Dimensions unknown.

Provenance: Florence Anita, Countess of North-
brook (Christie, June 11, 1937, lot 11) to V.
Bloch.

Reference: Curtis 1883, no. 142.

22 *Holy Family in Joseph's Workshop*
Dimensions unknown.

Reference: Mayer 1913, pl. 254 (as copy).

A study for a painting at Chatsworth (see Mayer
1913, pl. 55).

23 *Saint Joseph and the Christ Child*

29 x 22 cm.

Provenance: C.G. Candamo (Paris, December
14-15, 1933, lot 39, pl. 11).

References: Curtis 1883, no. 349; Angulo 1961, p.
12, fig. 24.

A study for a painting in the F. Valdés collection,
Bilbao.

24 *Baptism of Christ*

36.8 x 25.4 cm.

Provenance: F. T. Sabin (1951).

Reference: *Connoisseur* 128 (August 1951), repr. p. xviii (in advertisement).

A study for a painting of 1668 in the baptismal chapel of Seville Cathedral. Another sketch of larger dimensions (50 x 64 cm.) was in the López Cepero collection (see Curtis 1883, no. 178e).

25 *Miracle of the Loaves and Fishes*

33.6 x 76.2 cm.

Provenance: M. Asscher, London (1970).

Reference: Curtis 1883, no. 181.

A study for a painting of 1666-1670 in the church of the Hermandad de la Caridad, Seville.

26 *Lazarus and Dives*

31.7 x 32.4 cm.

Provenance: Earls of Ellesmere.

References: Curtis 1883, no. 193b; Mayer 1913, pl. 116; Angulo 1966, pp. 166-67 and 175.

An oil sketch of this subject was in Murillo's atelier at his death.

27 *Christ Giving the Keys to Saint Peter*

36.8 x 25.4 cm.

Provenance: F. T. Sabin (1951).

Reference: *Connoisseur* 128 (August 1951), repr. p. xviii (in advertisement).

28 *Heavenly and Earthly Trinity*

48 x 38 cm.

Provenance: H. Say (Paris, November 30, 1908, repr.).

Reference: Curtis 1883, no. 135a (?).

29 *Virgin and Child Giving Bread to Priests*

63.5 x 57.1 cm.

Provenance: Ehrich Galleries, New York (1920).

Reference: Curtis 1883, under no. 113.

A study for a painting executed in 1678 for the refectory of the Hospital de los Venerables Sacerdotes, Seville (now in Szépművészeti, Budapest).

LIFE OF THE VIRGIN

30 *Virgin of the Immaculate Conception*

53.3 x 38.1 cm.

Provenance: R. G. Price (1892); Kenny (New York, April 3, 1937, lot 42); Koetser, London 1937).

31 *Standing Virgin and Child*

Dimensions unknown.

Reference: Angulo 1964, p. 279, fig. 10.

A study for the *Vision of Saint Bernard* in the Prado.

SAINTS

32 *Vision of Saint Anthony of Padua*

63.5 x 40.6 cm.

Provenance: W. S. Stewart (Sotheby, December 7, 1927, lot 43).

Reference: Curtis 1883, no. 244.

See cat. 62, above.

33 *Mystic Marriage of Saint Catherine*

73.3 x 53.3 cm.

Provenance: I. M. Scott (Mendelssohn Hall, New York, 1906, lot 31).

Reference: Curtis 1883, under no. 264.

See fig. 10 and cat. 94, above.

34 *Saint Felix of Cantalice and the Christ Child*

46 x 35 cm.

Provenance: R. Langton Douglas.

A study for a painting in the collection of the Earl of Wemyss (see Mayer 1913, pl. 91 [as Saint Francis of Paula]).

35 *Saint Joseph and the Christ Child Seated*

24 x 33 cm.

Provenance: Lord Profumo (Christie, June 27, 1975, lot 83, repr.).

36 *Pope Alexander VII Signing a Bull in Favor of the Doctrine of the Immaculate Conception*

34 x 25 cm.

Provenance: A. L. Nicholson (1927); Heinemann, Munich.

A copy of a preparatory drawing by Murillo for this composition was recently on the Paris art market (1975).

DRAWINGS BY MURILLO
IN THE COLLECTION OF BARON ST. HELENS

The sale of the collection of drawings belonging to Alleyne Fitzherbert, Baron St. Helens, contained approximately sixty works attributed to Murillo. According to the catalogue, St. Helens had obtained the drawings *en bloc* from the Cathedral Library in Seville between 1790 and 1794, when he served as the British Ambassador Extraordinary to Spain. The sale of works of art by Spanish cathedral chapters was not unusual at the time and there is no reason to doubt the provenance. Naturally the provenance is no more a guarantee of authenticity in this case than in any other. But it may be imagined that the Cathedral had obtained the drawings as a gift from a private person, who may have kept an earlier collection intact. Whatever the ultimate provenance, the few drawings that can now be traced are mostly undoubted works by Murillo, indicating that the collection was made with knowledge and discrimination. One of the most surprising aspects of the group is the large number of red and black chalk drawings, which furnishes valuable evidence that Murillo often employed this medium. In the hope that some of these drawings may still exist unrecognized in public and private collections, the relevant lots in the 1840 sale are listed here (retaining the original orthography). Unfortunately, the dimensions are not given and the identification of subject matter is often careless or inaccurate, making it impossible to rely absolutely on the entries. The subsequent history of each drawing, where known, is given in brackets following the entry.

[From *A Catalogue of the Valuable and Choice Collection of Drawings by the Ancient Masters of the Italian, French and Dutch Schools; a highly interesting assemblage of sketches, by Murillo, obtained from the Cathedral Library, at Seville, and a few prints, The Property of the late Right Hon. Lord St. Helens. Christie & Manson, Tuesday, May 26th, 1840*]

ORIGINAL SKETCHES BY MURILLO, IN PEN AND BISTRE
Obtained by Lord St. Helens from the Cathedral Library, at Seville

90. Five Sketches of Saints
91. Slight pen sketches
92. Sta. Veronica, and head of St. Peter
93. Sketches of Angels [Perhaps British Museum 1873-6-14-212; see cat. 11, above.]
94. St. Joseph and the Infant; and St. Francis with the Crucifixion—on the reverse [The Saint Francis may be related to cat. 27 and cat. 28, above.]
95. The Infant St. John, pen and Indian ink; St. Sebastian on the reverse on blue paper
96. Two of Angels [Public Library, Museum and Art Gallery, Folkestone; they are copies of cat. 42 and cat. 48, above.]
97. An Angel; and the Crucifixion by Alonzo Cano
98. The marriage of the Virgin
99. The Assumption of the Virgin—a pair
100. The Crucifixion; St. John at the foot of the Cross
101. The Assumption of the Virgin, with Angels, in pen; a sketch on the reverse [possibly Hamburg, Kunsthalle 38570, which is now laid down; see cat. 34, above.]

102. St. Joseph, with the sleeping Infant; and St. Francis leading a cow [Boston, Museum of Fine Arts 20.811; see cat. 2, above.]

103. The Virgin and Child; and the Roman Charity [Rotterdam, Museum Boymans-van Beuningen S-8; see cat. 70, above.]

104. St. Francis; the Temptation; and the Baptism of Constantine

SKETCHES BY MURILLO IN RED AND BLACK CHALK

105. A group of Angels on blue paper [A drawing entitled *Etude d'Anges* in red chalk, 240 x 250 mm., was sold as lot 153 in the Lefort sale of 1869. Another sheet, called "a highly finished Study of Angels, in black and red chalks," was sold by C. Morse (Sotheby, July 4, 1873, lot 151). It came from the collection of Lord Northwick.]

106. St. John, the Assumption, and another sketch

107. A man's portrait, and one by A. Cano on the reverse

108. The Virgin and Child, in black chalk—small

109. St. Francis healing the sick, with a sketch on the reverse

110. St. Francis receiving the Infant; and the Virgin and Child, heightened with white, on the reverse [The "St. Francis" may be Saint Anthony of Padua and the drawing may have been the one in the H. Wellesley sale (Sotheby, June 25, 1866, lot 898), which measured 184 x 260 mm.]

111. St. Francis, with the Infant Christ sleeping on the reverse

112. The Presentation in the temple

113. A group of Angels

114. The Assumption of the Virgin, on blue paper

115. The Magdalene praying [See cat. 31, above.]

116. The Infant St. John, with the lamb [Possibly Hamburg, Kunsthalle 38584; see cat. 32, above.]

117. The Virgin and Child at a Window

118. St. Joseph leading the Infant, two Angels above [Hamburg, Kunsthalle 38583; see cat. 58, above.]

119. Sta. Justa and Sta. Rufina bearing the tower of the Capuchins at Seville [Perhaps a study for a painting for the Capuchinos, Seville; now in Museo Provincial de Bellas Artes, Seville. A copy of the painting in black and red chalk is in Pittsburgh, Pa., Carnegie Institute Museum of Art 341. See cat. 33 and fig. 59, above.]

120. Head of the Virgin, and Salvator Mundi

121. Heads of Christ and the Virgin on blue paper

122. St. Roch distributing alms; the head of the saint only finished [Possibly a study for a painting of Saint Thomas of Villanueva Distributing Alms. Versions of this subject are in Seville (Museo Provincial de Bellas Artes), London (Wallace Collection), Pasadena (Norton Simon Museum of Art), and Munich (Alte Pinakothek).]

123. The Virgin in adoration before the sleeping Infant; *a beautiful study*

124. The Madonna

125. A bishop attended by priests before an altar, the sketch for the great altar at Seville, and two heads for the same [A study perhaps related to an oil sketch listed in Appendix 2, no. 36.]

126. The Nativity; *a grand composition* [Probably London, British Museum 1895-9-15-891; see cat. 61, above.]

127. The Infant Christ sleeping on his cross, a skull by his side; *a beautiful design* [London, British Museum 1858-7-24-1; see cat. 23, above.]

128. Sta. Theresa with the Infant

129. Two heads of the Magdalen in red chalk

130. The three Maries at the foot of the cross

131. The good shepherd; *the study for Sir Simon Clarke's picture* [Hamburg, Kunsthalle 38580; see cat. 26, above.]

132. St. John, with the lamb; the sketch for Sir Simon Clarke's picture [Norfolk, Va., Chrysler Museum 50.49.18; see cat. 25, above.]

133. The Virgin and Child; *a sketch from the picture in the Capitol* [Perhaps a study for the so-called *Gypsy Madonna*, now in the Galleria Nazionale d'Arte Antica, Rome.]

134. Ecce Homo; *very fine*

135. The Holy Family, washed with red; *very elegant*

136. The Assumption of the Virgin

137. The Virgin and Child; *a beautiful finished study* [Possibly C. Morse sale, Sotheby, July 4, 1873, lot 142.]

BIBLIOGRAPHY OF WORKS CITED

Abbreviations of frequently cited periodicals
AEA = Archivo Español de Arte
*BSEE = Boletín de la Sociedad Española
de Excursiones*

Angulo Iñiguez, Diego. "La Academia de Bellas Artes de Méjico y sus pinturas españolas." *Arte en América y Filipinas* 1 (1935):1-75.

——. "Miscelánea murillesca." *AEA* 34 (1961):1-24.

——. "Murillo: Varios dibujos de la 'Concepción' y de 'Santo Tomás de Villanueva.'" *AEA* 35 (1962):231-36.

——. "El retrato de Nicolás de Omazur adquirido por el Museo del Prado; varios bocetos; la 'Adoración' de Leningrad." *AEA* 37 (1964):269-80.

——. "Bartolomé Murillo: Inventario de sus bienes." *Boletín de la Real Academia de la Historia* 158, no. 2 (1966):148-80.

——. "Las pinturas de Murillo, de Santa María la Blanca." *AEA* 42 (1969):13-42.

——. "Un dibujo de Murillo para el cuadro de San Salvador de Horta." *AEA* 43 (1970):407-8.

——. "Quelques tableaux de Murillo." In *22nd International Conference on the History of Art.* Vol. 2, pp. 781-84. Budapest, 1972.

——. "Los pasajes de Santo Tomás de Villanueva de Murillo en el Museo de Sevilla y en la colección Norton Simon de Los Angeles." *AEA* 46 (1973):71-75.

——. "Murillo: Dibujo del Museo de Boston para el 'San Francisco Solano' del Alcázar de Sevilla." *AEA* 46 (1973):435-36.

——. "Algunos dibujos de Murillo." *AEA* 47 (1974):97-108.

——. "El 'San Pedro' de los Venerables de Sevilla." *AEA* 47 (1974):156-60.

——. *Murillo y su escuela en colecciones particulares.* Servicios de Acción Cultural de la Caja de Ahorros San Fernando de Sevilla. Seville, 1975.

Angulo, D., and Pérez Sánchez, A. E. *A Corpus of Spanish Drawings.* Vol. 1: *1400-1600.* London, 1975.

Banda y Vargas, Antonio de la. "Los estatutos de la Academia de Murillo." *Anales de la Universidad Hispalense* 23 (1961):107-20.

Barcia, Angel M. de. *Catálogo de la colección de dibujos originales de la Biblioteca Nacional.* Madrid, 1906.

Bartsch, Adam. *Le Peintre Graveur.* Vol. 18. Vienna, 1818.

Baticle, Jeanine. "Le Dessin en Espagne au XVIIe siècle." *L'Oeil,* no. 81 (September 1961):49-53, 82.

——. "Un Tableau de Murillo." *Revue du Louvre* 14 (1964):93-96.

Bayne, William. *Sir David Wilkie, R.A.* London, 1903.

Binghamton 1969. *The Lynch Collection.* University Art Gallery, State University of New York at Binghamton, April 20-May 8, 1969.

Brown, Jonathan. "Notes on Princeton Drawings 8: Bartolomé Esteban Murillo." *Record of The Art Museum, Princeton University* 32, no. 2 (1973):28-33.

———. "Pen Drawings by Herrera the Younger." In *Hortus Imaginum: Essays in Western Art*, edited by R.E. Enggass and M. Stokstad. Lawrence, Kans., 1974.

———. Review of *Spanish Baroque Drawings in North American Collections*. *Master Drawings* 13, no. 1 (1975):60-63.

———. "Drawings by Herrera the Younger and a Follower." *Master Drawings* 13, no. 3 (1975):235-40.

Calvert, Albert F. *Murillo: A Biography and Appreciation*. London, 1907.

Cambridge 1958. *Drawings from the Collection of Curtis O. Baer*. Fogg Art Museum, Harvard University, Cambridge, 1958.

Carriazo, J. de M. "Correspondencia de Don Antonio Ponz con el Conde del Aguila." *Archivo Español de Arte y Arqueología* 5 (1929):157-83.

Catalogue . . . de la Collection Standish 1842. *Catalogue des tableaux, dessins et gravures de la Collection Standish legués au Roi par M. Franck [sic] Hall Standish*. Paris, 1842.

Catalogue des peintures anciennes 1938. *Musée des Beaux-Arts de la Ville de Strasbourg: Catalogue des peintures anciennes*. Strasbourg, 1938.

Ceán Bermúdez, Juan A. *Carta de Don Juan Agustín Ceán Bermúdez a un amigo suyo, sobre el estilo y gusto en la pintura de la escuela sevillana*. Cádiz, 1806.

Colnaghi 1969. *Old Master and English Drawings*. P. & D. Colnaghi, London, May 28-June 13, 1969.

Crombie, Theodore. "London Galleries: Baroque and Bristol Cream." *Apollo* 89 (June 1969):468-72.

Cumberland, Richard. *Anecdotes of Eminent Painters in Spain during the Sixteenth and Seventeenth Centuries*. London, 1782.

Curtis, Charles B. *Velázquez and Murillo: A Descriptive and Historical Catalogue*. London and Rivington, N.Y., 1883.

Delacre, Maurice, and Lavallée, Pierre. *Dessins de maîtres anciens*. Paris and Brussels, 1927.

Denon, Dominique Vivant. *Description des objets d'arts qui composent le cabinet de feu m. le baron V. Denon*. 3 vols. Paris, 1826.

Dessins du Musée du Louvre. Series 7. Alinari, Florence, n.d. [1890s].

Edinburgh 1951. *Catalogue of an Exhibition of Spanish Paintings from El Greco to Goya*. National Gallery of Scotland, 1951.

Frölich-Bum, Lili. "Zeichnungen alter Meister bei Christie's." *Weltkunst* 35, no. 22 (1965):1107.

Gestoso y Pérez, José. *Biografía del pintor sevillano Juan de Valdés Leal*. Seville, 1916.

Gómez Sicre, José. *Spanish Drawings: XV-XIX Centuries*. New York, 1949.

Gradmann, Erwin. *Spanische Meisterzeichnungen*. Frankfurt, n.d. [1939].

Guerra Guerra, Arcadio. "Como salió de España 'La Caridad Romana' de Murillo." *AEA* 27 (1954):336-39

Hamburg 1966. *Spanische Zeichnungen von El Greco bis Goya*. Catalogue by Wolf Stubbe. Hamburger Kunsthalle, October-November 1966.

Hand-list 1956. *Hand-list of the Drawings in the Witt Collection, Courtauld Institute of Art*. London, 1956.

Harris, Enriqueta. "A *Caritas Romana* by Murillo." *Journal of the Warburg and Courtauld Institutes* 27 (1964):337-39.

Hartford 1960. *The Pierpont Morgan Treasures*. Wadsworth Atheneum, Hartford, Conn., 1960.

Hernández Díaz, José. "Arte español del siglo XVII." In *Estudios de Arte Español*. Seville, 1974.

Hernández Perera, Jesús. "'La Caridad Romana' de Murillo." *AEA* 32 (1959):257-60.

King's Lynn 1969. *Drawings by the Masters (From the 15th to the 20th Century)*. Fermoy Art Gallery, King's Lynn, 1969.

Kubler, George. "El 'San Felipe de Heraclea' de Murillo y los cuadros del Claustro Chico." *AEA* 43 (1970):11-31.

Lafuente Ferrari, Enrique. "Dibujos de maestros andaluces." *Archivo Español de Arte y Arqueología*, no. 37 (1937):37-59.

Lafuente Ferrari, Enrique, and Friedländer, Max J. *El realismo en la pintura del siglo XVII: Paises Bajos y España*. Barcelona, 1935.

Lefort, Paul. "Murillo et ses élèves, IV." *Gazette des Beaux-Arts* 12 (1875):251-61.

Leporini, Heinrich. *Die Stilentwicklung der Handzeichnungen: XIV bis XVIII Jahrhundert*. Vienna and Leipzig, 1925.

Lipschutz, Ilse Hempel. *Spanish Painting and the French Romantics*. Cambridge, Mass., 1972.

London 1938. *From El Greco to Goya*. T. Harris Gallery, London, 1938.

London 1974. *Richard Ford in Spain*. Wildenstein, London, June 5-July 12, 1974.

London, Royal Academy 1938. *Exhibition of 17th Century Art in Europe*. Royal Academy of Arts, London, 1938.

London, Royal Academy 1962. *Primitives to Picasso*. Royal Academy of Arts, London, January 6-March 7, 1962.

Longhi, Roberto, and Mayer, August L. *Gli antichi pittori spagnoli della collezione Contini-Bonacossi*. Rome, 1930.

Los Angeles 1976. *Old Master Drawings in American Collections*. Catalogue by Ebria Feinblatt. Los Angeles County Museum of Art, Los Angeles, Calif., April 20-June 8, 1976.

Lugt, Frits. *Les Marques de collections de dessins et d'estampes*. Amsterdam, 1921. *Supplément*. The Hague, 1956.

Madrid 1927. *Exposición Franciscana. VII Centenario de la muerte de San Francisco de Asís: Catálogo general ilustrado*. Madrid, 1927.

Mahon, Denis. *Studies in Seicento Art and Theory*. London, 1947.

Mayer, August L. *Die Sevillaner Malerschule*. Leipzig, 1911.

——. *Murillo: Des Meisters Gemälde in 287 Abbildungen*. Klassiker der Kunst, vol. 22. Stuttgart and Berlin, 1913.

——. "An Unknown Portrait by Murillo." *Burlington Magazine* 24 (January 1914):231-32.

——. *Handzeichnungen Spanischer Meister: 150 Skizzen und Entwürfe von Künstlern des 16. bis 19. Jahrhunderts*. New York, 1915.

——. "Die Spanischen Handzeichnungen in der Kunsthalle zu Hamburg." *Zeitschrift für Bildende Kunst*, n.s. 19 (1918):109-18.

——. "La colección de dibujos españoles en el Museo de Hamburgo." *BSEE* 18 (1920):129-34.

——. "Anotaciones a obras murillescas." *BSEE* 42 (1934):14-18.

——. "Anotaciones al arte y a las obras de Murillo." *Arte Español* 13 (1936):46-48.

Mirimonde, A.-P. de. "Les Instruments de musique et le symbolisme floral à l'exposition de peinture espagnole au Louvre." *Revue du Louvre* 13 (1963):277-88.

Missirini, Melchiorre. *Memorie per servire alla storia della Romana Accademia di S. Luca fino alla morte di Antonio Canova*. Rome, 1823.

Montoto, Santiago. "Nuevos documentos de Bartolomé Esteban Murillo." *Archivo Hispalense* 5 (1945):319-57.

Muller, Priscilla E. "The Drawings of Antonio del Castillo y Saavedra." Ph.D. dissertation, Institute of Fine Arts, New York University, 1963.

Murray, C. Fairfax. *Collection J. Pierpont Morgan: Drawings by the Old Masters Formed by C. Fairfax Murray*. 5 vols. London, 1905-12.

Newly Acquired Drawings 1965-66. *Newly Acquired Drawings for the Witt Collection*. Courtauld Institute of Art, London, October 1965-March 1966.

Norfolk 1950. *Old Master Drawings*. Chrysler Museum, Norfolk, Va., 1950.

Pacheco, Francisco. *El arte de la pintura*. Edited by F.J. Sánchez Cantón. Madrid, 1956.

Palomino, Antonio. *El museo pictórico y escala óptica*. Vol. 3: *El Parnaso español pintoresco laureado*. Madrid, 1947.

Parris, Leslie. *The Loyd Collection of Paintings and Drawings*. London, 1967.

Pérez Sánchez, Alfonso E. *Catálogo de los dibujos*. Real Academia de Bellas Artes de San Fernando, Madrid, 1967.

———. *Catálogo de la colección de dibujos del Instituto Jovellanos de Gijón*. Madrid, 1969.

———. *Gli spagnoli da El Greco a Goya* (Disegni dei Maestri). Milan, 1970.

———. *Museo del Prado. Catálogo de dibujos, I. Dibujos españoles: siglos XV-XVII*. Madrid, 1972.

Pevsner, Nikolaus. *Academies of Art Past and Present*. Cambridge, 1940.

Popham, Arthur E. *Catalogue of Drawings in the Collection Formed by Sir Thomas Phillipps, Bart, F.R.S., Now in the Possession of His Grandson, T. Fitzroy Phillipps of Thirlestaine House, Cheltenham*. London, 1935.

Richards, Louise S. "Bartolomé Esteban Murillo: A Drawing Study for a Virgin and Child." *Bulletin of the Cleveland Museum of Art* 55 (1968):235-39.

Robinson, John C. *Descriptive Catalogue of Drawings by the Old Masters Forming the Collection of John Malcolm of Poltalloch*. 2nd ed. London, 1876.

Rouchès, Gabriel. *Maîtres espagnols du XVIIᵉ siècle*. Paris, 1939.

Sánchez Cantón, Francisco J. *Dibujos españoles*. 5 vols. Madrid, 1930.

———. *Spanish Drawings*. Drawings of the Masters. New York, 1964.

Sentenach, Narciso. "Dibujos originales de antiguos maestros españoles." *Historia y Arte* 2 (April 1896):28-32.

Stift und Feder, nos. 1-6 (1926).

Stirling-Maxwell, William. *Annals of the Artists of Spain*. 4 vols. London, 1847-48.

Trapier, Elizabeth du Gué. "Notes on Spanish Drawings." *Notes Hispanic* 1 (1941):1-61.

———. "A Christ Child as the Good Shepherd Attributed to the School of Murillo in the Hispanic Society's Collection." In *Homenaje al Profesor Rodríguez-Moñino*. Vol. 2, pp. 273-76. Madrid, 1966.

Truro 1936. *Catalogue . . . Alfred de Pass Collection*. Cornwall County Museum and Art Gallery, Truro, England, 1936.

U. of Kansas 1974. *Spanish Baroque Drawings in North American Collections*. Introduction and catalogue by Gridley McKim Smith. University of Kansas Museum of Art, Lawrence, October 19-November 24, 1974.

Valencina, Fr. Ambrosio de. *Murillo y los Capuchinos: estudio histórico*. Seville, 1908.

Velázquez y Sánchez, José. *Anales de Sevilla de 1800 a 1850*. Seville, 1872.

Volk, Mary Crawford. "Vicencio Carducho and Seventeenth Century Castilian Painting." Ph.D. dissertation, Yale University, 1973.

Waagen, Gustave F. *Treasures of Art in Great Britain*. London, 1854.

Wallace Collection 1968. *Wallace Collection Catalogues: Pictures and Drawings*. London, 1968.

Wellington, Evelyn. *A Descriptive and Historical Catalogue of the Collection of Pictures and Sculpture at Apsley House, London*. 2 vols. London, 1901.

Wethey, Harold E. "Alonso Cano's Drawings." *Art Bulletin* 34 (1952):217-34.

Wichita 1967-68. *Masterpieces of Religious Art*. Wichita Art Museum, Wichita, Kans., 1967-68.

Young, Eric. "A Drawing of 'The Annunciation' by Murillo." *Burlington Magazine* 115 (September 1973):604-7.

INDEX